CW00764683

WEAVING CHIAPAS

Weaving Chiapas

Maya Women's Lives in a Changing World

EDITED BY
Yolanda Castro Apreza, Charlene M. Woodcock,
and K'inal Antsetik, A.C.

TRANSLATED INTO ENGLISH BY
Leíre Gutiérrez with Charlene M. Woodcock

FOREWORD BY
Inés Castro Apreza

WITH CONTRIBUTIONS BY
Barbara Schütz

University of Oklahoma Press : Norman

*Published through the Recovering Languages and
Literacies of the Americas initiative, supported by
the Andrew W. Mellon Foundation.*

Library of Congress Cataloging-in-Publication Data

Names: Castro Apreza, Yolanda, editor. | Woodcock, Charlene M., 1939– editor, translator. | K'inal Antzetik, editor.
Title: Weaving Chiapas : Maya women's lives in a changing world / edited by Yolanda Castro Apreza, Charlene M. Woodcock, and K'inal Antsetik, A.C.; translated into English by Leíre Gutiérrez, with Charlene M. Woodcock.
Other titles: Voces que tejen y bordan historias. | Maya women's lives in a changing world
Description: Norman, OK : University of Oklahoma Press, [2018] | Includes bibliographical references and index.
Identifiers: LCCN 2017033395 | ISBN 978-0-8061-5983-6 (pbk. : alk. paper)
Subjects: LCSH: Maya textile fabrics—Mexico—Chiapas. | Maya women—Mexico—Chiapas—Interviews. | Weavers—Chiapas—Interviews. | Hand weaving—Mexico—Chiapas. | Jolom Mayaetik (Organization)
Classification: LCC F1435.3.T48 V63 2018 | DDC 972/.6—dc23 LC record available at https://lccn.loc.gov/2017033395

RECOVERING
LANGUAGES&LITERACIES
OF THE AMERICAS

Weaving Chiapas: Maya Women's Lives in a Changing World is published as part of the Recovering Languages and Literacies of the Americas initiative. Recovering Languages and Literacies is generously supported by the Andrew W. Mellon Foundation.

The paper in this book meets the guidelines for permanence and durability of the Committee on Production Guidelines for Book Longevity of the Council on Library Resources, Inc. ∞

Copyright © 2018 by the University of Oklahoma Press, Norman, Publishing Division of the University. Manufactured in the U.S.A.

All rights reserved. No part of this publication may be reproduced, stored in a retrieval system, or transmitted, in any form or by any means, electronic, mechanical, photocopying, recording, or otherwise—except as permitted under Section 107 or 108 of the United States Copyright Act—without the prior written permission of the University of Oklahoma Press. To request permission to reproduce selections from this book, write to Permissions, University of Oklahoma Press, 2800 Venture Drive, Norman, OK 73069, or email rights.oupress@ou.edu.

1 2 3 4 5 6 7 8 9 10

To Juana Sántiz Díaz, Rosa López López, and the grandmother of Pascualita, our female colleagues and sisters who are no longer with us and who opened the way for the women who are in the Jolom Mayaetik weavers cooperative today

Contents

Illustrations

MAP

COLOR PLATES

FIGURES

Foreword

The vibrant voices in this book provide testimonies of rural indigenous Maya women, members of the Jolom Mayaetik weavers' cooperative, who wanted to record their views and experiences. The book constitutes, in effect, a historical document that tells the life stories of the cooperative members, including the textiles they produce as well as their lengthy organizational process. These women, Tzotzil and Tzeltal Maya of Los Altos de Chiapas, in the highland Chiapas region, have extensive organizational experience that has become an example for many other women's groups aspiring for change and transformation in their lives.

Jolom Mayaetik had been in development for more than a decade when, in 1995, many women agreed on the necessity of forming an organization of their own, autonomous and independent of government support, free from the obstacles and constraints of both government and well-intentioned volunteer advisors.

The women who joined together began their journey in the late 1980s. Along with other women in Chiapas, they are the pioneers of the women's movement in the public spaces of handicraft collective and artisan cooperatives. They have demonstrated that rural women can and should be organized around productive projects that not only improve the living conditions of families, but increase women's agency in terms of economic and human development. These women of Jolom Mayaetik have taught other young women to recognize artisanal production as an alternative path for their lives. These women, adults and adolescents, represent two generations making history by way of their increased participation in the public sphere, both within and outside their communities.

For me, it is an honor and a great privilege to know and be close to these women. In 1995, I arrived in the state of Chiapas and almost immediately came into contact with some of the founders of Jolom Mayaetik. They were engaged in a discussion process about what current strategies should persist within the old organization while planning to give birth to the new. The internal political differences from the old organization were deepening each day in the context of a difficult political climate: the armed uprising of the Zapatista Army of National Liberation (EZLN) in January 1994 had given rise to intense mobilization of a range of social sectors that converged and became known as civil society. This civil society manifested itself in different ways in favor of the eleven initial demands that the Zapatistas raised in the First Declaration of the Lacandon Jungle.

Joining a movement like the Zapatista uprising was not easy because society in Chiapas was divided and polarized in that historic year as perhaps never before. To join as indigenous rural women was even more complicated. Nevertheless, with the support of mestiza women, nongovernmental organizations, and social organizations, indigenous women and farmers quickly became involved in the organizational processes that took place in the months following the Zapatista uprising. Marches, rallies, workshops, forums, and conferences multiplied, establishing essential public spaces in which rural women often participated for the first time. Ideas and information poured into all these spaces, new strategies were designed, and public documents related to the rights of women were discussed.

The first publication of the Zapatista Women's Revolutionary Law (appendix B) was endorsed by dozens and dozens of women. Rural women were prominently involved in these organizational processes. No other state has given as much evidence, in so little time, of the strength, the unity—sometimes fractured, yet real—and the female solidarity expressed in Chiapas at the time. And the women of Jolom Mayaetik, then organized as J'Pas Joloviletik, were always at the forefront of this process. Since the 1990s, they have been a distinct presence in those public spaces, standing out as women leaders and protagonists with great organizational skills and independence.

During this time, J'Pas Joloviletik suffered attacks, robberies, and suspected surveillance at the cooperative's store. Alongside many other women, the leaders in 1994 and 1995 who became the founders of Jolom Mayaetik were courageous. At this decisive point in their own organizational process, they did not hesitate to renounce their material possessions and other privileges, including a government concession from the National Indigenous Institute (INI), to find a way to build their own future. They did not yield to the temptation to re-form their organization with the original name but including the adjective "independent," as did many organized groups in the state. Instead they started from scratch, harnessed their talent and character, realized their own aspirations, and made Jolom Mayaetik a model of a women's organization that derives its moral authority from their own communities.

Today, Jolom Mayaetik is one of the most important women's cooperatives in Chiapas, the organization with the longest history and most notable economic success, earned by the members' own hard work. At times a textile production cooperative did not seem to be viable, and more than once women were forced to sell their work at low prices in private stores of San Cristóbal de las Casas and at the Santo Domingo market, but these women were determined, above all, to preserve their cooperative as their livelihood and way of life.

Their tenacity was surprising in an economic context dominated by individuals seeking personal gain. It would have been impossible without the help of several generous people from around the world (some of whom created the so-called fair trade market) and without the financial support of others, as well as the accompaniment of mestiza women, who have not bowed in the face of difficult situations. The present status of the members would hardly have been achieved however if they, the women of Jolom, had not resisted the temptation of easy solutions. To believe in their own ideas, in the project itself, in their ability and potential has been a constant among the women of Jolom who have succeeded and thereby transmit their experience to the next generation.

From a strictly economic perspective, the form of production and marketing that the cooperative has practiced might be considered as a kind of women's economy that seeks to affirm integral human development,

not with individualistic but with collective objectives. An economy with a female face recognizes women's potential to contribute to family, community, and municipal well-being. An economy with a female face does not detract from the struggle to build a different world where equality exists in gender and social relations, and the full rights of women and men of different nations and groups are recognized. This economy with a female face supports a dignified life for all women.

While textile production now provides the women with a steady income and an ability to contribute, often in a fundamental way, to the family income, the cooperative has also helped to create other public spaces, both inside and outside of indigenous communities. Now the assemblies or meetings held in local communities to support artisan work are socially accepted as normal and, often, as an essential part of the local dynamics. This is easily said but was no small task. And the women know who has contributed to achieve community cooperation.

After decades of experience, Jolom Mayaetik now offers this book that chronicles the lives of its members, their tenacity, their strength, their integrity, their autonomy, their independence. That no obstacle is insurmountable is surely one of the main teachings of these women, as is revealed on each of the following pages that narrates their lives.

Inés Castro Apreza

Preface to the English Edition

Published in Spanish in 2007 under the title *Voces que tejen y bordan historias: Testimonios de las Mujeres de Jolom Mayaetik* (Voices That Weave and Embroider Histories: Testimonies of the Women of Jolom Mayaetik), this book contains interviews conducted over four years with members of the Jolom Mayaetik weavers' cooperative, indigenous weavers from traditional rural Maya communities in the highlands of Chiapas, the southernmost state of Mexico (see map).

This book provides a glimpse into the memories and daily lives of women still in touch with an ancient indigenous culture, at a moment when that culture is abruptly being drawn into the global mainstream. Most of the women who participated in this book were monolingual speakers of one of several Mayan languages. They grew up in indigenous communities not yet tied into the mainstream by radio, telephone, television, or computers. But as this English edition of their book goes to press, they now have more ways to connect with the outside world. Many of them now use cellphones and have access to the radio, and some have learned to use a computer. (During the Zapatista uprising, in which several of the women featured in this book participated, radios were an effective mode for organizing.)

Many of the interviews were translated from the Mayan languages of Tzotzil or Tzeltal into Spanish by Merit Ichin Satiesteban, Gustavo Jiménez Pérez, Cecilia López Pérez, Micaela Hernández Meza, and Rosalinda Sántiz Díaz. Chapter 2 includes the words of José López of Bayalemó, San Andrés Larráinzar—a respected elder and the father of two members of the cooperative—on religions and traditions in the Maya communities.

The book was conceived by the members of the cooperative, who wished to document their life experiences, and was facilitated by members of the Mexican nonprofit organization K'inal Antsetik. Formed to advise and support the weavers when they created their cooperative in 1996, K'inal Antsetik now includes the indigenous past presidents of the cooperative, who work on documenting and sustaining cultural traditions alongside the economic self-help projects K'inal Antsetik supports throughout Chiapas.

Leíre Gutiérrez, licentiate in translation and interpretation from the University of the País Vasco (Basque Country), completed the initial translation of this book from Spanish. Charlene M. Woodcock, former editor at the University of California Press and friend of the cooperative since 2000, refined the translation, edited the text, and wrote chapter introductions. The intent of the translators was to preserve the voices of these rural indigenous women. Some of them were unable to continue their schooling after the sixth grade and therefore communicate only in their native Mayan language or hesitantly in Spanish, while others are bilingual and speak fluent Spanish in addition to their native indigenous language. In the women's accounts, Tzotzil terms are retained for some of the basic elements in their daily lives; these words appear in italics on first use and are followed by an English translation in brackets. Spanish terms that appear frequently in the accounts are also italicized initially and followed by English glosses in brackets. Translations of Tzotzil and Spanish terms that appear in parantheses in the interviews were provided by the speaker herself or the Spanish translator in the Spanish edition. The foreword, the introduction, and the afterword, "Voices and Stories of the Women Weavers of Los Altos de Chiapas, 1984 to 2006," were written by members of K'inal Antsetik, university-trained women whose use of Spanish (as the English translation here reflects) is informed by their education.

Charlene M. Woodcock

Acknowledgments

Thank you to the following organizations and individuals for producing the original Spanish edition of this book.

For direct financial support, thank you to the Council of Mondragón, the Council of Oñate, Madre, the Swiss Embassy in Mexico, and the Basque Government through Paz y Solidaridad.

Thank you as well to the following foundations, whose support enabled oral history workshops: Public Welfare Foundation, Solidago Foundation, Global Fund for Women, the Council of Donostia, and Semillas.

For the idea and development of the project, thank you to Yolanda Castro, Merit Ichin, Micaela Hernández, Rosalinda Sántiz, Barbara Schütz, Imelda de la Cruz, and Arnulfo Calvo.

For collecting and organizing these narratives, thank you to Merit Ichin and Verónica Pacheco.

For the translation into Spanish, thank you to Merit Ichin Satiesteban, Gustavo Jiménez Pérez, Cecilia López Pérez, Micaela Hernández Meza, and Rosalinda Sántiz Díaz.

For conducting the interviews, thank you to Merit Ichin, Verónica Pacheco, Micaela Hernández, and Rosalinda Sántiz.

Special thanks as well to Mertxe Gómez, Lourdes Aldekoa, Marla Gutiérrez Gutiérrez, Georgina Molina Terreros, Gloria Soneira, Cristina Orcí Fernández, Nellys Palomo Sánchez, Sara Lovera, Komités Internacionalistas, Candelaria Marrero, Ricardo Iglesias, Mª Inés Castro Apreza, Elizabeth J. Rappaport, Kate O'Donnell, Charlene M. Woodcock, Vivian Stromberg, Mónica Alemán, Jason Wallach, Reyna Coello Castro, Laurie

Wilkins, María, Daniel Luna Alcántara, Don Lauro, Mª del Carmen Martínez, Patricia de la Fuente Castro, Eva Schulte, Rosaluz Pérez, Hilaria Klein, Vivián (K'inal), Adriana, Ana Laura Hernández, Anne Grillet, Julio Falquet, Fernando Rodríguez, Marisa Kramsky, Aide Rojas, María Meyers, Carolina Huwiler, Carmen Morales, Marina Patricia Jiménez, Janet Corzo, Silvia Solís, Mª Elena (administrator in K'inal), Doris, Dora Mª Chandomí, Concepción Villafuerte, Guiomar Rovira, Rosa Sántiz Ruiz, Pascuala Gómez, Aurora Apreza Patrón, Lucia Castro Apreza, Pepe (Paz), Juana Mª Zebadúa Cerda, Movimiento de Resistencia Popular del Sureste, Andrea Jung, Beate Mulfinger, Ricarda, Blanca Espinoza, Guadalupe Gutiérrez, Alejandra Álvarez, and Christine Eber.

Introduction

This book has had a long history. Women of the Jolom Mayaetik Cooperative have dreamed of telling their story ever since Yolanda Castro and Cecilia López visited Corpus Christi, Texas, in October 1998. They traveled to the United States to participate in the *Mayan Images* exhibition organized by Laurie Wilkins of the University of Florida, where Cecilia demonstrated some of her weaving techniques and told attendees about the life of the women artisans from Chiapas. When Cecilia learned of the meanings ascribed to the different Maya symbols within the exhibition, she said, "This is not correct; this must be an invention of some anthropologists." However, Cecilia, a young woman from the municipality of San Andrés Larráinzar, had learned to weave those symbols from her mother and did not know their exact meaning. So Yolanda suggested that older women from the cooperative should teach younger women the meanings of the symbols they wove, saying, "We have to restore this knowledge!" On returning from the United States, the women attended the assembly of the cooperative and discussed the idea of initiating a dialogue between generations so that the women themselves could talk about their culture, their textiles, and their lives. At that moment the idea of this book was born.

A series of workshops called the "Oral Story" was organized in 1999 and 2000 to promote intergenerational dialogue. The first workshops were sponsored by K'inal Antsetik, a nonprofit organization formed by mestiza and indigenous women in the early 1990s to support the organization and economic development of indigenous women in Chiapas.

Later, Micaela Hernández and Rosalinda Sántiz arranged workshops conducted in Tzotzil and Tzeltal, the indigenous languages of the weavers, with some workshop preparation support from K'inal Antsetik. In these later meetings women talked about a variety of topics, from Jolom Mayaetik and how they learned to weave, to health concerns, their bodies, puberty, and marriage. Usually, the older and younger women of the cooperative met first in separate groups, then the two groups shared their stories. The younger women listened carefully and sometimes were surprised to learn how different their lives were from what their mothers and grandmothers had experienced.

All these workshops were audio-taped. Initially, Merit Ichin, Barbara Schütz, and Yolanda Castro transcribed the audio recordings, then Micaela Hernández, Rosalinda Sántiz, and Cecilia López translated them into Spanish. After this team had invested considerable time and work, the laptop storing all the workshop information was stolen, suddenly leaving them with nothing. The women were furious because they could not understand who would want to steal their words. They became even more determined to publish their own book, so that their words and stories could be read all over the world. From that moment on, they no longer wanted to be simply artisans but also authors of their own story.

The transcription and translation processes started over again, and once a substantial body of material had been gathered, Verónica Pacheco was hired to edit the narratives. As Verónica edited and organized the material, she discovered some omissions and gaps that she presented to future workshops for deeper discussion. Up to twenty or thirty women participated in these workshops and they all wanted to talk, so each contribution had to be limited to a few minutes in order to record everyone's voices. Some subjects also proved difficult to address in the group, and others were addressed tangentially, as they were not of primary interest.

It was decided to carry out a second round of individual and group interviews of key leaders of the cooperative, conducted in the weavers' communities and the municipal center of San Cristóbal de las Casas. Thus, the process of transcription and translation started once again, with Merit Ichin as project manager.

During 2003 and 2004 the cooperative weathered many internal conflicts and the book project was relegated to the back burner as the coop-

erative and the assemblies, both women and their husbands, debated their core purpose.

During this period, young women from the cooperative took a photography course in order to document the world from their viewpoint. One photo taken during the course, by Susana Sántiz, was included in the Spanish edition of this book. Other women from various countries—advisers and companions, friends and supporters of the cooperative—also took photos reflecting their worldviews and showing their love for these women. Many of their photos were published in the Spanish edition of this book as a way of acknowledging their advocacy and support for the cooperative. [Unfortunately these photographs were unavailable for the English edition.] Cooperative members were able to grow and assert themselves through constant dialogue with "the others." Finally, in 2006, Barbara Tello was given the task of finishing the project. She edited and formatted the texts into a book manuscript, adding an interview with Pascuala Patishtán, a midwife from Bautista Chico.

Many people have shared ideas and given their time, love, solidarity, and financial support to this project of the Jolom Mayaetik cooperative. Only some of them appear in this book or are mentioned by their given names or surnames, but nonetheless their support and contributions live in the hearts of all the women from Jolom Mayaetik.

We were unable to recover the meanings of many of the woven symbols, which was our initial intention. Yet these symbols still live in the beautiful weavings and collective memories of cooperative members, even without exact definitions. We were able to recover the names of seventy symbols from San Andrés and also have created two beautiful fifteen-foot woven tapestries documenting this ancient knowledge. This worldview cannot however be shared in words. These women's collective memory lies in their bodies, culture, textiles, language, and emotions. It belongs to them. They offer in this book what they with thoughtful consideration were willing to share with other readers from around the world—their deepest understandings about their lives and culture. They are the authors of their own story, the weavers and embroiderers who give voice to the stories of Jolom Mayaetik.

Barbara Schütz

WEAVING CHIAPAS

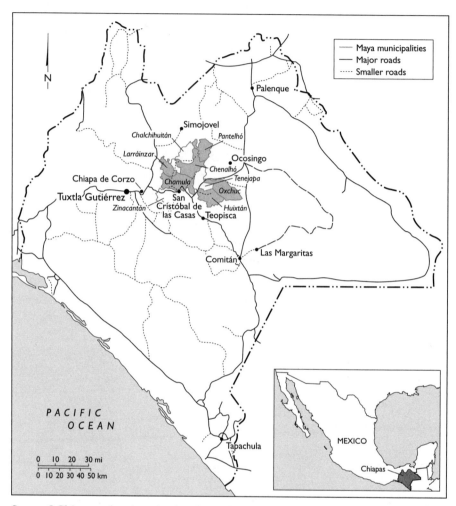

State of Chiapas, showing the borders of major highland municipalities. Map by Bill Nelson. Copyright © 2018, University of Oklahoma Press.

A Woman's Life,
from Childhood to Marriage

These are the memories and stories of women born into traditional Maya families in the highlands (Los Altos) of Chiapas between the 1930s and 1980s, where a large indigenous population lives in rural, essentially self-governing communities within the larger *municipio,* or county organization. The communities have to a large extent preserved their indigenous languages and cultural traditions, subsistence farming practices, food traditions, and particular styles of clothing, which vary from community to community. Styles of dress, and even hairstyles, identify members of specific communities. Many families continue to cultivate their milpas (small agricultural plots), where they grow corn, other vegetables, and coffee for their own use and to sell. Men who do not have land of their own for coffee cultivation work on other peasant-owned land or on lowland plantations, or do construction work. By custom, the women are responsible for managing the home and caring for domestic animals and have been restricted from more public occupations. Children are expected to work from an early age. Girls take care of younger siblings to free their mothers to fulfill their other responsibilities. The past thirty years have seen an evolution from a barter to a cash-based economy, which has made finances more difficult for most families. The communities carry on traditions of civic responsibilities, restricted to men, but while women are responsible for decorating the church or caring for the school, some would like the opportunity to take on broader civic obligations.

In this chapter the women look back upon their childhoods—a carefree time for some, even though they were expected to help their

mothers. As with children anywhere whose families live close to the land, the pleasures of childhood play soon give way to an obligation to participate in family chores, care for siblings while parents work, and take care of domestic animals. Nonetheless, there is a freshness to these memories of early childhood play, before the burdens of household tasks—learning to cook or helping parents take produce to the market—begin to push them into adult responsibilities.

The memories of some women darken as they recall the sometimes unwelcome, premature expectation that they marry. Traditionally, the parents arranged the marriage after the suitor visited them with a request to marry their daughter. If the parents were receptive, the arrangement was sealed with a gift of alcohol. More recently, however, recognition of the damage done by excessive drinking has encouraged the substitution of soft drinks for alcohol in this and other traditions. After the wedding the young woman went to live with her husband and his family, and was subject to his parents' wishes. These customs are changing, so the difficulties and conditions some of the women interviewed here faced as newlyweds would be diminished for young women marrying today.

In the section on childbirth, note that several participants in the discussion live in the Tzeltal community of Yochib, where there is a *partero* (male midwife). In most communities the midwives are female.

OUR GAMES

We can't remember the games we used to play very well; it was a long time ago and we can't really remember and tell.

Pascuala Díaz, Bayalemó

I remember playing in the milpa behind the bean bushes, hiding myself. I used to play the whole day. We didn't have a name for the games. I liked climbing the trees. I was around eight years old.

Francisca Pérez, Chichelalhó

I used to carry a dog instead of a doll. I pretended he was my baby and I nursed him. Nursed the dog! My mom told me not to carry the dog,

View from Los Naranjos, Pantelhó, 2010. Photo by Charlene M. Woodcock.

but I didn't obey. I remember that my mother used to buy flour and I liked eating it. She got angry and that's why I played in secret. Once, I hid myself in the grass and I started eating it [flour]. But it wasn't flour, it was lime instead! [Laughter] I ate lime! I thought I was going to die because my tongue was numb, and because I was really afraid, I had to tell my mom.

Antonia Hernández, Bayalemó

When I was eight years old, I used to cut the leaves from the trees to make tortillas. My friends and I boiled the leaves and pretended that was our meal. Sometimes the game ended up with anger or blows. My mother wanted me to include my little brother, but I used to get bored soon, and I left him on the ground and ran off so that my mom wouldn't notice. After doing that, it was hard going back home because I knew what I did was wrong.

Rosa González, Jolxic

When I was a little girl I used to play all the time, and I made my dolls and gave them hair of corn silk. I also used to make toys during the harvest. My mother taught me. I had a little machete and I used to play with it. I built myself a little house and because I saw that my mom had a metate [grinding bowl] I also wanted one. I played with my machete. But I cut myself with it; here are my scars.

Pascuala Patishtán, Bautista Chico

When I was a child, my mother suffered because she had to look after me and carry me, so I kept her from her work. When I got bigger I started to play. My mom collected corncobs to make our toys.

When I was older I played with my little brothers while my mother did her work. When my sister went out with the sheep she used to invite me to play, but I used to say, "Help me prepare the wool before we play," and she helped me. When we finished our work, we began to play, or we sat in the hills.

Tending sheep, Chamula, 1993. Photo by Joan Ablon.

María Gómez, Yochib

When we were little girls we didn't leave our mothers. We couldn't walk yet and we were being breastfed. When we got bigger the main thing we did was play, even though our mother told us to bring some wood or water to the house. We didn't obey, we just played. That's why we used to get beaten sometimes, but we didn't feel the blows much because we loved playing.

Juana Jiménez, Bautista Chico

I liked to play. I made my toys; I looked for leaves to make tortillas, I used to make my dolls. But my mother used to get angry because I didn't help her; then she slapped me and said, "That's the way you feed yourself? You can't feed yourself with that!" I remember well.

While my mother did her work, during harvest time, we used to collect the cobs to turn them into dolls, and we used the corn silk for the dolls' hair. We also collected bottle tops and we pressed them into leaves to make tortillas, it makes them really round. With the leaves of a tree called *chijilte'* [Mexican elder] we made dresses for the dolls.

Adela López, Bayalemó

When I was a little girl, I used to steal the hens' eggs before my mother collected them. I ate them raw and my mom used to say, "This hen is no good, it never lays eggs."

WORK AT HOME

I stopped playing little by little. . . . "We have to weave and work. If you just play we earn nothing!" my mother used to say.

Francisca Pérez, Chichelalhó

I think it wasn't until I was twelve years old that I started doing some work. I stripped kernels of the corn from the milpa and I looked after my little brothers. I remember that I used to go with my mother to the milpa to take home the vegetables, corn, and beans. Sometimes our mothers told us to grind the corn or to make tortillas, and if we didn't obey they wouldn't feed us. We would say to them, "I don't care, I can stand the hunger. I can live from air or from my spirit" [laughter], and my mother answered us, "We will see if that's true, but don't come tomorrow asking for food."

Rosa González, Jolxic

I stopped playing little by little. I suffered because I didn't have a father to support me. My mother had to work in the milpa and she also wove things to sell to the *san pedranos* [indigenous people from San Pedro, Chenalhó].

I grew up hungry. We suffered a lot; we used to eat two or three tortillas. My mother was the one who endured the most hunger. "We have to weave and work. If you just play we earn nothing!" my mother used to say. She asked me if I had prepared the wool, and if I hadn't, she beat me. Then I was afraid, but the next day I tried harder so that I could play.

When I came home with the work finished, my mother was satisfied. As I grew older, my mom told me to carry water and to grind corn. Then, we didn't use the hand grinder but the metate. My mother bought me a little metate, but I didn't know how to use it so I had to grind the corn twice. "Why can't you grind the corn? Do it carefully, pay attention to your metate; we're not going to throw away the corn, it is not shit!"

When I finished, I couldn't lift the metate because it was too heavy. The metate gave me blisters in my hands, I wanted to cry.

Then my mother told me I should learn how to make tortillas. My sister and I went to look for banana leaves; with the banana leaves we made tortillas. We stored them, but the next day they were rotten. I don't know whether nylon bags existed or not, but we used banana leaves. That's how we made tortillas.

"Don't get used to that. When you get married you are not going to use banana leaves; aren't you embarrassed?" my mom said to me. I didn't know how to make tortillas, I suffered a lot growing up. My dad had died; so we went to Chenalhó to sell fruits and vegetables. We carried limes and oranges, they weighed a lot and we couldn't sell them. We offered six or eight for five cents, but we earned almost nothing. That's how I grew up and left my childhood behind.

Pascuala Patishtán, Bautista Chico

When I was older, my mother taught me how to work. She taught me to prepare the wool, and I used to carry it in a basket as my mom told me. "You have to have everything ready, I don't want you to play."

I went out with the sheep; I took them to graze, and when I came back my mother asked me if I had finished my work. I told her that I had, then she checked it. That way, there were no slaps or scoldings.

I have a sister who didn't like weaving very much, so she buried her work under the grass or in the ground. When my brothers went to work the land, they found her work buried and beat her. In my case, they didn't beat me for my work.

I used to look after my little brothers so that my mother could work.

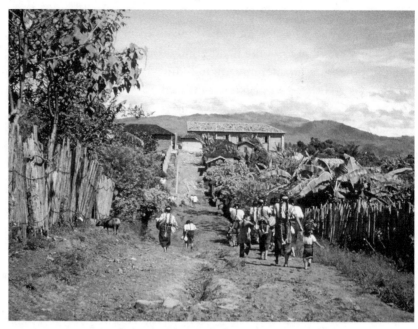

On the road, Pantelhó, 1977. Photo by Joan Ablon.

As I grew up my mother told me I had to start working, but I didn't want to work. I just wanted to play. She told me that I had to learn to take care of myself and to make my clothes. She wouldn't always do it for me. "I won't always be living with you; you'll grow up and you will have to make your own clothes. If I die, who will make your clothes?" That's what she said to me; she always urged me to learn how to work.

Juana Jiménez, Bautista Chico

When I was a little girl my mother sent me for water. One time I dropped the jug when I was going for water. When I came back home with the broken jug I tried to hide it, but my mom realized and asked me what I had done. I didn't answer because I was afraid that she would scold me.

She didn't beat me, she only scolded me. She was angry when she realized that I wasn't carrying any water. There was nothing to drink and she said to me, "Why did you break the pitcher? Don't you see that we have no money to buy another one?"

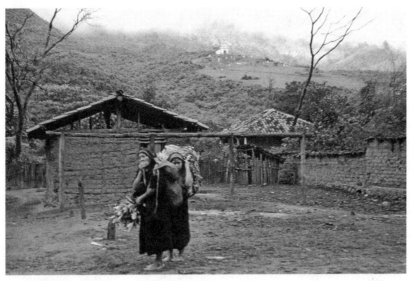

Taking produce to market, 1959. Photo by Joan Ablon.

I was eight or nine years old [then]. When I was twelve I was still afraid of carrying the pitcher.

When I was seven years old, my job was to carry the water and wood. I don't remember doing anything else. My dad died when I was very young. Maybe he scolded me sometimes, but I can't remember. I grew up with my mother. With her we went for wood, she cut the branches and we carried the wood.

María López, Oventik Grande

By the time I was five years old my mother already made me cook beans and do housework. If I didn't obey, she beat me with a stick and she didn't let me play. When my mother went to the market, I used to go with her to carry the children because we couldn't leave them alone at home. Later, I went to the market with my parents to carry the things they had bought.

THE TEACHINGS OF OUR PARENTS

How are you going to take care of your husband if you don't know
how to cook and you burn the beans?

Francisca Pérez, Chichelalhó

When things didn't turn out well, my mother used to get upset and scold
me—for example, when the beans burned. My mother and my grand-
mother told me not to have tangled, untidy hair but I didn't obey. I
wouldn't let them check my hair for lice. I used to get angry and run
away so that I couldn't hear them, and I said, "¡Ah, it's because they are
already old women!" Sometimes we fought with our brothers or sisters.
We said to them: "Why do you take my clothes when you already have
your own?" or we would complain about [those things] to our parents.
"Why do you only buy clothes for her if I'm also your daughter?" That's
why we complained: because they bought more for some daughters than
for others. We also fought during meals because one of us ate more tor-
tillas or corn than the rest, so we started fighting and saying, "I was the
one who went to the milpa and carried the corncobs; you didn't want to
carry them, that's why I can eat the tender corn!" What we did with the
ones who didn't want to carry the corn was we left them the old corn
that wasn't sweet, and we did the same with the *pozol* [drink made from
cocoa and corn, dating from prehistoric times]. We said, "I can eat more
than you because I was grinding for everyone. Besides, I woke up early to
make the tortillas so I can eat more than the others."

Another thing, we didn't want to wash our clothes, because we also
had to wash the clothes of the little ones. So we didn't obey and our
mother used to say, "Those who don't want to wash their clothes will be
naked or dirty. Won't you be embarrassed?"

Marcela López, Bayalemó

My mother used to get very angry and she would say to us, "Don't you
see that the beans are getting burned!" She didn't beat us, but she
scolded us.

Almost always our mother was the one who reprimanded us. It was because we didn't know how to do things properly, and if we didn't learn we wouldn't be able to find someone to marry. That was true. They told us, "How are you going to take care of your husband if you don't know how to cook and you burn the beans?" And they said the same to the boys.

On Sundays, when my parents went to town, we took the opportunity to sell pears and keep the money. At that time there weren't shops like there are today. We didn't spend the money until we had another chance to go to town because there we could buy things that we liked, but we did this in secret. For instance, on a saint's day festival, even though my parents were there, we told them, "Look, mom or dad, we found this coin on the ground!"

Cecilia López, Bayalemó

Yes, the parents scolded both boys and girls. For example, they told them not to play all the time, but also to work; or that they had to go for wood but they could also play with the cars. If they didn't obey, they said the same thing they said to the girls: "You are not going to find someone to marry."

Celia Sántiz, Bayalemó

When the children are really little, parents don't scold them. But when they grow bigger they are taught that they have to work; they have to sow and bring wood to the house, even if the quantity of wood is small. It is usually the father who takes the boys to the milpa and shows them how to weed and use the hoe.

The father tells them how to do it properly, and if he notices that the children don't want to learn, he scolds them by saying that if they don't learn how to work properly they won't be able to find a woman to marry and they won't be able to feed her.

Rosa González, Jolxic

As I was growing up my mother said to me, "That's enough playing! Why do you spend the whole day playing?" Then I went to herd sheep, and she said to me, "Do your work and don't start playing." My father was dead then. My mother stayed at home working and I went to herd sheep with my grandmother. "Hurry up, girl, and stop playing! You have to realize that nobody supports you! Don't you see that your father is dead? Start working and stop playing!" my grandma said to me. I didn't obey, I just played.

Pascuala Patishtán, Bautista Chico

My parents used to beat me because I didn't wake up early. One day, my dad woke me up with a lashing.

Once when I was herding sheep, it started raining, and since I didn't want the sheep to get wet I made them run. Unfortunately, they went into the milpa and destroyed the harvest. They [my parents] beat me again that time. When I was older they woke me up earlier. "Wake up; you can't be sleeping the whole day! Nobody will support you; as a woman you have to cook for your mother," my father told me. "You won't be living here forever; one day you will get married and you will have to cook." "Make me pozol and give me my tortillas! I don't want you to serve only your husband when you get married," my father continued. I obeyed him in everything; that's why he didn't beat me much.

Juana Jiménez, Bautista Chico

My mother wanted us to learn and she always got angry and said, "How are you going to learn how to work if you don't stop playing? Remember that your clothes will wear out and we don't have enough money to buy more!"

Rosalinda Sántiz, Bayalemó

I remember always fighting during meals. In order to avoid the fight, we had to wait for my mother to serve the food on our plates, because if

we didn't we always ended up fighting. We threw the food and hit each other.

María Gómez, Yochib

My parents and my brothers raised corn. They worked and we didn't go hungry; we had food to eat even though we had no land. My parents rented the land from the owners and cultivated many things. They always made the effort to rent land, work it, even going to places far away. I never knew what it was to go hungry because we always had new corn.

There are a lot of people with lands that don't want to work them. My brothers didn't have land, but they rented the lands known as *tierra caliente* that were far from the community.

I was the oldest daughter, so my duty was to take care of my little brothers. When I played I carried them on my back, and if one of them fell, my parents beat me because my brothers were crying.

Martha Gómez, Yochib

I didn't get to know my mother because she died when I was very young. I can't even remember her face. She died from a dreadful stomachache after her stomach swelled up.

My father looked for medicine for her but she didn't get better. She was in bed for many days until her hands, legs, and face started to swell, and in a few days she died.

My sisters and I stayed with my father. We were very poor; we had nothing, not even clothes.

My father, together with my older sister, brought us up. She cooked for us, bathed us, and washed our clothes. We didn't know how to do it because we were very little.

My father didn't look for another woman. He was worried that she might not treat us right. That's why he stayed by himself until we were old enough. It was eighteen years before he looked for a partner.

He didn't look for a woman until my older sister was married and we could cook and do the housework and take care of him. Unfortunately,

he was unlucky once again because this woman also died soon after due to a high fever.

After that, my father decided to stay single. Nowadays, he lives in his house with my only brother.

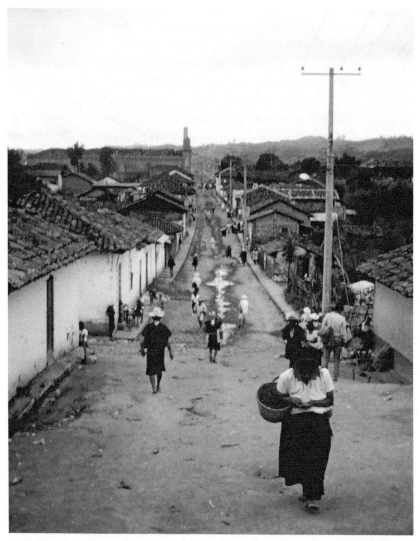

View down a street in San Andrés, 1974. Photo by Joan Ablon.

OUR BODIES

We were taught that touching ourselves is wrong.

Celia Sántiz, Bayalemó

We were taught that touching ourselves is wrong, but when we take a bath we have to touch our body to clean it properly, because there is no other way of doing it. If not, we would be dirty and we would get sick. If we don't clean our hands before eating we get sick, [and] the same happens in this case. When I was a little girl I didn't know about growing up; when I was little, nobody told me about my body. Neither my mother nor my father told me anything. When I realized it, I was already old enough. I learned by myself that boys were different from girls. I was twelve or thirteen years old when my nephew was born, and I saw he was a boy. It was then that I realized that boys and girls were different. When boys are born we can see that they are different from girls. I never asked my father about the body. Besides, he didn't know how to read or write and he didn't know the parts of the body in Spanish.

Rosalinda Sántiz, Bayalemó

In primary school we saw the drawing of the body in our books, that's when I knew little by little about my body. I saw the way my girlfriends were growing up and I knew that I would grow up the same way. Like that. But women are not allowed to touch or to know our body. It is believed that the parts of our body are dirty and nobody speaks about it. Nobody touches on that matter. Before, I wouldn't speak about it, but now I do.

Among women, we tell each other when we suffer from headaches or stomachaches, but nobody speaks about "that part of a woman's body."

Boys aren't told about their bodies. For instance, my parents didn't tell my brothers They didn't know about their body until they started school. My brothers didn't ask; they weren't used to asking. That's the way it went in my family. Nobody touched on those matters.

Verónica Gómez, Jolxic

When we were little girls our mothers told us that our body would change as we grew up and for that reason we had to take care of our body. But that's all they told us, no more. They didn't tell us that when we were fourteen or fifteen we would have our menstruation. They just told us that we had to take care of our body but not what was going to happen. They didn't tell us that something was going to change in our lives.

Rosa Gómez, Yochib

We realized that boys and girls are different during the *temascal* bath [steam bath, like a sweat lodge]. A boy's body is different from a girl's body. We also realize it when we have our babies.

At school we were taught about the difference between boys and girls, but I didn't learn anything because I was really embarrassed talking about those topics. So I hung my head in the classroom.

Zoila Sántiz, Yochib

When babies touch themselves and pull their penis . . . [laughter] they are scolded and sometimes they [adults] slap their hands, but they are very little and they don't know anything.

"It's not okay to touch yourselves." That's what our mothers told us, even if we bathe in the temascal. And, of course, we all touch ourselves.

María Gómez, Yochib

We realize the difference between men and women because the clothes are different. Boys wear trousers and girls wear the *nagua* [traditional cotton skirt], as my granddaughter does. I dress her with the *nagüita*, not with trousers.

Pascuala Patishtán, Bautista Chico

Nobody told me about my body.

Pascuala Pérez, Yochib

My parents told me that I was a woman, but they never said to me that I was different from the boys.

MENSTRUATION

When I had my first menstruation, it took me by surprise because I didn't know anything about it.

Martha Gómez, Yochib

When I had my first menstruation, it took me by surprise because I didn't know anything about it or about my body. Nobody told me about it. In fact, I don't remember how I found out about menstruation. I think it was on my own, but I don't remember because it was a long time ago.

Other married women have told me about how much they suffer during their period. They say that during those days their husbands avoid them because they feel disgust for them. Then they don't get their pozol or their meals prepared by the women and so they get angry.

What they want is that nobody is aware that their wife is menstruating, but it is not our fault. We can't do anything, it is not as if we wanted to disturb [people].

There are husbands who don't let their wives sleep in the same bed during those days. During her period, the wife sleeps in another place.

In my community very few women use something during menstruation. There are women who don't know what to use and those who know but have no money to buy them. Maybe some women use something.

María García, López Mateos

When I had my first menstruation I wasn't scared because I knew it was something natural. I didn't take anything for the pain; I just went through it the same way as my sisters-in-law. I knew that the other women felt the same.

When we have our period we can't walk. During those days we don't work. We stay at home to take baths and clean ourselves, that's what the doctor and male nurse of our community told us. We have to rest and not do hard work.

I don't spy on other women; they are in their house and I am in mine. If you go to visit a woman at her house when she is menstruating, it is only to make fun of her. That's why I don't visit anyone, I stay in my house.

I do buy sanitary pads and so does my daughter. When I was young, sanitary pads already existed and I am forty years old. I never told my daughter; she knew how to buy them. She knows because her brothers are teachers and they even buy disposable diapers for their children.

Juana Gómez, Yochib

Our mother didn't tell us anything about it because she didn't know that we were menstruating. Of course we were sad, because we didn't know anything the first time. When it happened to me I was really embarrassed and scared. I didn't tell anyone, I just wanted to wrap myself in a blanket. I didn't want to go out because I thought that my woman's body was useless.

Men have very ugly reactions when they see that we are menstruating and our feet are spotted with blood. They spit at us if they come across us and say, "Why are you walking if you don't feel well?" This that I am saying happens in the present; don't think that it was [just] in the time of our grandmothers. This is what women have to suffer even now.

These are people from our community. They do it when we go out to work. Most of them are men, but there are also women. I think that these women do it because they bleed less when they menstruate or because they already use sanitary pads.

My husband doesn't say anything. He knows when I am menstruating and I don't go with him to work. I stay at home instead.

I believe that if we don't bathe ourselves or take a temascal bath, the people around us will smell the odor, because there is an odor on those days. For instance, when I begin to menstruate I take a bath every day and there is no problem; but if I don't bathe my husband may grumble.

Men and women are very different. They don't have the period but we do, and "always our body is bad."

María Luisa Ruiz, Oventik Chico

Our mother never told us anything; she didn't even tell us that once you start menstruating you can get pregnant. If we knew that a girl was pregnant it was only because she had an abortion due to her parents' lashes. I have a young sister and she has already asked me. She realized that I didn't worry about it, [so] she asked me "What do you do?" I told her, and then she asked me to buy her sanitary pads. I bought them for her and that's how she found out about menstruation.

Rosa González, Jolxic

My mother didn't tell me because she had already died when I had my first menstruation. I don't know how it would have been if she had been alive.

When I had my first period it lasted for a long time. I thought that my time to die had come and that I wouldn't stop bleeding. That's what I thought the first time. There are women who don't feel embarrassed when they menstruate and they go walking to their work, but they have their nagua full of blood. I prefer staying at home rather than going out.

It's hard to be a woman. If we bleed a lot it goes down to our feet. We are very different from men. When we are in that situation, we don't go out. And even if we don't bleed so much, we don't go out either. If we bleed just a little, then we do the things we usually do when we are not menstruating: we go to the milpa, we bring wood home, and we endure the pain.

The one thing that I know about is childbirth. It is said that we can't eat bananas or beans when the child has just been born.

Manuela Hernández, Tzutzbén

Nobody told me anything. Although I didn't have a mother, I have sisters and brothers, but they didn't tell me anything. We just worked.

I did tell my daughter, "This happens every month; don't be afraid." I told her so. I didn't tell her more about it because I don't know more.

Rosalinda Sántiz, Bayalemó

Some of us found out at school, others found out from the people around them, but there are other women who don't know anything about menstruation.

In the community our mothers don't tell us that eventually we will menstruate. In my case, when I had my first period I didn't know anything about it. I began to find out from my girl classmates at school. The teachers talked to us about it but not very much, and we didn't talk between us about that topic because boys laughed at us. I didn't tell my mother what I was learning. I felt embarrassed, and my mother never told me either.

I heard the women talking about it. They said that we shouldn't drink lemon juice because we would bleed more. Some women lie in bed and rest and others don't take a bath, but we don't do that; [during] those days it is better to take a bath because you feel better and cleaner.

Some women are sad or change their emotional state to anger when they are menstruating. It also happens to me—suddenly I don't want to do anything and I am in a bad mood.

It is important to learn how to take care of ourselves and our bodies, but we are embarrassed and that's why we don't dare to ask.

When I had my first period there were no sanitary pads. Because I was living in the community, I didn't come to the city so I didn't know about them. You get used to the thing you use. The cloths, we made them from a nagua that was no longer useful.

I started using sanitary napkins when I came to San Cristóbal in 1996. I was nineteen years old. For me, they were easier to use and more comfortable. I felt more secure. Before I didn't know what were they for, even though they sold them in Larráinzar, the municipal seat. Then I didn't know what they were or how to use them.

Nowadays the majority [of women] knows. For example, my sisters already use them because they find out about things earlier. And it is also because in the present girls talk about it among themselves or at school.

Micaela Pérez, Bayalemó

My mother didn't tell me a thing about it. I didn't tell my daughter either. She found out on her own. I didn't tell her because we women feel embarrassed and also because we don't know very much about it.

She had her first period when she was thirteen years old. But she found out on her own.

Celia Sántiz, Bayalemó

I never told my mother when I had my first period. I was around thirteen or fourteen years old. I had pain in my belly but I didn't tell anyone. I stayed quiet because I was embarrassed. When I am menstruating, I stay at home working. I work even if I my back hurts, no rest. Nowadays I work in the Jolom Mayaetik shop and it is the same; I go to work even if I have pain. There is no way that I will close the shop for two or three days—I have to go to work.

I didn't take any medicine for the pain. I think that my menstruation has changed. When I was younger I used to have more pain and bleeding, and now I bleed less and also the pain is not so strong. I am thirty-six years old. I don't take anything for the pain, it just disappears. In the past, I used to take some plants to relieve the pain. The plant is called *mesté*. It is very bitter and it takes away the pain, but I don't take it anymore.

It is said that if we get close to an apple tree or a peach tree when we are menstruating, the fruit will fall down.

My grandma and mother didn't use anything during those days because they didn't know what to use. They didn't even wear *ropa chiquita* [underwear] as we do today. In the community there are few women who use sanitary pads; the majority don't use them. When I first menstruated I didn't know about sanitary pads or use underwear, I just used my nagua. Then I didn't come to San Cristóbal. It was when I started going out that I found out about sanitary pads. If I had stayed in the community who knows what would have happened. Maybe I still wouldn't know anything about it, like the other women. Now I feel more comfortable using ropa chiquita.

Verónica Gómez, Jolxic

I told my mother when I had my first period. I was fifteen years old and I was afraid because nobody ever told me anything about it when I was younger. My mother told me that it is women's nature to menstruate and that we can have headaches, pain in the belly, and in the back. My mother told us to go looking for plants to relieve the pain because menstruation always comes with pain. However, if the pain is really intense it can be due to another illness and not just the period.

When I menstruated the first time I really suffered from back pain. I thought that I was very sick. I thought over time it would get better but it got worse, because I had my period every fifteen days. I asked other people for different plants to regulate my period. I began to take other herbs, and this really helped me.

We all felt embarrassed about it and that's why we didn't tell anyone. We kept quiet. Although we have much pain when we have our period and we are unhappy, we don't rest! We keep doing our normal housework, continue to bring water and wood. We endure the pain and the shame that we feel. Although we feel embarrassed during menstruation, our parents tell us, "Hurry up and do the work! Hurry up with the wood, with your chores." I don't say anything. I act as if nothing is going on. I would like to rest, but I don't protest and I keep quiet.

Sometimes when we have a heavy menstruation, blood falls down to our feet. That's when boys start laughing at us and saying bad words about girls. They have no idea of what women go through. We don't know how to protect ourselves because we are indigenous women and we have no information about how we can be well. So that's the way most of the women go through their menstruation, and we are really criticized. Even those women who don't know about sanitary pads laugh at the women who know and use them.

Our grandmothers didn't use anything. They don't know about sanitary pads and they don't even wear ropa chiquita. In the past I didn't know anything. I didn't know something to protect me existed, but because I have visited different places and I am involved in health care, I have found out. If it hadn't been for that, I would have continued suffering the pain because nobody tells us anything as we are growing up.

Some women say that if you drink orange juice during the period you stop bleeding. They also say that we cannot eat sugar. But they didn't tell us that. They told that to our grandmothers, who also suffered a lot.

María Gómez, Yochib

Although we feel pain, the work in the house never ends. Even if I feel a little pain, I continue working. I believe that menstruation is an illness. If you feel good you can walk, and if you can't that's because you are ill.

Our grandmothers and mothers said that they were sick when they were menstruating. That idea of being sick continues. Nowadays, there are still women who think they are sick when they have their period.

On those days we wear our oldest nagua because it gets stained, and we keep the newest ones for other days.

We also take a bath in the temascal and we wrap ourselves up to feel better. The pain eases and I feel that I am coming back to life. In the temascal the pain in my bones eases. For me, it is like a medicine.

Our grandmothers and mothers didn't use anything; they weren't accustomed to it. Those who know of sanitary pads say that they don't feel comfortable with them, and the rest don't even know that they exist.

We don't know about sanitary pads and we continue in the same way: our nagua gets stained, but we use our ropa chiquita.

I think that there are women that know and use them [sanitary pads], but they are expensive. I use some cloths because sometimes we have visitors and I feel embarrassed that they will see my stained clothes. Because I am an old woman I don't use sanitary napkins, I just use my ropa chiquita.

Cecilia López, Bayalemó

Even if they have stained clothes or they feel sick because of menstruating, women don't stop working! That's what I have seen.

In some communities the boys laugh at girls when they start having their period, and so the girls don't go to school when they don't know exactly what day are they going to have their period. Or when it's the first time, they stain the chairs or where they are sitting. That's when

boys find out that the [girls] are menstruating and they laugh at the girls.

I didn't dare to ask anything about menstruation, but in the end it was a matter of necessity. I dared to ask once when I was on a trip.

When I go to Mexico City or other cities it gets complicated if I'm menstruating, but the sanitary pad helps a lot. That time when I was on a trip, I had my period but I didn't notice it, and I felt very embarrassed. That's when I dared to ask about it and how I found out about the sanitary pads. What we have to do is to lose the shame.

The women in the rural communities still don't use sanitary pads. Their clothes get stained because they don't use the sanitary pads or because they don't have enough money to buy them. But we women who live in the city use them.

Zoila Sántiz, Yochib

My husband notices when I am menstruating and I have pain, and he doesn't take me to work. I don't have to hide it. But when I was living with my parents, the situation was different. I couldn't stay by myself, I had to go to work even though I was in pain, as if nothing was going on. They knew that I was having my period but they wouldn't let me leave work, so I had to make myself strong. When we bathe with cold water while we are menstruating, we feel sicker. It is said that the cold gets into our body. That's why the women who have the temascal use it to bathe their bodies with hot water and that way they warm and heal their bodies. That's our custom.

Marcela López, Bayalemó

Our grandmothers and mothers didn't use anything to cover themselves when they were menstruating, so the blood sometimes fell to their feet, even to the ground. They suffered a lot. Nowadays most of us know that there are sanitary pads in the pharmacy.

Pascuala Pérez, Yochib

In the community it is said that menstruation is something bad and that's why women are not useful. They say that we shouldn't carry water or climb the fruit trees because we would dry up the fruit and make it fall.

Carmela Ruiz, Oventik Chico

The women who have no money don't use anything; they don't even know that there is something to cover ourselves with.

THE ENGAGEMENT

When the parents of the young boy propose to the young girl, they pay the girl's family three thousand pesos (this is in Bayalemó). But now the cost of soft drinks and other things is increasing. People spend more money today.

Rosalinda Sántiz, Bayalemó

The boy is the one who chooses the girl he wants to marry. In the past, boys and girls couldn't talk to each other; it wasn't allowed. If they were caught talking, they were locked up or had to marry. In the last two years things have changed a little bit. The young couples talk to each other secretly, but they have to get married as soon as possible.

When a boy likes a girl, he talks with his parents about it: "I like this girl. Would you come with me to her house to propose?" If the parents agree, the boy goes together with his father and mother to the house of the girl, and they talk with the girl's parents and propose in a proper way. They might go four, five, or even six times to the girl's house.

After the girl's family answers, "Yes, that's fine; my daughter accepts your proposal," they plan everything—when and what the party will be. The families meet and talk about how the young couple is going to get married, whether the girl wants to get married in the church or in a civil ceremony. When the wedding is planned, they establish a date for the

party. It is more like a big meal than a wedding celebration. The boy and his family take food to the girl's house. They take meat, soft drinks, some bring alcohol, sugar, bread, and everything they want to eat. In the girl's house, they cook the meat and share the bread and the soft drinks. The girl's whole family eats with the boy and his parents. (The boy can't bring his whole family.)

Then the girl's family gives the boy advice about how to treat the girl: "You have to take care of her and respect her." "Don't you even think of returning her [to her] home or saying that you don't want her and that you are going to look for another woman."

Then they decide how long the girl is going to stay at her parents' house. She can stay at home after the celebration for one, two, or even three months. After that period the boy and his family come back to the girl's house. They bring five or six soft drinks for the girl's family, but they aren't going to meet with all her family, only the girl's parents, who are going to give away their daughter. The woman always goes to the man's house. There are some men who have their own houses, but by custom the couple goes first [to live] with the boy's parents, and they live there for five months or a year. After that, the couple builds their own house. A few couples go to live on their own from the first day.

In my case, a boy and his parents came to propose to me. They came to meet with my father, and my father let them in. Usually, they do not come inside the first time. The boy's parents began to say that they wanted to talk, and they brought soft drinks. (I think they also brought alcohol.)

My parents talked with the boy's parents, but they didn't accept the drinks because if they had accepted and drunk, I would have been obliged to go with the boy and marry him. So my parents didn't want to accept the drinks.

However, the boy and his family insisted. There they were, and they continued offering the drinks, saying that my father had to take some, but my father didn't accept.

My sister and I were listening and laughing about what they were saying. They said many things, but my dad always answered the same way: "The problem is that my daughter doesn't know how to make tortillas." This is how fathers avoid the proposal, by saying that their daughters

don't know how to do anything, that they don't know how to make torti-
llas and they are not ready for marriage.

The boy's parents returned home and they didn't set another day to
come. Then one day they came back. They asked my father to be at
home, and he said he would be there but he wasn't. When they left, my
father said, "I'm not going to be here the next time they come. Besides,
I don't like him as a son-in-law." So this is how it all ended. The boy's
parents came twice, but there was nobody at home. And even if there
had been, I wouldn't have accepted his proposal, and they couldn't have
obliged me to get married. Twenty days later we saw the boy and he
was already married. So I guess he had also proposed to her. That's why
I believe that what he said wasn't true; he just wanted to play. It was
great that my father defended me and didn't force me to marry. My par-
ents have never obliged me to do something that I didn't want to do.
In some cases women are abducted and not brought back. But many
times the girl also wants to get married, and if they are not allowed they
run away.

My mother was obliged to get married. I don't know if it was the same
with my father, but I think so because my grandparents told him to look
for a woman.

My mother told me that in the past the proposals were similar to
nowadays, but in the past they offered alcohol instead of *refrescos* [soft
drinks]. Formerly, the boy's parents went to the girl's house and talked
with her parents. They had to decide at that time if they would accept
the proposal or not. If they accepted the proposal and drank the alco-
hol, the girl didn't know that her parents had decided for her, and when
she found out they told her, "We have made the decision because we
are your parents, and you can't say anything against our decision. You
are going to marry that boy and you can't do anything to avoid it." It
was very tough. My mother couldn't say anything, and I asked her, "Why
didn't you escape?" "Because where would I go? I didn't know where to
go." And thus, at the age of thirteen years old, she married my father. "It
is very difficult, because once your parents have drunk the alcohol, you
have to go with the boy's family."

It is as if you had been sold and you were no longer the property of
your family. And after that, if you don't know how to do the tasks in

the kitchen, there are mothers-in-law that treat you badly and make you learn. Most of the women who are forty or fifty years old were obliged to get married. They were sad and cried because they were too young for marriage.

Girls still marry when they are from fourteen to eighteen years old, but not after twenty years old. Few women get married when they are in their twenties, because they are already considered to be old. If you are twenty-five—no, definitely no! Boys choose younger girls, or they wait for the youngest ones to grow a little bit. "Men always get together with very young women."

Celia Sántiz, Bayalemó

In Larráinzar women get married very young, when they are fourteen or fifteen years old. That happened to one of my nieces. She is fifteen or sixteen years old, and she already has two babies. This is how it is in the community. Women get married very young. In the past, they were obliged to marry even if they didn't want to do so; but when I got married nobody forced me. Fortunately, my parents didn't oblige me to marry and I was happy. I loved my husband, and I also think that other women love their husbands.

When the parents of the young boy propose to the young girl, they pay the girl's family three thousand pesos (this is in Bayalemó). But now the cost of soft drinks and other things is increasing. People spend more money today.

Unfortunately, it often happens that when boys make the girls pregnant they claim the baby is not theirs. Even if the girl and her family go to the authorities they don't marry, and then no boy wants to marry the girl; nobody is responsible, and the girl is left on her own.

However, it also happens that some girls get involved with lots of boys, and they don't know who the father of their baby is. For example, when a young couple is in love and they have a baby without the father of the girl knowing it, if the baby is already born the father usually gets angry. Nowadays, fathers don't get as angry with their daughters as they did in the past. In these cases, if the baby is delivered in the girl's father's house, he goes to the authorities claiming that his daughter has had a

baby without being married; then they go to find the boy to oblige him to get married. Sometimes the boy doesn't accept that the baby is his. When the boy denies his paternity, the girl's father doesn't oblige the boy to marry the girl; instead, he asks the boy's family for money. Only money, not drinks or food.

Some fathers ask for eight or ten thousand pesos, because in the community it is a crime when a boy doesn't propose to the girl and her family. Many only pay two or four thousand pesos, and they have to make the payment in front of the authorities. If he doesn't do it officially, the authorities send him to prison until he gets all the money to pay for the girl. Once he pays it, he can return home to live with his new wife.

In Larráinzar, when the woman and man marry in the usual way, his parents go to her parents to ask for the girl [and] set a date for the party. At the party they'll bring drinks, meat, corn, chile, and so on. The families of the boy and the girl arrive—their brothers and sisters, grandparents, uncles and aunts, and so on. They eat the meat and drink soft drinks. In Larráinzar this celebration takes place in the house of the girl.

At the wedding we don't wear any special clothing. We wear our usual clothes, but our newest ones. If the father of the girl has money, he buys her a new dress. If not, she wears her usual clothes. When the celebration is over, she stays in her house with her parents, and he goes back to his house as well. The new wife stays two or three months longer with her parents, to finish her tasks and to make her blouse. The period that she stays at home depends on the agreement between both families; it may be from one month to three months. While she is at home with her parents, her husband can come to visit her and bring firewood; they can't sleep together, he can only bring firewood. Those who do this are the good sons-in-law. The bad sons-in-law don't do anything; they just wait for the time when they can take away their wives.

After the wedding, the men start asking for children.

Verónica Gómez, Jolxic

In Jolxic, if the parents of the boy propose to the girl's family, they spend eight or nine thousand pesos. This can be in cash, or they [can] buy things like meat or soft drinks. It depends on what the girl's parents

want. However, if the girl gets pregnant or was involved with the boy before they got married, the family of the boy spends less money—2,500 pesos and nine boxes of soft drinks or sometimes more, ten or twelve boxes. In any case, the costs are less than when it is a normal wedding, but still it is a lot of money.

If the boy doesn't have money, he has to ask for a loan or credit. When a man wants to get married, he has to start working somewhere to earn money to pay to the girl's family.

When the party to celebrate the proposal ends and they've eaten all they want, then the father of the girl is asked. The girl stays at home three more days, and then she goes to the house of her parents-in-law. It is the tradition that after the wedding celebration is held and they eat what the groom has brought—meat, bread, sugar, soft drinks, and about twenty liters of alcohol—the bride has to go with her husband.

If they have money, they [the couple] wear new clothes; but if they don't, they wear their usual clothes. After that the wives go to live with their parents-in-law for three or four months, then the couple leaves to live in their own house.

Women in the community sometimes get married between thirteen and fourteen years old. Whether they want to get married or do not want to depends on what they have been told about marriage.

María Gómez, Yochib

Women get married very young, at the ages of thirteen or fourteen years old. In my case, I got married when I was twenty years old, and they [the groom's family] proposed to me three times. The parents of my husband came to my parents' house three times to propose, and it was the fourth time, when they brought fried tamales, that my parents accepted. They brought everything—they even brought a little *trago* [locally-made brandy]. My father liked to drink and he often got drunk. He carried his own *limton* [five-gallon bottle]—he had a special limton for his trago. My parents asked me my opinion about the proposal. As the man had asked me on several occasions, my parents asked me, "What do you think, girl? What do you think? Shall we invite the man to come inside?" "You have to see reason," my parents told me.

"All right, since I will have to get married sooner or later," I said. So my father told the boy's parents: "The girl has returned an answer to your proposal." Consequently, they started to collect money to invite the relatives of my family, the Mulxetik, from the family Mulex that I belong to in the community.

The family of the boy gave money to buy the food for the meal: beans, meat, sugar, and everything needed to serve all the relatives. There was a great variety of food that day, including *ichilmats'* [masa with chile], *petu'ul* [tamales with beans]. They gave a piece of meat, ten eggs, ten *petules* [tamalitos with beans], and sweet bread to share between the two families; so much they took some home. They also passed out cigars.

At that time there were no soft drinks; we used coffee. Actually, there was one soft drink called *raseosa* [soda water], and we used to buy it in San Cristóbal because nobody sold it in the community. We used that soft drink in the wedding too.

I wore new clothes at my wedding. My parents bought me the cloth and I sewed a dress myself for the special day. The dress was made of Kaxlan pak' [commercial cotton]. I didn't have [any other] good clothes—my only skirt was stained. My parents didn't have money. I wore clothes made from store-bought cotton because at that time only people who had money could afford clothes woven on the backstrap loom. In the community those who had handwoven clothes were well-off. Then it was very difficult, but that was a long time ago. I am forty-five years old, and I got married at the age of twenty.

After the wedding my husband lived in my parents' house to pay them further, but this time with work. He went to the cornfield, brought the firewood. He cleared the land for seed, depending on the season: sowing or harvest season. My husband stayed at my parents' house for one month because that's what my parents agreed on. However, there are fathers who decide that the husband has to stay for a year working for them. "Those are the ones without a kind heart." My father only asked him to stay for a month.

Nowadays, it is very common to ask for money for the hand of the girl. Some fathers ask for six or seven thousand pesos. Another thing that is happening is the return of the girl. Even if they pay much money for the girl, they [may] return her and lose the money they spent. Three

months ago I heard about a girl who was returned. The boy's family got back half the money they spent for the girl, but they lost the other half. The reason money was returned was that the woman got involved with another man.

When my father married my mother, he had already been with another woman; he was not unattached. I think that my mother knew this, but hers was an arranged marriage. She was a fatherless child so she was forced to marry. She said she was just a girl when she got married: "I wasn't a grown woman who knew what was happening. I was still a child when they gave me a husband," my poor mother told me.

She also told me that my father offered a limton of trago when he proposed, and that was enough for her family to accept the proposal. When women didn't accept such proposals, they were told that they were going to die. In those times it was a very difficult situation, my mother said. They told my mother that if she didn't want to get married, her feet would rot and she would die. She said that it was a girl's uncles who did the most harm. When they didn't get any alcohol, they said that the girl was going to have an illness because she wasn't getting married. However, if they had alcohol, they didn't mention any illness. My mother said what frightened her most was that they would make her sick.

Juana Méndez, Yochib

It was a long time ago when marriage was proposed to me. I am now forty-six years old, or at least that's what my birth certificate says. I remember that when my parents-in-law came to propose, my parents didn't want them to come in the house and sit down. So the man who is now my husband came to ask for me himself, because my parents didn't talk with his parents. I don't know why, but my husband continued to ask for me until my parents let him in. My father was a man of strong character, so my husband had to work very hard and insist that my father let him in and give him an answer.

My husband continued to insist that he wanted to marry me. As I said, the first time he went to my house my parents didn't invite him inside, and it continued that way until my husband entered by force. That time, my parents-in-law also came because my husband's persistence had become

a problem. My late parents-in-law told my parents, "There is nothing we can do with our son because he has set his heart on your daughter and we can't stop him." My parents answered, "You have to control your son"; and they answered, "But how can we do that if his heart is here?"

This was made more difficult because they had been drinking, but my father didn't receive any alcohol from my parents-in-laws, so he asked them for Tecate [a Mexican brand of beer] and they complied and bought him Tecates. Finally, my dad accepted and drank the Tecates and then the trago they offered him.

After that visit, my husband stayed at my house; he didn't return to his house. He begged my parents to let him marry me. He paid my parents, but I don't remember the amount. When I married, it was because that was what I wanted. So when he stayed at my parents' house, I felt happy because it was he who offered.

We only stayed for a week in my parents' house because he paid them. If the boy pays money to the girl's parents, the marriage process is quicker because he pays for the days he would have worked. So one week later I went to live at the house of my parents-in-law, together with my husband.

In the past it was said that if women didn't accept the marriage proposal, then the *tatabiletik* would come to eat them. These were the spirits of the grandparents that lived beyond the earthly world. They came to our world and made girls sick because they didn't obey their orders, and the tatabiletik were looking for a husband to marry them. The whole community knows about the tatabiletik, they have strong hearts and the power to harm people. Nowadays, this belief no longer exists among the girls in the community. They don't get frightened so easily. For them, the devil does not exist—that is over.

Martha Gómez, Yochib

I got married because my family was very poor, not because I was happy to marry. I didn't know anything about life when I got married. I was sixteen; he was seventeen years old. My husband told me: "Let's go. It's better that we should marry even though our parents don't want to talk. Afterwards they can arrange the marriage." We both thought the same

and I went to his parents' house, and after that his mother had to talk with my father.

My father couldn't say anything because I was already married. He didn't have to give me his blessing. Then my parents-in-law went to talk with my father and took soft drinks, and they said, "Although we didn't give them permission, this is what our son and daughter want, and it is our duty to solve the problem; we can't do anything else." My parents-in-law offered my father soft drinks. My father didn't make it difficult; he was a person who wasn't accustomed to asking for things or for money. He didn't say, " Give me four thousand or five thousand pesos for my daughter."

Finally, both families arranged that there should be a wedding, as if he had asked for me in the usual way. The relatives of both families were to be invited, and food and drink were to be shared. When they talked, everything went well [and] they set a date for the celebration. But my husband's stepfather mistreated his wife; he was never interested in having a wedding, and time passed. After a year of marriage we realized that we were never going to have that celebration, and my husband was embarrassed because my father hadn't received a thing, not food nor drink nor money. Then my husband decided to pay for the value of the things that had been agreed upon and should have been shared between the two families. It was not a large amount of money, but at least he paid off the debt to my father. So this is the story of how I got married; it was not for pleasure but by necessity because we were very poor.

When I hear older women talking about their marriage, including my grandmother, I know that back then young women didn't choose the person they wanted to marry. If someone proposed to them—"Cho'mtayel" [a proposal]—they were obliged to accept the proposal and marry the man, because if they didn't do so their father hit them with a *chicote* [leather belt]. "You have to go with him, you have to marry him," the parents used to say to the girls. It was the girl's responsibility to marry the man and join his family so that she didn't dishonor her family. Besides, the man's family was very polite when they proposed, and because of that the girls had to obey; that is what the older women said. If the girls' parents received a liter of alcohol, that was sufficient to accept the proposal

and give away their daughters. If the girl didn't want to get married, she was beaten with the belt; then she went.

Nowadays, women decide if they want to marry the man or not; they have the chance to see him with their own eyes. But in the time of our grandmothers, [when] they were very young, ten or eleven years old, if they were asked for, they had to go.

THE EXPERIENCE OF MARRIAGE

It pleases me that today women can decide whether they want to get married or not.

María López, Oventik Grande

I was very young when my parents told me that I had to get married. Because it is better, they said. They accepted the liquor, and I cried because I didn't know what to do. Even now, I feel a lot of anger and sadness every time I remember that; I feel ugly.

It gave me nightmares. I always dreamed bad things, and that made me think a lot about my situation. I believed that I had to run away, but I returned. When the day of my wedding arrived, I had to obey my father. My father used to ask the *Ilol* [healer] what to do. When I was given to my husband, I didn't know how to work because I was very young. I am now sixty-five years old, but it was then I started to suffer from hunger and having no clothes.

Francisca Pérez, Chichelalhó

Nowadays marriage is different, everything has changed. In my case, I went with my husband because I wanted to, I liked him. However, in former times perhaps I would have been given away to my husband, or even stolen by my husband.

It's not necessary that my husband be handsome. Nevertheless, my parents asked me, "What do you see in that man? If he is ugly, what is it you like about him?" [Laughter]

The man must work. If he doesn't, what are we going to eat? Still, they don't force you; your parents ask you if you want him for your husband. When I went with my husband, my parents didn't force me but with much reluctance they let me go. They said, "Why do you want to go? We give you food and clothes. We always have something to eat."

When my sister left, my parents were angry. My sister got married two or three months ago. She married a man from Tivó.

My parents were very upset because they didn't want to give my sister away to the boy's family. Although the boy's parents came to talk with my parents, they didn't answer because my father didn't want to give her away. After they came four times, my father, really angry, said to them, "Do you have the ears of a dog? Don't you understand that we don't want to give our daughter to you?" The boy's parents didn't say a word.

The problem is that my sister is very young; she is only fifteen years old, and that's why my parents didn't want to let her go and they were angry. But the boy's parents didn't understand reason, and that's why my father said they were like dogs.

Well, it also happens that they [boys] don't come to propose. The girls run away with older boys who are twenty years old or more.

This happens in my community. Thus, nowadays we are no longer forced to get married. We are the ones who decide to go live with the boy's family. In the end, my parents told my sister, "If you want to get married then do it, but remember that we didn't force you to do it and that you always have food to eat here."

Rosalinda Sántiz, Bayalemó

I am almost twenty-six years old, and women my age don't get married. It is usual to get married before you turn twenty years old. I think that women get married so soon because they are afraid of not finding a husband later. Many girls marry at the age of thirteen or fourteen years old. It pleases me that today women can decide whether they want to get married or not. Parents don't force them to get married, as they did in the past. At the least they should be eighteen to marry. They don't know what's going to happen, [and] few boys know; there are things they will

discover later. As for me, I would like to get married for love. Today, everything is changed. Nowadays, couples can at least talk and see each other before they get married, but in the past they couldn't have any contact. Now, when the boy likes the girl, he proposes as soon as possible, and they get married. There is no courtship— perhaps a little but almost none—and [there was] even less in the past.

After the wedding everything goes well [at first]; they care for each other, respect each other, for perhaps two or three years. But then they start to fight. At first, if they love each other very much, they might go on for five or six years. Then the man may leave you, he may say harsh things.

Celia Sántiz, Bayalemó

After the marriage the man has to go to work in the field all day and he returns in the evening, and the woman has to prepare beans for the meal. If she has not cooked the beans and the meal is not ready when the husband arrives home after his work, he is angry because his wife has stayed at home all day.

She has a lot to do in the house. She washes the clothes, takes care of the children, weaves, and feeds the chickens and the pigs. The women have to do all that! When we weave, we can't finish quickly. Because we have so much to do, we can only weave two or three hours a day. We rest a short time at night because the next day we will have to get up early; some women get up at three o'clock in the morning.

When it is time to clear the field, the man works all day and returns late to the house. And when he comes back home in the afternoon, he takes a bath—some go play football—but he doesn't help his wife. The woman has to be working all the time.

Verónica Gómez, Jolxic

If the man comes home and there is no meal ready, he gets angry and grumbles, hits his wife, and continues to complain. But not all men do this. Some take their wives to work in the field with them, so the wife has to wake up very early to prepare the meal. When they come back home,

Feeding chickens, 2015. Photo by Marla Gutiérrez.

the woman has to clean the house and cook. Her work never ends; she works all day and the man does nothing at home.

Those men who beat their wives don't listen to the counsel of the church. And those who listen and take into account the advice, they are the ones who don't beat their wives. In those places where the old traditions prevail, men continue hitting and scolding women and getting drunk. It is sad to see what those women have to suffer on the weekends, when their husbands come home drunk and they hit their wives just because they see them or they arrive home angry.

I think that there are differences between single women and married women. Among married women, some husbands don't let their wives walk alone or let them go to other places, talk to other women or to their children, or even go out of the house. The majority of men are jealous and they don't give their wives or children the right to speak or to leave the house. These women must be working all the time, washing their husband's clothes, preparing meals, caring for their children. But those of us who aren't married can go wherever we want—go alone to other

places—and there is no one who prevents us from exercising our rights. Our parents also give us the right to go out.

However, not all the parents let their daughters go out. In my case, I am free to do what I want, provided that I don't do any bad things and that I work well to be able to live better through crafts. We can't live or eat if we don't work. We have to go out to deliver our textile products. But it's best when no one impedes us from exercising our rights. If we were married, our husbands wouldn't let us go out to deliver our textiles because of their jealousy, and they would hit us.

María Gómez, Yochib

Before getting married I thought it through and came to the conclusion that someday I would have to marry. I also thought that being won over by a man was not the best way to do it, because maybe one day he would abandon me. Thus, I thought that the best thing for me would be to get married in the proper way.

Things changed when I got married. As a single woman I never had to worry about anything or feel sad, but when I got married I began to feel sorrow.

It was my parents-in-law who came to my house to propose marriage. My husband was in Mexico City at that time, so I didn't see him, but he had told his parents to ask me. So we never saw each other; we never exchanged smiles before our wedding, because if we did something like that our parents would hit us. "If that's the way you want to look for a husband, there's no way to save yourself. I will shoot you dead," my late father used to tell me. I think he said such things because he drank too much.

It seemed to me correct to accept the proposal. "It's fine," I said. "Anyway, I will have to get married sooner or later, so give my answer to the man's parents," I said to my parents.

After the wedding I felt sad but there was nothing I could do; I was already married to my husband.

Although I had made the decision, I couldn't help feeling sad. I always thought that if I had run away on my own with a man, to my parents it

would not have seemed correct, and if that happened they would say "you're looking for your death."

All of my sisters except for the youngest one had arranged marriages. My youngest sister didn't receive a marriage proposal because at that time my father was old and no longer so strict. She was won over by a man in San Cristóbal, so my parents didn't receive anything from that man. The couple just started to live together. What happened was that only the oldest children were made to suffer by our parents.

That was my life. I felt sad when my husband went to look for work and earn some money. But I also bred chickens, and when they started to lay eggs I used to sell them and buy sugar and other things we needed with that money.

When my husband was at home, we talked and walked to the river for water. In the past, there was only the river, and we took water from there both to drink and for bathing. We went together to carry the water; sometimes we had to do this when it was already dark because it was sowing time. In the mornings we worked in the field, and in the afternoons we bathed in the river and carried water home. We did the tasks together and we were very happy for that. That has been my life.

I believe it was best that I married. It was best for me because I have several children. I delivered eight children, but two of them died and six are living. I know that they love me and they give me much happiness and it warms my heart and I don't have any problems now. My parents-in-law have died and my mother is still alive.

I am not worried about anything now, because I know that my children will take care of me and dress me the day I die.

There are women who don't want to have anything to do with men because they want to be alone. In my case, I also wanted to be alone, but if I were alone who would bury me when I died? Who would I talk to? Who would take care of me and call someone if I needed medicine? If I hadn't married I wouldn't have children, and in my case they are always by my side. If I am sick they run to look for medicine, so I don't know why some women don't want to get married.

In our community there is a woman who lives with her dog, but for me a dog is not enough, because I can't talk with him [laughter]!

This woman lives alone and I always see her walking her dog. Once I asked her, "Why didn't you want to get married?" And she said, "Why would I want to get married? Why would I want a man? I am better on my own." And I said, "But what if one day you die, or you fall down and hurt yourself, no one will look for you?" "Nothing is going to happen to me, I am always with my dog," she answered; and I finally said, "But it's not Christian; you can't talk to him, he's just a dog." Nobody knows why she doesn't want to get married. We just see her working all the time, working her field because she has nobody to help her, neither husband nor children.

Juana Méndez, Yochib

In my case, getting married was the best choice for me. Unlike my husband, my parents scolded me all the time because they were very strict. Back then my relationship with my parents was very difficult.

I am afraid that people in my community will read this and know about it, and that then my parents will say, "Our daughter is talking about us." This will happen if someone hears; I only hope that it will be useful. Anyway, as I was saying, my parents were very hard on me; they scolded me a lot, both of them. They used to say, "Get out of this house."

I think that getting married is a good idea because when women are single they have difficulties and nobody helps them. It's not the same if you are two. Between the two of us we can get the work done. For example, when my husband hires workers to help him in the field I stay at home and prepare lunch for everyone. I think it's always better if we help each other. If you are alone, you can only count on your own hands, but if you are two then you can do more work and, of course, you can have children. In my case, I have ten children, six women and four men and, thank God, all of them alive.

There are a few cases in which women go with a man without him proposing. It is always the man who wins the woman over, so it is not very common that a girl goes to a boy's house; when this happens it's because the boy already was in love with her. Here we say that "someone has invited her to enter," because she wouldn't go there on her own.

We hear people saying, "She just went in the boy's house"; but we all know that the boy planned that before, because the girl is not going to do that on her own without the boy's having proposed it. So it is planned and the girl agrees.

In these cases, the parents of the girl ask for something; you have to do something as a marriage gesture. Where have you seen someone order a coffee without paying for it? So, they [the boy's parents] have to pay something, the man has to give something to the girl's parents.

Martha Gómez, Yochib

Certainly, times have changed. In the past men used to propose to the women's parents. I don't think that this happens now.

Girls begin to see the boys somewhere, and they start to talk to each other, but then he has to propose and talk to the parents, because it is not right to hide that they want to get married.

My husband thought about getting married because he was a fatherless child. His mother remarried, but his stepfather didn't treat him and his brothers well. The man used to drink a lot and beat them, and he also made them work harder than the children he had with his first wife.

Over time things did not improve; the relationship was ever more difficult, and my husband decided that it was time to get married. He told his mother that he wanted to get married, but she didn't take his plans seriously and told him, "You don't know what you want, you are very young." He was seventeen years old.

He wanted to propose to me correctly, but his mother didn't support him and, of course, his stepfather didn't support him—that didn't matter to him since my husband wasn't his real son. When he saw that they wouldn't support him, he came to my parents' house by himself to ask for me, but my father didn't accept his proposal because he said we were very young; he was seventeen years old and I was sixteen years old. Therefore, my husband thought it was best if I went with him to his house. Although my father didn't give his permission, my husband insisted.

I knew how to do everything because I had no mother; my sisters and I had to take care of ourselves. I had learned how to grind corn, how to make tortillas—it was always my work—I learned how to cook, and my

big sister guided me. But when I got married I didn't know how to weave or embroider as I know now. I felt that my hands were useless because I didn't know how to weave or make clothes.

After a while I wondered if getting married was a good idea. I realized I was in the same situation as my husband; I was also a motherless child. My father raised me, but for him it was very difficult to take care of my sisters and me; he had to get food and clothes for us, so sometimes we had them and sometimes we didn't. Even though my father took care of us, it was not the same as living with our mother. I believe that our children are always dependent on us and, on the contrary, men sometimes forget that their children are hungry. That used to happen to my dad; he didn't think that we were important. I couldn't continue to study because my dad didn't have enough money to buy food, clothes, and shoes for four people. We began to feel ashamed when we were thirteen or fourteen years old because we didn't have clothes; our naguas were old and faded. All these reasons—not having food and clothes—made me decide to get married.

After all I have a good husband. He is a kindhearted man, and we make the decisions of our lives together; he doesn't ask his mother or his stepfather for advice. He only takes my words and thoughts into account.

LIVING WITH THE PARENTS-IN-LAW

The woman has to do everything her in-laws ask of her.

Rosalinda Sántiz, Bayalemó

It is difficult. Each family is different. For example, if the family of the boy gets up early, you have to do the same; if they work in the field, you have to work there too, and to have breakfast earlier than in your own house. No way! You have to learn how to do everything as if it were your house. It is difficult because you don't know anything when you arrive the first day. Sometimes they are nice and treat you right, but most of the time they don't. Now, if you are accustomed to waking early in the

morning, and you know how to make tortillas and how to do the house-work, then there is no problem.

Sometimes the daughter-in-law doesn't want to be with her parents-in-law, so she says, "I don't like eating with my parents-in-law." There are also cases in which the *Jmeni'* [mother-in-law] doesn't allow the girl, if she's hungry during the day, to eat something. This makes the girl feel bad. Many times there are problems, but nobody talks about them. That is the reason many couples don't stay very long with the parents-in-law, and they go to live on their own. It is more peaceful if they don't have to live with the Jmeni' or Jme'alib [mother-in-law], or the Jmoni or Jmo'alib [father-in-law], and the brothers and sisters.

Verónica Gómez, Jolxic

The woman has to do everything her in-laws ask of her; it's not the same as when she lived with her parents. Everything changes. If a woman isn't obedient, then the father of the boy goes to talk with the father of the girl to say that she doesn't obey. The girl's parents advise her to obey her parents-in-law.

Celia Sántiz, Bayalemó

Women have to do what their mother-in-law tells them to do; it is no longer the same as in their own homes. And if they don't obey, then the family sends the girl back to her own family. In fact, the boy can return his wife to her house, but the family doesn't give him back the money he paid for the girl. The girl's parents tell her she has to obey.

In my case, I went to live with my parents-in-law and it was fine; they treated me well, but I had to do everything my mother-in-law did.

María Gómez, Yochib

When I went to live with my parents-in-law, I felt a little sad because it was different. I missed my parents and I was used to our way of living, our house, our land; so everything was new and different for me. I had to do the housework. I had to wake up at three o'clock in the morning

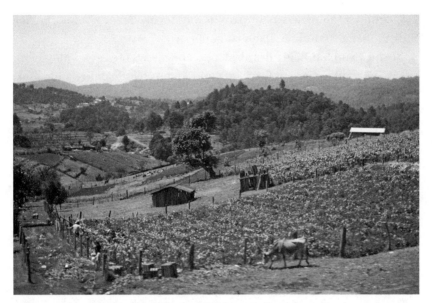

Milpa and cow, 1993. Photo by Joan Ablon.

to grind the corn and make the tortillas. I had no sister-in-law so I had to do all the work on my own. After making the tortillas, I worked in the milpa. I brought water to the house, and in the afternoon, when I came back home, I cooked.

I went to work with my parents-in-law because my husband worked on a ranch, so I stayed with my mother-in-law.

Parents-in-law always scold you. They would say to me, "Wake up early! How are you going to eat? How are we going to harvest the corn if you don't work? I want always to have corn and beans, because this is the only way that we live well." And I used to say, "Yes! I'm going to work now," and so I did.

If we don't obey, they scold us and tell us, "Whoever believes that they're going to eat if they don't want to work is lazy!" And it is true. Sometimes when we talk to them they don't even answer, and that means that they didn't like something that we did or said. I must say that I suffered when I lived with my parents-in-law, but they never said I had to return to my parents because I didn't know how to do something— nothing like that. But, of course, they scolded me. I couldn't do anything.

I knew that if I returned to my parents' house, my father would bring me back to them, so nothing like that happened.

My husband has never drunk alcohol; he always uses good judgment. Every weekend we go out for a walk and we buy a little chile, some lime, and then we go back home. And when we have a little money, we buy meat and we cook it and eat it with my parents-in-law; we don't have any problem.

I do all the housework, and when I can, I also wash the clothes of my parents-in-law. "Give me your clothes, mother, and yours, father, so that I can wash them," I used to say to my mother-in-law.

That's how I lived with them, obediently, and if they scolded me, I didn't answer, I just cried because I felt sad that my in-laws were very strict.

Juana Méndez, Yochib

I lived with my parents-in-law for two and a half years. It was a short time because we shared the house with my husband's brothers and their wives. The other men began to be jealous and they fought among themselves, so my husband and I decided to leave.

My in-laws continued to live with the jealous son who said that my husband was getting involved with his wife. My husband said that he was not involved with his [brother's] wife, he didn't even talk to her. That was the reason we left.

During the time that I was with my parents-in-law I had to work. I used to prepare and weed the milpa, I brought firewood to the house, and I also cut beans—back then my parents-in-law had lots of beans. All the work I had to do, I had to finish. It's as my friends have already said, in those times the parents-in-law were very, very hard. They didn't weigh their words when they scolded us. They used ugly words that I cannot repeat now.

Even when we got pregnant we still had to work, because according to them it was our duty to take care of them.

Even if we had delivered a baby recently, we had to start grinding corn. If, for example, the baby was born in the morning, in the after-

noon we had to make tortillas. And the next day we were already washing clothes.

My mother-in-law never helped me; she just wanted to hear me say, "Give me your nagua and dirty clothes so that I can wash them." Back then we had to go to the river to wash the clothes. So, just one week after I had given birth to my children, I was at the river washing the clothes of the whole family.

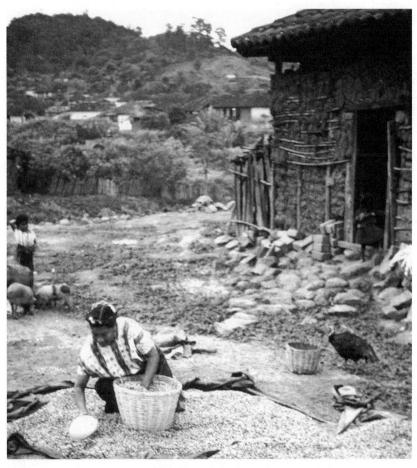

Sorting beans, Pantelhó, 1977. Photo by Joan Ablon.

Martha Gómez, Yochib

After our marriage, my husband and I stayed for only a short time in my parents-in-law's house, because my husband's stepfather didn't want us staying with them. My husband didn't want to be there long, because his stepfather said to us, "You should go to your own place, build a house and live there! I don't want you staying here because I have my own children."

My husband has three brothers; he is the oldest one, and that's why he thought about getting married.

We went to live on a piece of land and built our house, but we had to take care of my husband's little brothers. At that time I didn't have any children of my own, so they were like my children. My father-in-law used to say to my husband, "The children should work on the coffee plantation and in your house, and you should take care of them." It was very hard work for my husband and me. I've kept it in my heart, all our suffering. The most difficult thing was to get money to feed the family, because it wasn't time for the coffee harvest. I think that we supported and took care of my husband's brothers for three or four years.

When my mother-in-law realized that they had grown up and that they were able to work, she told us they were to come back to her house so that she could take care of them, and besides, they were not our children. So the children returned to see their mother and wanted to stay with her. Their stepfather also accepted them because they already knew how to work—they were not just given the food they ate—and so they went.

Formerly, people in the community believed in persons who had *Lab'* [powers]. If women didn't get along well with their parents-in-law, their in-laws killed them by sending a sickness because they weren't obedient—at least that's what my grandmother used to tell me when she was alive.

When I was a daughter-in-law I was obliged to wake up early and prepare hot water for my parents-in-law to wash their faces and to prepare a hot atole [corn-based drink] for them.

When they got up I had to say, "Here is your atole, father, here is your atole, mother." The daughters-in-law who didn't do that got sick.

Today, everything is better; we are freer, they don't oblige us to do things we don't want to do. When the in-laws take a temascal bath we have to prepare *palapak'* and *jalbil pak'* [woven clothes and *huipiles*, blouses] for them. The daughter-in-law has to wait until they finish the bath, then she has to bring them a pitcher of atole, pozol, or water. This shows the daughter-in-law's respect for her parents-in-law. If you didn't do that, you would die. At that time, people believed that the demon existed, because they didn't know the word of God.

PREGNANCY

During pregnancy we continue working. We go to harvest coffee, and when it's the season we prepare the land to sow it. We work until two months before the baby is due.

Micaela Hernández, Shishintonel

When we are pregnant, our period stops during the nine months. When we give birth to our child, we bleed for three days or a week. And then nothing more happens until the child grows a little bit. Every woman is different. There are women who start menstruating just half a year after giving birth to their baby, these women get pregnant quickly. And there are other women who don't menstruate for two years after giving birth to their baby; these women have children every three years. Some have children every year and a half, and others every year. It's the length of breastfeeding. Once you menstruate again it is possible to get pregnant. You have your period once or twice, and then begin to count nine months until a baby is born.

Celia Sántiz, Bayalemó

I know a woman who began to menstruate very soon after giving birth to her child, and when the baby had grown a little bit, she got pregnant again. She has babies every two years. It's true. Some women menstruate

a year after giving birth, but others after six months, and others after eight months. Each woman is different.

My children are born every two years, so I have my period a year after giving birth.

I think that women don't use anything to protect themselves, that's why they have so many children.

When I got pregnant with my first son I realized it because I didn't have my period. If you are married or together with a man and you menstruate, that means that you are not pregnant. But if you don't have your period, that means that you are pregnant.

When I had my first son I didn't think anything of it; I felt good and I ate everything I wanted. But with my second son I felt dizzy and sleepy and wanted to throw up all the time.

Micaela Pérez, Bayalemó

I have my children every three years. When my children are born I don't menstruate for two years because I am breastfeeding. Then my period comes back.

Pascuala Pérez, Yochib

I don't think it is like that, that breastfeeding prevents pregnancy. I think that's a myth. I think that you have to visit your doctor if you're not menstruating.

I know when I am pregnant because I stop menstruating and feel sleepy, and because I don't want to eat beans and other foods. Sometimes I throw up. When I was pregnant I didn't want to eat anything—beef, chicken, eggs—but after the baby was born I started eating everything again.

Some pregnancies are very bad; others make you eat every kind of food.

We can't stop working during pregnancy because our husbands and children want their meals. They can't work in the milpa and do the coffee harvest by themselves. They have to pay other people to help them, but we don't have enough money, so we and our children have

to work. What's more, we have to grind the corn for the pozol and the tortillas.

Rosa Gómez, Yochib

There are women who already have gray hair when they stop having children. They can have fifteen children or more.

Zoila Sántiz, Yochib

When we are pregnant we have cravings. In my case, I wanted to eat a plate full of chiles. But I also craved coffee.

When we are about to give birth we take a medicine that contains red or green pepper. We have to grind it and mix it with chiles and black sugar—that's the sugar that comes wrapped in banana leaves; in Spanish it's called *panela*. We put the mixture in hot water, and that's what we know as "hot medicine." The drink is a little bit spicy but they say that it warms our belly and causes our breasts to have enough milk to feed the baby.

In my case I can't stand the smell of beans when they are cooking; the odor makes me want to throw up. There are very few things I can eat— just vegetables and a little bit of pozol. During pregnancy we continue working. We go to harvest coffee, and when it's the season we prepare the land to sow it. We work until two months before the baby is due. Then we stop doing that work but we don't stop doing the housework. We carry water and wood.

María Gómez, Yochib

When we are pregnant there is no way that we can stop working, and especially if [we] live with [our] parents-in-law. We have to do what they say.

Besides, we feel ashamed if we just sit, because they start hinting that we are lazy women and that we don't want to work. They also say that we don't endure anything and that we think that just because of having a baby we are about to die. So what they want to see is that even if you are

ill or pregnant, you are always smiling and working without any problem. That's what the parents-in-law want.

CHILDBIRTH

> We believe it is a good thing to bury the placenta so that when the children are growing up they will be humble and obedient.

Martha Gómez, Yochib

Some women give birth to their babies in the clinic of the community because the doctor has monitored them during the pregnancy. The doctor gives us an appointment every month or two months at the beginning of the pregnancy, but in the end, a month before we are about to give birth, we have to go to the clinic every week.

I went to the doctor when I was pregnant with one of my daughters. The doctor really took care of us, so I went to the clinic. At first, the doctor told me that everything was fine, but two months before the birth she told me that the baby was in breech position and she could do nothing, so I was sent to the clinic at Ocosingo. However, I preferred to go to my partero to know if it was true or not. He examined me and [said] the baby was fine, and my daughter was born without any problem.

When women are going to have a baby, there are husbands who don't sleep with them. They are afraid and they think that it's better not to sleep with their wives, so they sleep apart.

I go to the clinic when I am pregnant but I also visit the partero. When I give birth I stay at home; the partero comes and takes care of me. He comes with his wife; she bathes the babies, and sometimes she also bathes us and even washes our dirty clothes. All of my children were born this way. I have never given birth at the clinic.

Petrona Sántiz, Yochib

All the women look for someone to take care of us when we're going to have a baby. When I had my children, the partero took care of me. I

had good care; the partero had everything ready; I had IV. I had a lot of pain and the baby couldn't come, so he gave me an injection to speed the childbirth. When you bleed a lot during the delivery, he gives you an injection and medicine to relieve the pain.

I have never taken any herbs to relieve the pain during my pregnancy. I have always looked for somebody to take care of me. I have never stayed alone with my partner.

In our community we are attended by a man who takes care of us because there aren't women who know how to do it. There are some women who try to do it, but with them the children always die. Maybe they haven't learned how to do it properly and they don't know how to adjust the baby in the mother's womb before she gives birth. They say that the children are in the normal position, but it's not true; they come in a breech position. I think that they only do this work because they like money.

We don't pay a lot of money to the man who takes care of us. We just pay him the cost of medicines and fifty pesos for coming to our houses. We pay for his feet (*stojol yakan*). We give him what we can; he has never put a price on his work or asked for payment. He leaves it to our heart how much we want to give him.

Zoila Sántiz, Yochib

When we are about to have our babies, a man attends the birth, the partero. He is the one who looks after all the women in this and other communities nearby. Sometimes he can't even sleep at home because he is too busy working. He lives in the community. He is not a nurse but he knows very well how to help us. For example, sometimes it happens that the placenta fails to be expelled naturally, so he rubs our womb and helps to expel it. He knows how to do it properly, and that's why everybody wants him.

There are also two or three female midwives in the community, but some babies died in their mother's womb because the midwife didn't know if the baby would come well or badly and what to do in each case. That's why many women don't want to be looked after by them. In the end, we find out about everything; we found out some women have died as well.

We give birth at home and we call the male midwife to be present while the baby is born.

In the moment of giving birth we kneel down over an old blanket, and when we feel weak our husbands raise us at the waist. When the pain is intense, the male midwife comes and he gives us an injection, and five minutes later the baby is born. After the baby is born we bury the placenta next to the hearth. We dig a hole and we bury the *sme alal* [placenta] there. We believe it is a good thing to bury the placenta so that when the children are growing up they will be humble and obedient. If they do something wrong, they will listen to their parents' words and will change their attitude. They won't run away from home. On the contrary, if the parents throw away the placenta, their children will be disobedient and leave home and go from one place to another. If something displeases their parents, they won't listen or obey and will run away. This is not the children's fault. This happens because their parents didn't bury the placenta. Sometimes it is also due to the dogs that find it and scatter it in different places, and this influences the children's behavior.

My parents told me they buried the placentas of all their children. I did the same with my children. I also hung the umbilical cord of the child so that he or she wouldn't be afraid of climbing trees.

After the children are born, it is customary to leave a big tree branch in the road. This is a sign so that children know how to return home and their souls won't get lost.

Juana Gómez, Yochib

I have given birth to all my children at home. When my husband sees it's time for me to give birth, he informs the partero, and he comes to care for me at home. I have never gone to a clinic because I feel embarrassed. The man who takes care of us is called Manuel K'aal. He doesn't use scissors or a *xelete* [knife] to cut the umbilical cord, he uses a machete.

My two daughters' navels stick out; maybe it's because they didn't have them well bandaged.

To cut the cord, he first burns the machete, then cuts the umbilical cord with it and he bandages it. I have always used a machete with all my children, never scissors. When I had my daughter, I suffered from birth

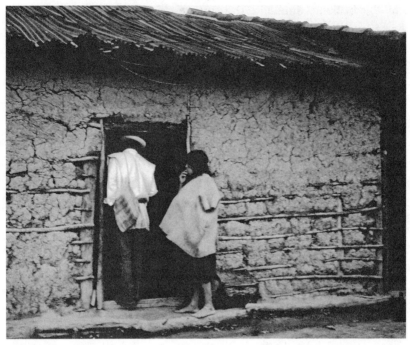

Couple in a doorway on the outskirts of San Cristóbal de las Casas, 1974.
Photo by Joan Ablon.

pain for three days because she couldn't come out. I didn't go to the
clinic because the doctor wanted to send me to the hospital so that they
could operate, and I was very afraid.

There is another partero in the community. However, he is about sev-
enty years old, and he only works during the day—he is too tired to work
at nights. This partero took care of me, although at that time he was
strong. The nurse told us that most of the childbirths take place during
the night.

The other partero is named Alejandro and he is a young man, about
forty years old. He always has all his instruments with him. When the
baby is born, he cuts the umbilical cord and he covers it. I have never
seen him use the machete.

There is also a female midwife. Her name is Pascuala, but people
say that she doesn't know very well how to take care of women during

childbirth. Some time ago, the youngest sister of my sister-in-law was pregnant, and this woman attended her baby's birth. She said that the child was in the correct position. The midwife asked her to push, but the child couldn't be born because he was in breech position, and then she said that she didn't know what to do.

My brother, whose children's births have been attended by Alejandro, said, "The woman doesn't know what she is doing; go call Alejandro."

They went for Alejandro, and the woman went away with great shame.

Sometimes Alejandro gets upset when there is another midwife taking care of the same woman, and he says, "The person who has taken care of the woman from the beginning should take care of her now, not me." He is right. He comes to do the work of the midwife who has taken care of the woman from the beginning of the pregnancy. When the woman is giving birth she realizes that the child is coming in breech position, and Alejandro has to save both the mother and the child.

We have to beg him to attend the birth because we want to save [the baby]. We have to pay him because he knows how to do his work. The female midwives don't know anything compared to what Señor Alejandro knows.

There is a tradition in the community. After a child is born, the tip of the umbilical cord is tied to the machete, and then it is burnt. This is [done] so that the navel will heal sooner and the child will urinate less.

My mother threw the placenta to the dogs to eat. She believed that if the placenta was buried the baby's body would get cold, and it would have stomachaches.

María Gómez, Yochib

We cut the umbilical cord with a xelete, a special one reserved just for this occasion, and we don't use it for anything else. We never cut it with a machete that is old.

I think that the knowledge of midwives is being lost. There are several male and female midwives in the community. I think that when these people who know how to attend a birth die, we are going to die because nobody will know how to take care of us. We are alive because of their

knowledge, although the only one who knows how to take care of us properly is Señor Alejandro.

When the childbirth is complicated, he raises us at the shoulders. He does his best to help our baby to be born. With him, we don't die. With him, things go well. He treats us with care and we don't cause him any disgust. He knows our bodies.

The partero helps us at the time of the birth but also before that; he knows if there is any complication or if the baby is in breech position.

He helps us in everything. What's more, he gives us vitamins when we are feeling weak and advises us to eat more. The partero is Señor Alejandro Gómez Méndez.

We are not afraid or embarrassed for him to see our bodies. He doesn't feel any disgust; he touches our blood and our child's blood. He is not afraid of us. He raises us and helps us until the child is born. He never leaves the work half-done; he stays and finishes attending the childbirth.

Sometimes we give birth to our babies by ourselves. We take a thick stick and we help ourselves to strain with it. We give birth in a kneeling position.

When I had my *waxuk tul* [eight children], only my husband was with me. He helped me to push and supported my back. With the effort of us both, we gave birth to our children. My mother used to hold me at the waist because in the past there were no midwives.

When it's time to cut the umbilical cord, we wrap it in a cloth, and in two nights it dries out and falls off. It is a tradition to hang it from a tree; we believe that this way the child, no matter if it is a boy or a girl, will be able to climb trees when he or she grows up.

When a baby boy is born, the custom is to put a man's tool into his hands, such as a hoe or a machete. And when a baby girl is born, we put into her hands parts of the backstrap loom [one of the weaving sticks]. In that moment we ask for the boys not to be lazy men and for the girls to be good weavers.

When the babies can't stop crying it means that their soul is lost, so we lay a red string on them. We also use amber sometimes. This is done so that the child's soul returns to the body. After that we put the baby on a dog and tell the dog, "Look for the lost soul of this child." When this

succeeds, the child stops crying and can sleep well, and it means that the animal was able to find the baby's lost soul.

When the babies are very young, we tie them from shoulders to toes with a strong cord so that they don't hurt themselves but also so that when they are growing they will be tranquil and won't get into mischief. We learned this from my mother. "Tie their hands," my mother used to tell me. Children who didn't have their hands tied are naughty now, and they don't obey even if you scold them.

Two months after the delivery, we tie a red string to the child's right wrist and to the left toe so that he or she doesn't get lost or lose memory.

It's also said in our community that when a baby can't stop crying it's because there is someone who wants the baby, so if we want the baby to stop crying, we have to take him or her to the person who cast the evil eye on the baby to be kissed. This happens when women are pregnant. It makes the babies feel anxious.

If we don't find the pregnant woman, we heal the baby with a special smoke made of *xacté* [sedge], a little bit of chile, and sometimes even corn silk. We blow smoke over the baby's body when he or she is sleeping in the hammock, and under the baby's body and feet. With this ritual the baby is free, and the evil returns to the person who sent it.

Rosa Gómez, Yochib

When babies are born, we give the placenta to the dogs to feed them. I remember that a long time ago my mother-in-law told me, "When you deliver your baby, don't throw away the placenta; you have to bury it under the corn mill instead."

I didn't obey and I gave it to the dogs. I never buried the placentas of my children because I thought that they could die.

When a baby is born, we eat chicken [to celebrate the birth] no matter if it is a boy or a girl. We also drink chicken soup.

There are parteros in the community, but some of them don't work carefully. We have heard that some of them use the same syringe with all their patients; they just boil it, and they don't throw it away. That's the reason why we don't want them to take care of us. Some chil-

dren had infections and pus where they had the injections with these syringes.

There are still people who are not prepared to attend deliveries, and they even use old and dirty machetes. I don't go to the clinic; I go to Señor Alejandro, the partero. He is the one who takes care of me when I am pregnant.

María Gómez, Yochib

I don't go to the clinic. When I have to deliver I stay at home with my husband, just the two of us. With my last three children I had to be attended by a partero, Señor Albanil Mulex, because in one of my deliveries I was at risk of death. He took care of me during the pregnancy, but when it was time to give birth to my son, it was my husband who attended me. Sometimes it was very dangerous because there was a lot of blood.

If I still had strength enough after the delivery, I took out the placenta on my own. It feels soft and round, and if you move it a little bit it comes out. After the delivery of my children, my husband prepared the temascal to bathe me and to steam me with palm leaves. If the child was born in the morning, we bathed together—the three of us—in the temascal in the afternoon.

We bathe the babies because they need to be washed and they like the heat of the temascal; they don't cry. I breast-feed them, they don't eat anything else. My family didn't help me when I gave birth to my children. My mother-in-law was afraid, and my parents didn't come to visit me. It was my late father who didn't want to visit me. My mother came in secret several times, but when my father found out he scolded and hit her. My father used to say that my odor stayed on the *jícaras* [gourd bowls] or the plates, and he didn't like that. I felt sorry for my mother and told her, "Don't worry; don't come anymore because my father is going to hit you." I had nobody to help me.

I don't know how my father found out that my mother came to visit me. Maybe my odor stayed in her clothes, or maybe somebody told him. My mother told me once that after she came to visit me, she prepared pozol for my father, but instead of eating it he threw it down because he felt the smell of a woman that had recently given birth.

That happened when my mother came to visit me because my son had breathing problems and I was afraid that he might die. She started to give him little smacks to the buttocks and blew air into his mouth; after much work he started breathing again. I told her to stop visiting me, but she didn't stop doing it.

Celia Sántiz, Bayalemó

We visit a midwife during the pregnancy so that she can adjust the baby in the womb. The midwife has to see if the baby is in the correct position or not, because sometimes it is in breech position, and it is very difficult to deliver the baby in that position. She is the one who knows about this. The midwife doesn't know the time of the delivery; only my husband and I know what month the baby will be born.

When it's time to deliver the baby, the pain begins and my husband runs to look for the midwife. We have to let her know more or less in what month the baby is going to be born so that she is aware of it.

The midwife arrives to see how the baby is being born. She helps me to deliver my baby—she pushes my stomach and I, too, have to make an effort so that the child is born. If I don't make any effort, the baby can't be born.

The midwife tells us to kneel down and to hold on to something. She sees how the baby is coming out of the mother's womb until he or she is born. Once the baby is born she washes the baby and puts on clothes if there are any. There are many women who don't have enough money to buy clothes for their baby.

After the baby is born, it is usual to kill a chicken for everyone to eat. I think that they still preserve this tradition.

In my community, women bury the placenta in their houses near the hearth. The tradition is to bury the placenta underground because if it is above, the baby's navel will stick out.

Verónica Gómez, Jolxic

Women usually give birth to their children kneeling down and holding on to something that enables them to keep straining. Sometimes their

husband holds them too. He places himself behind his wife and holds her arms. Women need their husbands to provide strength and help them feel better. When the baby comes, it's the most painful moment, and the husband pulls her from the waist upwards and backwards so that she is supported upright. This position is the most comfortable one for some women; they feel they can't give birth to a baby except in this position. The midwife checks to make sure the baby is healthy and fine. The mother is the one who does the work to deliver, together with her husband.

In the past it was a tradition when a baby boy was born to put into his hands the handle of a hoe or some other farm tool, so that he would become a good worker; and when a baby girl was born, to put into her hands part of the backstrap loom, so that she would become a good weaver. I don't know if they still do it.

In my community is usual to bury the baby's placenta outside in a place near the house.

INTERVIEW WITH A MIDWIFE

> I get very tired. The truth is there are times when too many ask me for help at the same time, and I can't refuse to do the work.

Pascuala Patishtán, Bautista Chico

There are many midwives in the community who have learned the customs of the past, but women stop me on the road to ask me to help them. I have experience and many women know me, and they like my work. Some women look for me immediately when they know that they are pregnant. They want me to massage their womb and make sure the baby is positioned properly before they give birth.

My mother was a midwife for many years. She had seven children, and for her first three deliveries, she was attended by a midwife. After that, she gave birth alone because by then she had experience. And my father also had this experience, so between the two of them they attended to the births of their other four children. My mother was Verónica Patishtán

Collazo. She was also a member of the weavers' cooperative. The truth is that not every woman can be a midwife.

I began to try with my first son. I massaged my own womb, and when I felt sick I asked another midwife for help and I paid attention to how she did everything.

Shortly before my son was born, my mother asked if there was any problem with the baby. I told her there was a little problem because he wasn't in the proper position, and she began to massage me. Little by little I tried to do it, too. One night I had a dream about a woman in pain who needed my help. In my dream I touched her body and my hands started to work. I realized that she was pregnant, and a voice told me that I had to help her and that everything was going to be all right. I didn't want to do it because I still had a lot to learn, but the voice insisted and told me again that I shouldn't be worried and that I was going to help many women to have their babies.

When I woke up that morning, a woman came to my house because she was pregnant and wanted me to massage her; I didn't want to because I felt I didn't know enough. The woman insisted that I had to help her because there was nobody else to do it. It was very difficult for me because I knew that I still lacked knowledge, but then I remembered the dream.

I made the decision to help this woman because I was told to do so in my dream. My mother insisted that I must do it because of my dream. If no woman had come to ask for my help, then I wouldn't have had a problem.

Then, my mother began to explain to me the difficulties during deliveries. She explained to me what to do when the placenta isn't expelled. In those cases I had to locate the navel and put my hand in the vagina to the height of the navel and take it out, although at times it comes out in pieces and is difficult [to remove].

I have progressed and have seen various problems that women have during delivery. One of the main problems is that some babies come in a breech position instead of in the position that they should be. That's the reason why women want to be attended by me—because I have progressed and I have experience. They are content with me, but I get very tired. The truth is there are times when too many ask me for help at the same time, and I can't refuse to do the work.

The authorities in the community don't say anything [about the work of midwives]. The important thing is the work with women who are going to give birth. If there is a serious problem with the position of the baby, then one of us [midwives] decides and talks with the family so that the mother is taken immediately to the hospital. It is a terrible thing when a baby dies, and it is difficult to see the pain and suffering of the mother. One never forgets that.

I don't have a specific fee for my work as a midwife; that is not what we do. It is voluntary and what the family wants to give me. Sometimes they give me fifty or one hundred pesos and they invite me to eat; they always offer me chicken soup.

Customs have changed. In the past nobody had baby clothes ready, as they do nowadays. There have been many changes. I used to take care of women for three days when they gave birth. Even women's attitudes after giving birth have changed. Now they start working again the day after they give birth. In the past, people believed that the demon could come, but now many things have changed. I think it's better now. Before, there were many beliefs that gave us fear, but nowadays I don't see that. We know that God will care for us. The Word of God [a Catholic ministry] has helped many women to change and to lose the fears that used to be common in the communities. For me what matters is what the woman who has just given birth says. If she feels strong and supported and has no health problem, it's not necessary for me to stay with her so many days.

There are some women who decide to go to the hospital and only want their womb massaged during their pregnancy. However, there are others who during the pregnancy I realize will have a difficult delivery, and they make the decision that it's better to go to the hospital. I don't feel upset by that. I think that every woman needs to feel safe, and that depends on the position of the baby.

Now, for me, it is important that I no longer have the custom of using candles or taking a healer with me. I don't give women alcohol during the delivery as I used to. These are customs that are disappearing, and I think that's best. In the past women have suffered due to these traditions. In my case, my mother-in-law used to drink too much, and she made me drink together with my husband. That is not a good thing to

do because when men are drunk they start hitting us [women]. I think
it's better not to use alcohol; that's why I stopped taking healers with me,
because they always use alcohol. I am not in favor of these traditions; in
the end the ones who suffer are the women. In our area it is a custom of
many years that one must drink, even little children are given alcohol to
drink. But now, little by little, there are more people who don't do it.

In the community there are also parteros, but women prefer to be
attended by female midwives because they are embarrassed to have a
man see their body. So there are days that I'm very tired and can't do so
much work. To be a midwife, and a craftswoman, and to take care of my
house and my husband is sometimes too much work.

UNWANTED CHILDREN AND
CONTRACEPTIVE METHODS

I have been told that there are herbs like rue that can cause
abortion.

Verónica Gómez, Chenalhó

Abortion is not very common. What happens is that they don't want to
raise the baby. What they do instead is to give birth and then abandon
the babies on the mountain or in another place until they die.

I have seen women who don't know how to take care of themselves;
they don't know how to avoid getting pregnant. They have twelve or fif-
teen babies. [Either] they hope that they will stop being fertile, or they
die from giving birth to so many children. There are women that can
have more children than others. Some of them can even have sixteen
or eighteen children, but the norm is ten to fifteen babies. They don't
want to have so many children, or at least they don't want to have them
so close, one after the other. The problem is that women don't speak
with their husbands.

I have been told that there are herbs like rue that can cause abortion.
Apparently, it makes the fetus fall, and women have their menstruation.
I know that some women want to try this herb to find out if it really has

these effects, but up to now they haven't tried it. Those who are most interested in trying this herb are women who don't want to have more children.

I think that it is important that women use contraceptive methods. In the past, no one told them that they could stop having children.

Celia Sántiz, Bayalemó

I heard once that a woman who lived next to Bayalemó was pregnant but her husband had died. Her son-in-law got her pregnant. People say that this woman had a baby boy at home, but because she didn't want to take care of him she killed the baby and hid him in the forest. The brothers of the woman found out about the murder, and now she is under arrest in prison for killing the baby. Sometimes we also hear that some woman has had an abortion, but it is not very common. They wait until they have the baby, and then they get rid of it.

Rosalinda Sántiz, Bayalemó

It is true that some women have a baby, and then they leave it in the woods or someplace else, a place no one knows because they don't usually leave the road, and sometimes it's not known they are pregnant.

I know a family in my community in which the father got his daughter pregnant, and when the baby was born, he threw him into the latrine and the baby died there and nobody realized it, but over time everyone in the community knew this story.

We think that the [baby's] mother agreed with killing the baby, or at least she knew about what happened, because she still lives in the same house with her family. However, she got pregnant again by her father. They again waited nine months, and after she gave birth to the baby, she put the baby inside a box during the night and left him in a field next to Bochil. Fortunately, a couple found the baby because he was crying, and a mestizo teacher adopted him in Bochil. Some years later the family saw the little boy when he was bigger and very good looking.

It happened once again. She got pregnant with her third baby, and after the delivery the father left with the baby wrapped in one of his

shirts. This time he left the baby in San Cayetano, next to Bayalemó. Some people saw him getting rid of the baby and heard her cry. It was a newborn baby girl, and they took her and raised her as if she were theirs. I think that she is now three years old and she is a very pretty little girl.

I don't know if this woman has become pregnant again. She is very young—she is twenty-five years old—and I don't know if she has agreed to this situation at home or if she is forced by her father. When she was pregnant with her second baby, a man came to propose. He wasn't from our community and he didn't know about her situation; that's why he proposed. But she is still not married and she is always together with her father and mother.

Zoila Sántiz, Yochib

Nowadays there are injections and pills to avoid pregnancy. Many women in the community use these contraceptive methods, but some of them say that it is bad for their body because sometimes they don't have their menstruation.

Rosa Gómez, Yochib

There are women in the community who have abortions. Not long ago, my son saw an abandoned baby. "Mom, you can take this baby if you want to have one," he told me. "He is lying out there. He is alive." He told me that the baby was alive, lying with the placenta next to a chair and a big backpack. I didn't go to see the baby because I was frightened, so we don't know what happened to that baby, because when my son went back he was gone.

I have taken the pill to avoid getting pregnant because I didn't want to have many babies, one after the other. I felt sick with the pills. They gave me many headaches and I felt that I was running out of blood. I still feel the same nowadays. I took them for three months. It wasn't a long period but I felt exhausted, without energy to work because I had less blood. I felt different.

Sometimes on my way back home I was so exhausted that I began to cry because I thought that I couldn't reach my house, and I had to rest

in order to get to my house. I also felt my heart beating very fast, and I could hear it striking like a clock.

I went to a specialist doctor, and he told me that I had to stop taking those pills because I was very weak. After that I used an IUD. And for me it works. We have the IUD put in here in the clinic in the community.

Martha Gómez, Yochib

We know of a young woman who was pregnant, but the father of the baby didn't want to marry her, so when she started to have contractions she left her house and went to the mountain to deliver the baby. After the birth she took the baby to another place and left him in a thicket of thorn-bushes. A man who was cutting coffee saw this woman have her baby and called the authorities. The authorities went to the place where she gave birth, and they searched for the baby but they couldn't find him. (When women give birth they leave drops of blood.) The authorities followed the drops of blood to the woman's house and they asked her about the baby, and she answered: "I killed him and threw him into the thorns."

They started to look for the baby where the woman said, in a place with many thorns, and they found the baby's body.

They took the baby to the school of the community. Some women and men from the community had a meeting, and they shamed the woman for leaving her child. The next day, everybody in the community knew what this woman had done. They took her to the municipal seat of Oxchuc, and they also took the dead baby.

There are women who have babies and abandon them. Maybe some women have abortions, but I don't know of any case.

Pascuala Pérez, Yochib

Some women have an operation to stop having children. They feel burning in the place where they had the cut, and they also say the womb is closed with a wire. The wire heats up, and they feel hot so these operated women have relations with other men.

I believe if it was me I would only do it with my husband and thus I wouldn't commit any crime.

OUR RELATIONSHIP WITH OUR
PARENTS AFTER MARRIAGE

I think that children have bad hearts. We don't want to be with or
care for our parents.

Juana Gómez, Yochib

If the parents can still work, they look out for what they need; between
the two of them they take care of themselves. Their grown children rarely
visit them. For instance, my grandmother is a widow. She takes care of
herself. Her husband died; she works alone, takes care of her milpa,
grows corn and beans. She carries out the farmwork by herself; none of
her relatives or her daughters look out for her. I think that children have
bad hearts. We don't want to be with or care for our parents.

María Gómez, Yochib

Most parents don't want to move in with their children because they are
used to their own things—their house, their food, and the way they live—
so they prefer to live alone in their own house. What's more, the children
don't want to move back to their parents' house because they already have
a family. My grandmother prefers to live alone. I can't take care of my
mother, but I have brothers who live with her. I visit her from time to
time. My husband helps me with my mother when we see she is out of fire-
wood, though this is unusual. It would be different if I weren't married.

I can't help my mother economically because I don't even have
[enough] money for my family. So I help her with working in her milpa
or sowing the field. I help her with her housework, and sometimes when
we have a little bit of money saved, we buy soft drinks and meat to share
with her, because my father died a long time ago.

Petrona Méndez, Yochib

When we get married the relationship with our parents changes. Although
our heart is with them, we cannot see our parents every day because we

have responsibilities in our own home. It may be that our husband can't be bothered [or that] because of the work at home we don't have time to visit them. It makes us sad that we are not able to help them. I would like to buy them some clothes or food, but sometimes we don't even have money for ourselves.

Zoila Sántiz, Yochib

From time to time I visit my parents, but just briefly; it's not the same as when [I] lived with them. We went to work together; we ground corn to make tortillas. I can't do that anymore because I have to take care of my house. Only occasionally do I go to see them; when they are sick, I go to bathe them. Now that they are alone, they work in their milpa and I help them one day with the fieldwork, but I can't do more. There are several brothers and sisters in my family, so we take turns helping them—those of us who have good hearts, because even though we are siblings, we are not the same. Some of us give them a little money for food and clothes, and thus make their lives less difficult; if we abandoned them, they would be sad.

Martha Gómez, Yochib

I visit my father when I can. I am his only daughter living in the community; my sisters married men from other communities. And when I can't go to see him, he visits me instead.

Rosalinda Sántiz, Bayalemó

Women are the ones who worry about their parents, the men rarely do. Our parents took care of us when we were young, and sometimes we forget that. When we find a job we usually forget about them and what they suffered to feed us. When we get married, women forget about their parents; it's not the same when you get married. Most women go to live with their parents-in-law. They visit their parents, but it's not the same; they even call their in-laws "mother" and "father."

Tzeltal father and daughters, 2016. Photo by Charlene M. Woodcock.

Petrona Sántiz, Yochib

When the children get married, the last daughter at home has the obligation to care for the parents; many times she doesn't get married in order to be able to care for her parents; also the youngest sons stay at home.

Magdalena López, Bayalemó

I have brothers who are older than I am. As men they should support our father because they, not I, are going to inherit his lands. If my husband has his own lands, that's where I go to live. That's why no one has a good plan to take care of aging parents.

Men should care for their parents because in the end they are the ones who inherit their lands. For instance, in our family there are eight children: four men and four women. Only the men will receive an inheritance from my father; the women receive nothing.

When our parents are old what we must do is bring them food or invite them to eat with us. We can't give them money because we don't have it.

Life is hard for parents who live alone if none of their children takes responsibility for them, if they're alone in their houses with no one to care for them.

I can't support my father. He is a craftsman and he continues to earn money making nets; and my stepmother knows how to weave, so together they make a living. I haven't thought about how to care for my stepmother because she is not my real mother. I haven't given her a skirt or even a blouse.

My father is very old; he is approximately seventy years of age, and I can't imagine how he is going to live when he grows even older.

Juana Jiménez, Bautista Chico

My sisters and I don't have anything, so we can't provide food for our mother. We can't give her clothes. From time to time we take care of her. Actually, my mother lives with our youngest sister, she cares for her, and we invite her to eat with us, but she still works and makes some money.

THE PROBLEMS OF MARRIAGE

If we women make a mistake our punishment is much harder [than men's]. If you are unfaithful to your husband, very hard and sad things happen to you.

Magdalena López, Bayalemó

When parents separate, the responsibility for the children goes to one or the other, depending on who cheated. If the wife was unfaithful, then the children go with their father; and if the husband cheats—this is most common—the children stay with their mother and the father supports them until they are eighteen years old, at least in theory but rarely in

actuality. Sometimes the woman gets involved with another man and takes her children with her.

When a woman has an affair with another man, her husband asks his wife's lover for money so that he can find another woman, without regret. If a man has an affair, it's different. He is not punished in the same way a woman is.

Celia Sántiz, Bayalemó

When a man doesn't keep his promise to support his children, he is put in jail. He has to comply, and the woman has to take care of the children. If the man goes with another woman, the wife gets angry; but when they fight over other things they can resolve their problems. Some women who have many children don't want the man to abandon them, so they forgive him.

In our community, there was a woman who was several months pregnant when her husband got involved with another woman. In spite of her pregnancy, she let her husband go with the other woman. She didn't regret it; on the contrary, she decided to leave her husband and separate from him completely.

Later, the husband cried because he wanted to return to his wife, but she didn't want him back. Even though other people talked to her and tried to convince her to forgive him, she didn't want to. Then the man told her that he would support the baby when he was born, but she didn't accept. She wanted to raise the baby on her own. "I have hands to support him, I know how to work as you work," said the woman. "You can't do anything." The man did everything he could, but the wife was prepared to send him to jail if he continued to insist that he wanted the baby when he was born. His wife's answer was no: "I will send you to the public prosecutor's office, I don't care how many years you have to stay in jail if you want to take my baby away from me," the woman said to him.

Over time, the man realized that he couldn't do anything so he stopped asking for his son, and the woman separated from her husband. It was the man who made the mistake of leaving his wife for another

woman. He didn't marry the other woman because she was also married and her husband just wanted money to look for a lover for himself. The man was with that woman for only a short time because she was pregnant and the baby wasn't his.

Francisca Pérez, Chichelalhó

When a man leaves his wife for another woman, the couple fights and may even strike each other. But in the end, they sort out the problem because they have children and don't want to abandon them.

There are men who have a wife and pursue another woman, and then they are together with two women. Of course, the women don't like the situation, and sometimes they fight and insult each other in the street, on the riverbank, wherever they encounter each other.

There is a case in our community of a fifty-year-old man who pursued a twenty-year-old woman. He was married but his wife couldn't have babies. On the pretext that he wanted a son he looked for a younger woman; he got her pregnant and she had a baby. A few days after the birth, the baby got a fever and died. When this happened, everyone blamed the first wife and she was accused of being a witch. They say the first wife has a lot of money and she hides it in a big box and she never stops counting it. In the end, the man left the first woman and stayed with the second one. Now they fight and this woman steals money from him. The money is from a business that both of them run, but she is skilled at stealing from her husband. The man wants to return to his first wife but it is very difficult because he now has children with the second one. He had four children—two of them died and two are alive. These children died from fever and spots, and every time this happened they blamed the first wife for the deaths; they say that she still does witchcraft.

The first wife doesn't want to get back together with the man. In the past, when the man lived with the first wife, he was always clean, his trousers white and his hat with ribbons. Now his clothes are ragged and worn-out. When he and his first wife ran the business, they sold many things and she managed the money well. They both worked equally. Now he

repents because she was not a bad woman; besides [working at] their business, she also worked to grow corn and beans.

Rosalinda Sántiz, Bayalemó

When a couple separates, they have to go to the community authorities to arrange the matter. They have to come to an agreement. If the couple has two children, a boy and a girl, the woman takes the boy and the man the girl; but if the man doesn't want to take care of his children, they have to stay with their mother. The father has to provide a little money for the children, but often the man doesn't want to pay the maintenance allowance, so the mother has all the responsibility.

In my grandmother's time nobody had two wives, but nowadays it happens. I know a case of a man who had two women; they lived together and were sisters. This is not normal in the community; this situation is seen as bad and the man is put in jail. The people of the community speak badly of him, because they find out everything and talk about it behind the backs of the man and the woman. It is harmful for the children if a man goes with another woman. He can't give his children advice because they may say to him, "You can't give me advice because you were the first one to behave badly."

A woman can't have two husbands. As far as I know, that can't happen! If a woman did it, what would the husband do! When a man does it, on the contrary, no one says anything. But if it were a woman, she would be beaten or even killed. It is sad because if we women make a mistake our punishment is much harder [than men's]. If you are unfaithful to your husband, very hard and sad things happen to you.

María López, Oventik Grande

When they obliged me to go with my husband, he was with another woman. The first woman returned to her parents' house because she couldn't stand the work; she had to wake up at three o'clock in the morning.

Rosa Gómez, Yochib

There are women who are married and are also "talking" with another man. Sometimes the children they have are not from their husband, but the husband raises them because he thinks they are his and he doesn't say anything.

Life in the Community

The political structure of the indigenous Maya communities in Chiapas and their relationship with the hierarchy of authorities in the *municipio* (county) government and the state and federal governments are somewhat complicated, especially since some of the communities have committed to the Zapatista Army of National Liberation (Ejército Zapatista de Liberación Nacional, or EZLN)* system of governance, called the Autonomous Councils of Chiapas. There are 122 municipios in the state of Chiapas. Indigenous communities in Mexico preserve the right to adjudicate minor offenses—public drunkenness, robberies, land disputes, marital disagreements. The Maya have a long tradition of resolving such disputes through reconciliation. Misdemeanors are resolved with small fines—formerly paid in alcohol but now commonly with soft drinks or a small amount of money—with more severe punishment consisting of a very short sentence in the small local prison. The senior local authority is the agent of the elected municipal council, who has his office at the local school, and he has a policeman to assist him. Serious crimes,

* The EZLN was formed in 1983. Its name honors Emiliano Zapata (1879–1919), the Mexican revolutionary who fought for agrarian reform. The Zapatista uprising of 1994 embodied the grievances the Maya had accrued over centuries of Spanish and then mestizo rule that virtually enslaved indigenous men in the plantation system as it reaped riches from their resources and fertile lands. The 1994 uprising in San Cristóbal de las Casas against Mexican military and paramilitary involvement in Chiapas attracted world attention. In the months after the Zapatista Army uprising, ongoing discussion among the participants in the effort to achieve a just and truly representative government led to a rejection of violence and eventually to the formation of *caracoles*, small communities that joined together to achieve good government, focused on the promotion of education and health care.

such as murder or rape, are referred to the state authorities, and if the accused is convicted, he or she is sent to the state prison.

The dominant political party for seventy-one years in Mexico was the Partido Revolucionario Institucional (PRI), and its influence has continued in Chiapas even after it was displaced by the center right Partido Acción Nacional (PAN) in the federal election of 2000. Politics at the national level is mentioned in these narratives only indirectly, through references to national health programs and the military. After the 1994 Zapatista uprising and at the time the first edition of this book was in preparation, many thousands of federal soldiers were present in Chiapas in an effort to quell the Zapatistas. That effort was blunted by the Zapatistas' effective use of the Internet to communicate with supporters all over the world. The heavy military presence caused both fear and defiance among the women, many of whom expressed anger at problems caused by the soldiers, some of whose camps were set up right next to Zapatista communities such as Oventik, in the municipio of San Andrés Larráinzar. They also express strong reservations about the federal programs created in 1993 by President Ernesto Zedillo—PROGRESA (Program of Education, Health, and Nutrition) and PROCAMPO (Program of Direct Support for the Countryside)—because their benefits are distributed unequally. One of the goals of Zapatista governance is to provide appropriate, needed health care and to ensure bilingual education for indigenous children. The original Spanish edition of the book noted, in the section "Healers in the Community and the Use of Healing Plants," that women from other communities did not discuss this topic, so it should not be considered as representative of all communities.

In Mexico, there is a strong indigenous tradition of civic duty, reserved to men—the unpaid obligation to serve the community on the municipal council or on civic committees. In addition to their complaints about being excluded from community governance, most women object to the poor quality of public education. The Mexican government is obliged to provide bilingual education for children in indigenous communities, but there are few successful examples, at least in the experience of these women. Indigenous languages are dominant. Primary school, first through sixth grades, is taught in the language of the community, primarily Tzotzil or Tzeltal. Secondary school instruction is in Spanish.

Teachers tend to be mestizo (mixed-race Spanish speakers) and often do not know the indigenous language of the community. During the childhoods of most of these women, girls from smaller communities who wished to attend secondary school would have to leave home and find housing and work to support themselves, since there were no local high schools. Thus, some of the older women with only a primary education did not learn Spanish in school and have difficulty interacting with outsiders, such as health-care workers. Some mistrust the government clinics where the workers do not speak their language, and there are stories of unwanted procedures such as hysterectomies being performed without the woman's knowledge during postnatal care.

There are glancing references to religious conflict among the women's comments, but most seem to be moderate in their beliefs and forms of worship, perhaps a reflection of their commitment to work together as a cooperative. There are remnants of prehispanic beliefs and references to witchcraft among their stories. Some women comment on the tension in indigenous communities between traditional Catholicism, whose rites have incorporated pre-Christian religious practices and beliefs, and the Protestant evangelical movement whose adherents are the product of U.S. churches' missionary efforts from the 1950s onward. The isolated traditional community of the Lacandon Maya in Chiapas was divided irreparably by the intrusion of Protestant missionaries in the 1950s. In Chamula, Protestant converts were expelled from the community in the 1970s and '80s. At the same time, liberation theology changed the practices of the Catholic Church, especially under the leadership of Bishop Samuel Ruiz, who served in the Diocese of San Cristóbal de las Casas from 1959 to 1999. Bishop Ruiz was deeply committed to serving the poor and demonstrated love and concern for indigenous Mayas. He instituted new forms of church work, called "Word of God" by the women as they talk about its effect on their lives, that encouraged discussion groups focused not only on church liturgy, but also on the lives of parishioners. In the Catholic Word of God movement, indigenous catechists, including women, were trained to take on wider roles in their communities, so that the term "Word of God" means not only reading the Bible and partaking of church sacraments, but also leading prayer groups or discussion groups. The latter have exposed the problems cre-

ated by alcohol, including domestic violence and waste of money needed to care for the family. Many women note the crucial role alcohol played in their own lives when, without their involvement, their fathers agreed to their marriages by accepting the traditional gift of alcohol. For many of the women, these discussion groups provided their first opportunity to consider their lives critically; to reject aspects of community and family tradition, including the use of alcohol in social transactions; and to recognize that domestic violence was unacceptable behavior. The discussion groups have thus led to a greater consciousness of the possibility of changing behaviors and traditions to improve families' lives. For example, to quite an extent, alcohol has been replaced with *refrescos* (soft drinks).

THE AUTHORITIES

> In the past, sometimes men got drunk and came home and beat
> their wives. Now the authorities punish them.

Celia Sántiz, Bayalemó

The municipal authorities intervene when there are problems of marriage, robberies, drunken fights, family problems, or land problems. They address all kinds of problems. When there is a family problem, it's the municipal authorities and not the people who resolve it. They invite the relatives of the man and the woman who have the problem. This is just a part of the work they do. In cases of sexual abuse of a woman, the punishment is seventy-two hours in prison; it's the same in cases of family violence and also when someone is a repeat offender.

Cecilia López, Bayalemó

When the problem is simple, it's usually the agent of the municipal council who resolves the problem. But if the agent can't resolve it, then the authorities of the council deal with it.

Rosa González, Jolxic

When there is a real sexual violation, then the person is put in prison and given some years of imprisonment. When the man and the woman commit an error, they both go to jail. It happened once that the man was married, and the woman was as well. So both of them went to prison. Of course, they went separately. Sometimes even if they are married, people get involved with someone else and that's why they are put in jail.

Francisca Pérez, Chichelalhó

Sometimes when people are accused of robbery or something else, even though it's a crime, the problem is resolved by the agent of the community; but if he can't solve it, then it goes to the municipal presidency.

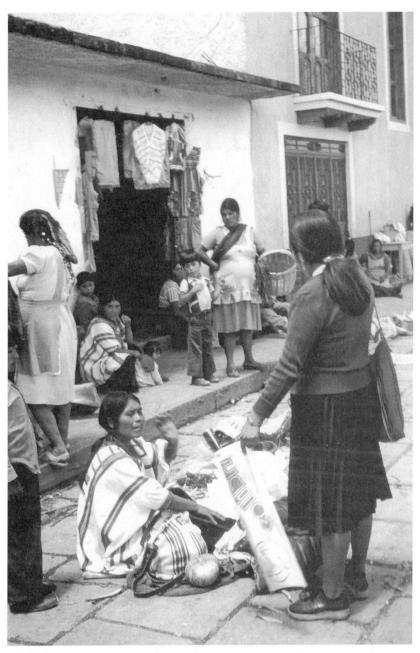

Selling goods in San Cristóbal, 1985. Photo by Joan Ablon.

For instance, in the past, sometimes men got drunk and came home and beat their wives. Now the authorities punish them.

When a drunkard is not capable of understanding anything said to him, he is put in jail. First, they counsel him and if he doesn't understand, he is imprisoned for at least twenty-four hours. If the crime is serious he can be in jail for seventy-two hours; that's the maximum penalty for those who commit serious misdemeanors.

Someone tried for murder, if convicted, is sent to the state prison. There is no other option.

In our community the Autonomous Council of the EZLN was created with the aim of avoiding future divisions among us. We hope that someday the people of the communities will become unified and our children can have a better life. We want it to be different, to have a stable and prosperous life with food, education, a home, and land for our children.

The Autonomous Councils of Chiapas struggle to recover the life of our ancestors. In the past, the authorities were paid by the government and even now, the authorities that belong to the PRI receive a salary each month from the political party. The Autonomous Council is not paid by any party or government. They live by their own work: they sow the milpa and carry the wood, the same as we all do. My father says that in the past, the authorities of the community forced people to sow the authorities' cornfields and carry their wood; the authorities drank alcohol during the workday. The Autonomous Council forbids that.

The authorities can't gossip. After working out a problem of the community they can't go talk about it. The authorities must have discipline. An indiscreet person can't be a representative of the community.

Petrona Méndez, Yochib

When someone commits a misdemeanor he or she has to give the authorities refrescos as a kind of fine [*ch'abajel*]. And if the misdemeanor is serious, he has to give money to the authorities as well as soft drinks.

Women are also punished. Women are imprisoned, for instance, when they are single and have sexual relationships with a married man or when a married woman meets secretly with another man. We can talk

to men in an appropriate way, but if we flirt with them or smile at them, that is wrong and is punished with jail. In general the punishment lasts one night or one day; it can be more, depending on the misdemeanor.

In my community a woman can only talk to her relatives, her father or brothers. Women cannot talk to other men in the community, and if people see you talking they begin to say ugly things about you. That happens in this community. If we are seen talking to another man, people think badly of us.

Of course, on occasion we speak with some man that we encounter; if we are friends we greet each other. But people in the community don't even allow this; they say that we greet them not because we are polite, but because we are accustomed to talking to other men. We can't have friendships with men, only with women.

Men are punished with jail when they rape a woman or kill a person, when they beat their wife or strike their father, or when friends fight with each other because they are drunk.

The committee is chosen every year but we women cannot participate. We don't attend the meetings, only the men meet to make decisions. Those on the committee don't receive a salary, it is unpaid work.

When the committee is going to be elected, all the men of the community are called to a meeting. They meet in the community school and they choose those who will be the authorities of the community for the next year.

The responsibilities of the committee are that its president together with the other elected members consider the needs of the community and work to solve the problems of the area. They go to the municipal seat in Oxchuc to see what possibilities for community support are available. They also supervise the school, to make sure the teachers arrive on time for classes and the students attend school. Their duty is also to be aware of the needs of the school; for example, the construction of new classrooms. That's part of their work; thus, they have to visit the municipal president in Oxchuc regularly to find solutions to the problems that arise in the community during the year.

When we report a crime it's the agent or his substitute that receives us. They are also the ones that imprison anyone who commits a crime.

Martha Gómez, Yochib

In each area we choose an agent and a substitute for him. We also choose committees for roads, safe water, electricity, and education. The men chosen for these positions have to accept the duty whether they like it or not. If they refuse, they go to jail. This is not paid work. For instance, when a man who is not in the meeting is elected, the committee waits until he returns to give him his charge. When a man is working outside the community, then the committee takes this into account [and waits] for another occasion [to elect him]. But one way or another, every man in the community is going to do this work one day.

For a man of the community to be elected, he needs to be kind, speak correctly, know how to listen, and not lose his temper. If a man wants to be on the committee, first he has to be an agent. After having completed his three-year term, he can't be elected to the committee again.

When men get older, they are candidates to be *principales*. This is a position for those with experience, who know the community efforts made previously. Their function is to guide the people and the committee to resolve the problems of the community. For instance, when there is a party in the community, first the committee has to ask the principal which days are available.

The work of the principales has no time limit; they can occupy that position until they die. Some are so old that they can't walk any more, and those ones may be asked to resign from their position. This also is unpaid work. When there is a problem, we have to go to the authorities to make a complaint and explain the harm that has been done to us.

We have to go to the committee that corresponds to our area, where they will hear whatever our complaint is, whether it be about a fight or about a man who's going to leave his wife. People first have to describe the problem. For example, if a woman comes to complain that her husband beats her or has another woman, she can ask the authorities to put him in jail. Then the assistants of the agent go to look for the husband, and they ask the woman how many days she wants her husband to be in prison: two days, three days? And so the wife says how many days and the agent complies.

There are two jails in the community. When a person is imprisoned to pay for a misdeed, the relatives take care of him or her. For instance, men that drink *pox* [a very strong alcoholic drink] can't recover because they drink every day. Sometimes they turn up dead; in that case, the authorities gather the men who drank with him and bring them to jail together in order to find out who had been drinking with him and for how many days, and who saw him before he died.

Even though they didn't kill him, the drinking friends have to pay a fine that consists of burying him and paying the costs.

There are also conflicts that the authorities cannot solve; for example, when a woman wants a divorce and she tells the agent that she no longer wants to live with her husband. In these cases the agent can do nothing, so he sends the woman to the judge in Oxchuc, the municipal seat.

If someone kills another person, the agent has no authority over that crime, the criminal has to go to Oxchuc. If two men have fought but regret it, and don't want to pay the fine, they have to deal with the problem [appeal the fine] in the municipal seat.

There is a payment to each agency or delegation called *Stojol mesa* [payment to the board]. Every time we go to the agency and report something, we have to pay the agent that is working at his table a certain amount of money. We pay about 100 or 150 pesos, depending on what the agent asks for.

Now the ch'abajel, that's when we have to buy one or two cases of refrescos. We all drink them together, the agent, those who work with him, and the people who have come to complain or report a crime.

María López, Bayalemó

The agent has his *mayol*, policeman. If a man or a youth does something wrong, the wronged parties go to the agency and report what happened and ask that they require the man to come to the agency so that the problem can be resolved. The agent and his mayoles solve the problem.

The mayoles go to look for the offender at his house or at work and take him to the agency, which is always at the school. Then the agent together with the mayoles and the counselors interrogate the person

who committed the offense. If they find out that the offender actually did something bad and he doesn't confess, he is put in jail. If the misdemeanor is a serious one, he pays a fine and that resolves it. Many times the agent just wants the person to pay the fine, and after it is paid, the offender is freed.

With the money from fines, they pay the mayoles for their time, and they also buy batteries for flashlights so that they can walk during the night.

When there is a serious problem and it happens during the night, the mayoles have to go out no matter what time it is, and they spend the whole night there and resolve the conflict at dawn.

We don't know exactly what is all this money used for because the men have the responsibility; the women do not participate.

Magdalena López, Bayalemó

Every community has its own school, and that is where the authorities meet. The position of the agent is the most important one and it lasts one year. The agent is in charge of the school and solves the problems of the community. There is an agent, a substitute, and the counselors, some of whom are mayoles and also messengers. If someone does something wrong, the mayoles arrest the offender in his or her house and take this person to the authorities.

When the authorities collect the fines, a part of that money is for the school. At least, that's what my husband told me, because he was once agent of our community. He says that neither the agent nor the counselors receive the money; the money is used to benefit all the area. They use it in cooperation.

When a woman does something wrong, she is taken to the authorities and put in jail. Women as well as men are imprisoned. If the problem can be solved by the authorities, they do it; but if it is serious, they turn to the municipality [the county seat]. The mayoles take the person to the municipality and the judges take charge of the problem. The process is that the judges determine if the punishment will be a fine, and the amount of it, or if it will be imprisonment.

There is also a committee in the school that works together with the teachers to make decisions about the students and help them with any problems they may have. The teachers are the ones responsible for calling the authorities if there is a matter to be resolved.

We chose the Zapatista Autonomous Council because we want a different life; we want a different authority than the federal government; we want something different than the PRI. We would like to change the way of life of our communities. We are very poor and we have nothing, that's why we choose our own authorities.

I believe that if we hadn't struggled, the people of the PRI would have won the municipal elections. They couldn't! In spite of the presence of PRI security officers, we expelled them from the municipal agency. Now, we just hope that one day we will take possession of the National Palace in Mexico City. When we change the president of the Republic of Mexico, then little by little the rest will change.

It's difficult for people to accept positions of authority in the community because it's unpaid work; no one supports them economically and like the Autonomous Council, they don't have a schedule; they have to be available at any time. Sometimes they don't even have time to sow their milpa.

Sometimes, when the authorities go home to eat, they have people from the community waiting for them outside [their homes]. They never have enough time.

María Gómez, Yochib

There is another position for a man, the administrator. To hold this position he has to be from the community and he has to be in the Cabecera Municipality of Oxchuc. This is a paid position. Because people want to earn money, there is competition for this work.

María Luisa Ruiz, Oventik Chico

In the municipal seat of San Andrés, the students under eighteen, usually men, lie about their age and say they are of legal age in order to vote. This way, the candidate for the elections has more people to vote for

San Cristóbal street, 1977. Photo by Joan Ablon.

him. At least that's what I have heard, and it happened in the last elections. It wasn't so long ago.

COMMUNITY ORGANIZATION

> When there are differences and the problems can't be solved, the
> community divides and people establish their own areas.

Martha Gómez, Yochib

Every community has its own school and authorities. When there are differences and the problems can't be solved, the community divides and people establish their own areas. They have to manage their own projects to construct schools, roads, and everything that is needed.

That happened in Yochib, where there are three different areas: the Yochib plaza and Che'n Tsu'ib are the small areas, and the biggest one, where the school is located, is called Emiliano Zapata.

Many people who had left and created their own area returned to the community, because managing their area on their own was too much work; so they returned to the larger community. Because they were the ones who decided to leave, they have to pay a fine of several boxes of refrescos for the people and authorities of the community.

Magdalena López, Bayalemó

In the communities, it's usual that even though they are from different political parties, the area committees meet in the school in order to solve the problems of the areas. Even though there are always critics, they continue to meet to solve the problems.

The PRD and the PRI each have their own agents; thus there are two agents in the area. The PAN doesn't yet have an agent, so they are allied to the PRD for the moment.

Pascuala Patishtán, Bautista Chico

In my community there are two political parties: the PRI and the PRD. All the children go to the same school, so among ourselves we solve the problems. There are no divisions in my community, we are all together.

Before they didn't respect us, they didn't want the children of *creyentes* [Catholic Word of God believers] to study in the same school. The creyentes didn't make an issue of it and, thanks to that, we returned to unity.

Petrona Méndez, Yochib

In the communities* there are several government programs to help people. For instance, there is one to support old people who can't work

*Editors' Note: Because Jolom Mayaetik is a cooperative that encompasses numerous communities, different types of local governments are found in these testimonies, from autonomous municipalities to communities that receive support from the government. We would like to emphasize that the testimonies are individual voices and are not representative of the cooperative. It is also important to emphasize that the majority of the interviews were carried out between 2002 and 2004, and there have been changes in subsequent years that are not recounted in this book.

anymore. Of the money that is provided, the old people only receive a part; the rest stays with the municipal presidency; the same with women as well. That is a national program; old people are supported in all the states of Mexico. It's not a program managed by the governor or the municipal president as they say [it is]; but they say it so that the people are grateful to them.

There is also the PROGRESA, a national program that during the presidency of Vicente Fox was called Opportunities. That [program] is to support women with school-age children to be used for health examinations.

Sometimes parents oblige their children to continue studying so that they receive the money from the government. They pressure teachers so that they don't suspend their sons and daughters and they can still have the scholarships. In the end, to avoid problems with the parents and the community, the teachers let the students pass even if they don't know how to read or write. Everything is very bad.

THE PARTICIPATION OF WOMEN

> I don't think a man would accept making the tortillas at home while his wife goes to work at the presidency. That's why there aren't many women participating in politics.

Micaela Pérez, Bayalemó

Only men participate in the presidency, but they sometimes collaborate with their wives because they can't handle all the work on their own. But only the men choose the officials.

Manuela Hernández, Tzutzbén

Women don't take part in politics because traditionally these positions have been occupied by men. If from the beginning this had been women's work, men would never have taken part. We don't mix men and women

in areas of responsibility; that has long been our custom, and that's why they don't elect women. It's impossible that they would accept women because the men think that women don't have the knowledge and they have to care for their children and chickens.

Francisca Pérez, Chichelalhó

I agree with Manuela, it's true that women don't work. In this council only men participate; it cannot happen that women accept a position and men stay at home. This has never been our custom. Besides, women have much work to do and it's not the same with men. I don't think a man would accept making the tortillas at home while his wife goes to work at the presidency. That's why there aren't many women participating in politics.

María López, Oventik Grande

It's that women have a lot of work to do at home. That's why the [local government] is composed of men only and has long been so.

Pascuala Patishtán, Bautista Chico

They say that men know more—although in my community it's not like that. But I have seen the *priístas* [members of the PRI party]: men go wherever they want; they go where there are problems, where a murder has taken place; they dare to arrest a criminal. I don't think that women are capable of that. I don't believe that it would be good if there were women as officials, because men work until midnight and they also work during the weekends. That's not good.

María Luisa Ruiz, Oventik Chico

Women don't take part in politics because they stay at home.

Martha Gómez, Yochib

The women don't have positions of authority, only the men. It has been this way for a long time. An official works with his wife, but the woman has no position.

Celia Sántiz, Bayalemó

It would be good for women to participate in politics. However, the councilor, the assistants, the president, and the judge—who are all men— would not accept a woman among them, and neither would the wives of these officials.

Juana Jiménez, Bautista Chico

It would be very difficult for a woman to be president and be surrounded by men. But if all were women—the councilor, the assistants, and the judge—then it would work well.

María Gómez, Yochib

In my community there are many women who struggle to be given some kind of work in the presidency. However, they are not elected by the community in the assemblies; only men are nominated for those positions.

Zoila Sántiz, Yochib

In my community there is a woman campaigning to be municipal president. She has the support of a lot of people because she gives presents like blankets, pots, and other things. People say that it would be better if she is the president because she gives lots of presents. What I hear within the community is that she is going to win because she is a kindhearted woman, but the reality is that she is going to win because of all the gifts she gives.

Pascuala Patishtán, Bautista Chico

The government committees are composed of men only. Women don't participate.

If a person commits an offense we don't have to wait for the municipality to act and solve it. Here in this area, the committee resolves the problem. If the problem is very serious, they call an assembly.

María López, Bayalemó

The only thing women participate in is the kindergarten. The kindergarten receives school breakfasts from the government, and there are six women in charge of [this program]. Their position lasts one year, and they all take part in an assembly to choose the women who will carry on the responsibility. Men don't participate in this assembly.

Women invite the mothers of the children when it's time to choose new women for the positions. This is the only position that women can have in our community.

I don't think that women should have another political position in the community because it would be viewed as bad. We can't work together with men because they would speak negatively about us, and they would get angry and be jealous. That's why women don't accept any position in the church; when the catechist invites us, we don't go. There have been experiments with other women and girls, and they didn't last long. Sometimes the meetings lasted into the night, and husbands got angry and didn't want them to continue in the position. Women can't occupy positions of authority because men put obstacles in their way.

Rosa González, Jolxic

I see well that men are the ones who take part in politics.

Magdalena López, Bayalemó

It's clear to me that there should be rights for women and they should have responsibilities in the area. It seems to me very good that this

should be. The problem is that from our grandparents' time, women haven't participated in politics. If women were given our rights, we would help solve the social problems of our community, no less than men do. Women have minds and hearts. But women aren't permitted to bear important public responsibilities, just the simple ones. To wait for a woman to become an agent is difficult; the candidates are only men, they forget about us.

If there were women who participated in governing, it would be viewed well by the community, but the husbands don't give them an opportunity. It's very sad that in the indigenous communities women can't have a political position when mestiza women do have public responsibilities. We poor women are trampled on.

Magdalena López, Bayalemó

The majority of men in the community don't let their wives take part in anything—not in the school, not in the church, nothing. There are a few men who let their wives do something. This is the situation; women are not taken into account. In the meetings held at the school, the authorities never mention that a woman could work, and so is it in all the areas.

A woman could be an official, express an opinion, make decisions. The problem is that we are not accustomed to do it.

It would be good if a woman bore a public responsibility, because that's the way to demonstrate that women are worthy, that they shouldn't spend all their lives at home. In the past women weren't taken into account. They had to stay at home all their lives; they couldn't express their opinions. The men considered only themselves to be serious.

When a woman spoke, the man silenced her and said, "You are a woman, you know nothing; I know because I am a man."

Men have felt superior to women for a long time. We hope that there will be equality between men and women one day. It would be very good to see women also have responsibilities, for men to take us into account. That would demonstrate that a woman has great value. We don't take part in anything. When they choose new agents, we don't participate, only men attend the meeting.

Cecilia López, Bayalemó

In the past women couldn't participate in anything. Nowadays, with the [EZLN] Autonomous Councils, men, women, and children can participate in all the assemblies that take place.

PROBLEMS IN THE COMMUNITY

One of the biggest problems that affects the communities is that the government offers their national programs PROGRESA and PROCAMPO to some people but not to everyone.

Zoila Sántiz, Yochib

The problems in the community are due to people making changes without consulting the authorities. They make paths, or divert water from the pipes to their houses, or they even move the boundary markers of their lands; they disagree over the boundaries of their lands. It has happened that some have knocked down the boundary wall, but this is always punished with jail time. There are men who don't want their lands touched, and if a boundary wall is knocked down, they go to talk to the agent instead of talking to the community. The agent sends a document to the judge, explaining the problem. Another problem the community has is with teachers; if they don't work, the community has to decide whether to send them away.

Francisca Pérez, Chichelalhó

Not too long ago the priest of the locality of Jolnachoj told us that ten women had recently died from AIDS, and that soon other infected women would die too. Many of these women are married and they infect their husbands; there are even babies born with AIDS. Women get infected because they become prostitutes; they sell their bodies to soldiers, and that's why many of them are dying. The priístas asked for soldiers to be [sent to] the community, but now women are dying. People of the

community are collecting signatures to take to the government to show that they don't want soldiers in the community. Many women of the community are forced to have sex by soldiers who threaten them with death; the autonomous officials can't do anything because the soldiers belong to the PRI.

Cecilia López, Bayalemó

One of the problems in the community is the presence of the soldiers. Many women have died of AIDS. Because they had no money to buy food, soap, chile, and salt, they submitted to having sex with the soldiers and ended up infected with AIDS. This has caused suffering in the community, and is why the people began the struggle [EZLN resistance]. We have expelled some soldiers from the community but it's a very difficult thing to do.

Ernestina López, Bayalemó

One of the biggest problems that affects the communities is that the government offers their national programs PROGRESA and PROCAMPO to some people but not to everyone. That's when the division began, because some are chosen to participate in the programs and others are not. And even though there are men and women in indigenous organizations, they leave them because they prefer that the government give them money, even though it's not enough for their daily life.

María Luisa Ruiz, Oventik Chico

Women receive the national program PROGRESA, and they have to go to medical practices where they get medicines or herbs. They have to go to the doctor once a month. Some of these women have declared that after going to the doctor they haven't been able to get pregnant anymore.

Another problem we have in the community is that there is no work. Many people go far to look for work—they go to Tijuana, Sonora, Cancún, or the United States; above all the young people, not so much the adults.

Many of those who leave to look for work, who go far away, convince the others to leave; they tell them, "There, there is money; you can earn good money."

Martina Hernández, Tzutzbén

A women said that after she began to take the government medicines not only did her pain not get better, but after taking those pills she wasn't able to deliver her babies naturally anymore. She doesn't know what these medicines did to her body, but she had to have an operation.

Petrona Méndez, Yochib

Thus are the programs of the government! No one comes to our house to explain the programs, they just give us the money and tell women they have to go to the doctor. If they do so, they get a scholarship for their children. But no one explains the benefits and conditions of the program. They also have to attend scheduled meetings, and if they don't go, the money stops. That's why women obey, for the money; because they don't have another way to earn money.

Magdalena López, Bayalemó

The areas of the community are divided, sometimes because of [different] religions, and other times because of political parties. There are many political parties: PRD, PRI, and PAN. There is no unity among the different areas of the community.

That's why we don't have a peaceful life in the community; the different groups begin conflicts, and each one defends its party.

Today everything is in disorder. When I was young there was only the PRI, so people were active in that party. Nowadays the community is divided because there are other political parties. Many times even though we are neighbors we have differences [of opinion] because we belong to different parties. This disunity is worsening our lives.

Another problem is the military. Although the people have tried to expel them, we have not succeeded. People from Jolnachoj are always

asking that the soldiers leave their community, but it's very difficult [to expel them].

Many of the families from Jolnachoj are part of the [EZLN] autonomous government, and they say that there are many young women who want to have sex with men from the community to infect them with AIDS. In San Cayetano there are men and women infected with AIDS.

Manuela Hernández, Tzutzbén

The community of Tzutzbén is divided; there are two political parties: PRI and PRD. When the parties meet, they do it separately. The community is totally divided; we don't have good relations among us.

The division is because the PRD didn't pay the electricity and members of the PRI created their own agency but the PRD stayed with the old one. They are not able to come to an agreement.

People from the PRI control the school, and the children of the PRD members are not allowed to attend that school; they have to go to the municipal school. Members of the PRI have two schools in Tzutzbén, one next to the agency of the authorities and another one next to the road.

This happened not so long ago. It happened because people divided themselves, some joining the PRD, others the Zapatistas, others the PRI. Now no one understands the others; Before, it wasn't like this; each [group] had meetings. If the agents had matters to resolve, each would resolve them with their people. The situation is very difficult.

Micaela Pérez, Bayalemó

The government offers programs like PROGRESA to women, and they accept them. What is bad is that they are injected with a medicine—I don't know what type of medicine—but if they don't accept it they don't get money from the government.

Magdalena López, Bayalemó

Nowadays, life has changed. Many youths and adults leave the community to look for work. I don't know if this is the case only here where we live; the people learned to look for work in Cancún, Tijuana, Mexico City, or the United States.

One or two set the example, and the others follow them. It's not that they don't have anything to eat; the thing is that they want money, and that's why they go looking for work. In the past it wasn't like that. People worked as day laborers, but nearby in the haciendas. They looked for work nearby in the coffee plantations, in Plátanos or in Tijera, or they went to other plantations to make a little money.

Today, they leave for other places. Buses come to the communities to take people to work in the grape harvest in Sonora. It's sad because they go and come back without money. Some adapt to life there but others don't. If they don't get used to it, they aren't going to suffer anymore [so they come back without completing the work].

If the man has a wife, she has to stay in the community, although there are girls that also leave to look for work.

There are many men who have coffee lands, but they also go out to look for work in other places. For instance, San Cayetano is a coffee-growing area but many men leave from there to look for work.

In the past, people were satisfied with corn and beans, and they filled their bellies; now it's no longer so.

The preferred place of the men who leave to look for work is Tijuana. A couple of months ago three young men of the community left for Tijuana, two of them single and the other one married. The married one had to leave his wife here in the community. They could hardly repay the loan for the trip to Tijuana, and in the end they didn't make money at all. After a while, they came back to the community. They say that they had to spend the money that they earned on the bus ticket home. I think that this is true, because they don't buy anything.

There are some men who go, stay for two or three years, then come back with their families.

Pascuala Patishtán, Bautista Chico

Recently, two officials from my community left because they saw that they couldn't solve the problems of the community. They left for the United States to look for work; they say that their wives remained [here] alone.

The men in my community go to look for work in Cancún, Tabasco, or Coatzacoalcos; not everyone dares to go to the United States.

One of our artisan partners of the cooperative went to the United States to look for work. She earned money here, but she wanted to earn more money so she went, and she never returned. They say that she lost her life. This happened three years ago. She tried to cross the border with her brother and she died for lack of water. It's not common that women go to the United States; most of them go to Villahermosa and Cancún.

A man from the community went to the United States to work. He didn't lack food to eat, but he wanted more money. They say that he bought a car and is going to return soon. This man sends money to his family; his wife no longer has financial problems, and even their children have money and mobile phones. What people look for is just money.

WOMEN AND EDUCATION

I wanted to continue studying, but my mother believed that the only reason I wanted to go to school was to find a husband.

Celia Sántiz, Bayalemó

When I was a child there were no schools in Bayalemó, so we went to the school in the community of Tres Puentes, where I studied until our community asked for a school in Bayalemó. I then went to school in Bayalemó and finished primary school [sixth grade], but I hardly learned to read, and I didn't learn to speak Spanish. I learned a little math, to add and subtract, but I couldn't continue studying because my father didn't have money to pay for it, so I just finished primary school.

Today, the schools are well constructed, but when I began to study, the schools were made of adobe and straw with earth floors. Now the schools have improved. They even have chairs to sit on.

The classes began at 9:00 in the morning, provided that the teacher came; if not, we just played. At 11:30 we had a break, then we returned to class at 12:00, and the classes were over at 2:00 in the afternoon.

They gave us books for mathematics and Spanish, also workbooks. I believe we had only those three books, no more. Nowadays the students have more books; when I studied we only had those books. They taught me to read a little; to add, subtract, multiply, and divide; and nothing more. Girls didn't go out to the playground. Now, the girls play outside the same as boys do. In the community of Bayalemó, the teachers didn't come on Monday, they usually came on Tuesday or even Wednesday, and then they didn't teach us well; that is why I didn't learn anything. It's as if I hadn't gone to school.

María Gómez, Yochib

I was allowed to go to school when I was young, my mother didn't object; but I didn't want to go. I ran away because I didn't want to go to school. I was afraid of the teachers, and I didn't want to go to school because I didn't like the classes.

I now realize it was a bad decision that I made, because I don't know how to read or write. When I see the letters they don't mean anything to me, I don't know what they say. I don't know how the books speak.

There are teachers who don't teach their students; they don't give classes all day, they only drink, so students don't learn as they should. This happens in the primary school, but we haven't heard of teachers who are drunk in the secondary school. There, they do teach properly. I know that because my daughters study there.

The secondary-school teachers are mestizos; the ones who drink are *lumaltik* [indigenous], and they speak in Tzeltal.

The people in the community don't say anything; they wait a while. Then they meet and decide what to do with drunkard teachers. If the [teachers] give up drinking and teach properly, they are forgiven; but

if they continue drinking, they are suspended from their work and removed.

Sometimes the children just go play on the playground when their teacher is drunk. However, it's important to say that not all the teachers are drunkards; there are also good teachers who teach the children properly.

Guadalupe Sántiz, Yochib

Things have changed a lot. In the past, only men went to school. Nowadays, both men and women can go to school.

My primary teacher didn't explain well what we saw in our books. Classes were held from Monday to Friday, but sometimes we didn't have class on Fridays. I think that the teachers didn't come because they had meetings or because it was payday. Our teachers in primary school taught in Tzeltal, but in secondary school [instruction is] only in Spanish.

The secondary-school teachers came to school from Monday to Friday all year. The teachers we had taught in Spanish only, because they didn't know Tzeltal. Even though they explained things well, it was difficult for us to understand because we didn't know Spanish very well. Although sometimes it was difficult to learn, it was best to have the classes in Spanish so that we could learn the language.

Martha Gómez, Yochib

When I studied, I remember there was much discipline; they even hit us. The teachers wanted us to learn. I think it was good that we were a little bit afraid of the teacher.

When I began to study in the first grade of primary school the teacher always hit us. She found a stick to hit us with if we hadn't done the homework or we didn't want to go up to the blackboard. When we didn't want to read, we had to kneel on stones. She said it was good that we were afraid of punishment because this way we would learn what she taught us and we would continue studying. And in this way, I completed the sixth grade, with teachers who were disciplinarians. But I think it was best that

Celebrating Yochib High School graduation, 2016. Photo by Charlene M. Woodcock.

way. They taught us and on occasion struck us so that we would learn to read and write.

Today, things are worse. I have noticed that teachers don't come to school every day; there are weeks when they give classes on only one or two days, and our children are getting used to not having classes every day. That is bad, because they are not learning what they should.

The teachers teach in Spanish and very little in Batsi' k'op [Tzeltal]; the children hardly understand Spanish, and only a few begin to learn two or three words but nothing more.

That's how the teachers of this community work: they don't come every day, they don't teach well, they arrive drunk, and this year I'd guess that fewer have worked.

One would think that each group has its teachers but, for example, the first-, second- and third-grade teachers came on Monday; and the fourth-, fifth-, and sixth-grade teachers came on Tuesday. Therefore,

children get used to not going to school. On one occasion the community met and told the teachers they had to work as they should, that they would be held responsible. The teachers were told to teach children some Spanish and not to teach only in Tzeltal because the [children] couldn't understand their books. The books are written in Spanish. Even though the people spoke firmly to the teachers, it seems they didn't understand.

Here in Yochib there are primary and secondary schools and a televised secondary school program.

When I was young there was no secondary school. That's why I didn't continue studying after sixth grade. There were secondary schools in San Cristóbal and Oxchuc, but one needed money to go to a different place to study. My parents didn't have enough money, and the little money they had they spent on taking care of the youngest children.

I learned to dance at school, because when you were obedient and read well, you were given the right to participate in dance class and poetry reading. I liked to take part in everything. I was also chosen to carry the flag on Mondays, the day to salute the flag. I was chosen to carry the flag for two years, in fifth and sixth grades.

The bad thing about my school years was that we didn't have enough money to buy pencils and notebooks. Although my father made the effort to buy them for us, if we lost them he hit us and scolded us: "What did you do with the pencil? I just bought it."

During that period it was difficult for parents to send their children to school, especially if they were very poor. In the past there was no support from the government for students so that they could have school supplies.

I never ran away from school because I loved to learn and was happy in school. I wasn't afraid the teachers would scold me; I liked the classes very much. There were school benches for two students, but in my school we had to sit three students per bench. We were always pushing one another off the bench. If one of our bench mates made us angry, we pinched her or pushed her off the bench. It's better now because children have their own chairs.

I think it's good that there are scholarships for children who want to study, but it's important that they put their heart and will into what they

do, because they need notebooks and other materials that cost a lot of money.

I see there are many young men and women who want to study. They are the ones who should be supported with scholarships, because there are others who leave to get married and no longer want to study. Some of them even get pregnant while they are studying at school! I think it's a waste of time and money; they were given the opportunity to study, and they didn't take it.

I would love to continue studying. Not so long ago we were told that we could have classes during the afternoons, but the teachers don't want us to bring our younger children with us.

At school they treated us the same, women and men. If a child didn't know the answer to the question, he or she was scolded and slapped. Teachers didn't choose who to slap [boys or girls]. I remember a teacher who paid more attention to the boys and said, "Why didn't you do your homework? You have less work than the girls; you don't have to carry water like they do, and still you don't do your homework! Where is your head? I'm sure that you don't even help at home, you just go out and play!" I believe the punishments were stronger for the boys.

Petrona Sántiz, Yochib

I finished the sixth grade, and I didn't continue studying because my parents didn't let me do it. I finished primary school just when the secondary school opened in Yochib. I wanted to continue studying, but my mother believed that the only reason I wanted to go to school was to find a husband—and besides, I would need money.

I thought, "Perhaps she's right." And since I didn't know how to think for myself very well, I thought that she made that decision for my own good. But I suffered because I couldn't go to school, I still remember.

When we finished sixth grade, we were very young and we didn't know how to think very well. We didn't know what was best for us; we thought that studying was not important, that it wouldn't benefit us. But later we realized how wrong we were, that it is useful to study.

If I had continued studying I wouldn't be here today. I have seen people leave this community as teachers with secure work, but those of us

who didn't study suffer because we have no way to make a living. Then I think, "I wouldn't be in this situation if I had continued studying." I feel sad because I could have studied and I didn't do it. Not everything is laughter and happiness in this life. It was because I was young, I didn't know that this would have a large effect on my life. The situation of men is very different because from the time they are small they leave the community; they travel to other places to look for work, and there they learn Spanish and other things. For example, I have three brothers and they all speak Spanish. We women cannot compare our situation to theirs because we are always confined at home. In our community, it is the men who speak more Spanish than the women.

The problem with sending children to school is the cost. My parents weren't able to buy the things we needed: pencils, notebooks, and pens. When they bought us a notebook it had to last a year and we had to take care of it. If we lost it, our parents didn't buy us another one. Now there is support for the children who study; they are given notebooks and pencils. There are scholarships. Now it's up to them whether they work and pay attention in classes or not. They live in better times than ours. I don't know why they don't take advantage of this opportunity and behave well. Now we see how they go to secondary school and get pregnant, because they don't want to study.

Pascuala Pérez, Yochib

Men are free to go to other places to look for work and other opportunities. There are men who didn't go to school; [they] leave the community looking for work in other places, where they learn even though they haven't been to school.

Zoila Sántiz, Yochib

I finished sixth grade because I had good teachers; they gave me classes. I understood what they taught us, I did well every year; I was never reprimanded.

Now there is support for our children to go to school, so that they will learn to read and write. I believe the community thinks it's better to sup-

port the children, because there are children who like to go to school, who feel happy to go to another place to learn new things. It's [the case] that if they are paid for the school day, the parents don't feel they are losing a day's work from their children.

The problem is that some children aren't very interested in going to school, but the parents require them to go because of the money they receive. The money that the parents receive from the scholarship benefits the parents, and they spend it on things not related to schooling.

In my community there was a teacher who didn't teach his classes, who slept in the teacher's lounge. He was my son's teacher, and my son didn't learn anything. The teacher didn't drink, but they say he had an automobile accident and his car went over a cliff. Since then, he has been not been well and always sleeps in the teacher's lounge. Several times the parents of the students went to school and said, "What's going on, teacher? Get up." Then he woke up, all confused. The parents said it was a problem for the committee to deal with, and the committee told the director of the school, and the teacher left after a replacement was sent. That's the custom in our community; if there are teachers who drink or treat the students badly, they are removed from the school.

Martina Hernández, Tzutzbén

In the past, only men could go to school, but today both men and women can go. But still today some parents don't allow their daughters to go to secondary school. In my family there is no woman who has finished her [secondary] studies. In the community I don't know anyone [who has] either. Maybe there is someone, but if so I guess she got married and stayed to live in the city where she studied.

María Luisa Ruiz, Oventik Chico

Many women want to go to school but their parents don't allow it. "Why do you want to go to school? You're only going to look for a husband." "It's useless to study; you're only going to look for a boyfriend." It depends on the thinking of each person.

It's very unusual for a woman to finish secondary school. It's the men who look for work after they finish secondary school. Many of them become teachers as part of the CONAFE [National Council for Educational Development]. They do social service for two years, and then they become professional teachers. I know of some women who became teachers, but they are very few.

When I finished secondary school I didn't want to continue in the college preparatory school. It was very difficult for me because I had to go to school at night and I was afraid of walking alone. It was difficult for me to study because the teachers gave us a lot of homework, and I didn't have enough time to do it because I had to work as well. What I liked most was to learn Spanish better.

Rosalinda Sántiz, Bayalemó

When I was a child, there was a school in Bayalemó and I studied there. The problem was that for four years I had monolingual teachers who behaved very badly toward us. They scolded and beat us, and shouted at us. They passed us from first to second grade even though we hadn't learned anything. The education at that time was very bad, and the parents had to meet to request bilingual teachers. They asked the officials of the community to remove all those teachers from our school. The new teachers that arrived spoke Tzotzil, but they spoke to us most of the time in Spanish and we couldn't understand what they were saying. All the books were in Spanish, and we couldn't learn readily to speak in Spanish.

There is a little difference between the monolingual and bilingual teachers; the latter are a little better teachers. For example, when Celia, who belonged to the previous generation of students, was in school, the teachers didn't come, or if they came, they were very late or came only two or three times a week. They didn't teach, they just scolded and told students that they didn't know anything and were very stupid. But it was the teachers' fault because they didn't teach properly. Teachers made fun of us; they were very rude. The school introduced hygiene for students; if we arrived dirty we had to take a bath at school.

When we completed sixth grade, we scarcely knew reading and writing and didn't understand the books. I believe that now there is some material in Tzotzil in the textbooks, although it's not enough, because few children learn to write in Tzotzil.

When I was a student, there was no secondary school in Bayalemó. If we wanted to continue studying, we had to go to another town where there was a secondary school, so it was very difficult to study.

I studied for a bachelor's degree and took a technical course in public health. I would like to study medicine, but I don't know if it's going to be possible. For indigenous women like myself, it's still difficult because we don't have the opportunity to continue studying. There are few indigenous women who study at the university; the majority of them fail or get married. It is very sad because it's time and money lost.

Petrona López, Bayalemó

When I lived in the community I studied, but I left school when I came to live in San Cristóbal to work and train myself in the cooperative.

Verónica Gómez, Jolxic

In our community we have a school, but not everyone finishes there; some transfer to the [school at the] municipal seat of Chenalhó. When I was a student, the school was adobe. Even though I finished primary school, I didn't learn anything. I am not able to speak Spanish because we learned just a few letters. I don't know if it was because the teachers were not very good or because I didn't have enough interest in learning.

THE SPANISH THAT WE LEARN

The women of the community who don't know how to speak Spanish are marginalized and feel bad. This is discrimination.

Petrona Méndez, Yochib

I didn't learn Spanish because my teacher never spoke a word in Spanish, or perhaps he did occasionally speak a few, but I've forgotten them.

I finished sixth grade without knowing how to speak Spanish. I do understand some words now but I am not able to converse and sometimes there are words I don't understand.

People of the community learn Spanish when they go to look for work in other places where Spanish is spoken. Thus, little by little, one begins to understand. Since I didn't go out looking for work, I don't understand more than a few words. Today, young men and women speak good Spanish, because they went to San Cristóbal, Tuxtla, or other places farther away.

We also learn Spanish when we listen to others speaking it, or when we have a television and hear it all the time.

The majority of men and women who live in the community don't know how to speak Spanish; for that reason we feel that we're not treated properly.

When we go to the clinic, the doctors don't know our language, so sometimes they think they can't treat us, and we don't understand their language. But those people who know Spanish can explain to the doctors how they feel, if they have pain or whatever other [ailment]; to these people they do give medicines.

Juana Gómez, Yochib

Many of us would like to learn Spanish. When someone speaks to us in Spanish, we don't answer because we don't understand what that person is saying; we don't know enough words in Spanish. We always suffer because we don't know how to speak it. One reason why we didn't learn Spanish was that our parents didn't let us go to school or to other places

to look for work. That happened to me; I wanted to go to San Cristóbal and I couldn't.

Sometimes when a mestiza woman wants to talk with me I can't because I don't know how to answer her.

When I go to the doctor, I explain what I feel, but they don't understand me and I don't understand what they say. That's why it's a bad thing not to know Spanish. The best thing would be to know how to speak both languages, Tzeltal and Spanish.

Martha Gómez, Yochib

When I started school I didn't know Spanish, I just knew a few words. Even though my teacher spoke in Spanish I didn't learn much. The little Spanish that I know today I learned in San Cristóbal, where I tried to continue studying in secondary school. I looked for work, but only for a short time because my father came and took me back to our community.

There are people who leave the community for two or three years, and when they come back they say that they have already forgotten Tzeltal. That's what they say, but I believe that they think they [have become] a different person. They speak Spanish all the time; if they encounter elders of the community, they don't salute them because they say that they don't know Tzeltal anymore. Indeed, they do know Tzeltal but they don't want to speak it; they feel superior because they know Spanish. Both men and women do this, but it's more [often] the men. It makes me want to smack them, because instead of helping us to learn Spanish, they make us feel bad. For instance, when we go to the clinic they could help us and translate what we say to the doctors, but they don't do it. Instead they speak in Spanish with the doctor just to show us that they really know Spanish. Women do this as well; they even sit in front, next to the doctor, so that we can see how they talk.

For me this is bad because it shows they believe they're better than us, but they are indigenous women like us, whether they like it or not. Adult women do this, but the younger ones are worse.

The women of the community who don't know how to speak Spanish are marginalized and feel bad. This is discrimination.

Martina Hernández, Tzutzbén

I dropped out of secondary school because I didn't understand what they said. They spoke in Spanish, and even though they explained the meaning and gave me homework, I didn't know how to do it. I did understand a little bit of Spanish, but everything got confusing when I had to do my homework. For me it is very difficult to learn Spanish; I think it's because I'm stupid. Of course I would like to learn Spanish! But I never learn; maybe if people would speak to me all the time in Spanish it would be easier.

Zoila Sántiz, Yochib

Sometimes the women try to speak a little bit of Spanish, but if women or men who really know it hear us, they make fun of us because we don't speak it properly. They belittle us.

Petrona López, Bayalemó

I would like to be able to speak Spanish properly so that I could answer the questions that people ask me and understand everything. But it takes a lot of work; sometimes I understand what someone says but I don't know how to answer, so I remain silent.

In secondary school I learned a little Spanish, but in primary school I didn't learn any because the teachers spoke only in Tzotzil. It was in the second year of high school that I learned a little bit of Spanish. I could understand what they said, but I wasn't able to answer because there were some words that I didn't understand, and that's still the case. Sometimes I wonder why I dropped out of school. I think about it a lot, and my heart is still there. For me, it's not a problem to learn, provided that they explain things properly. It's difficult nowadays not to know Spanish, and our parents still have no money to help us, because school costs money. Nothing is free.

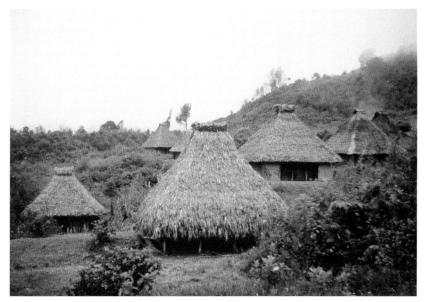

(*above*) Thatched-roof houses, Magdalenas, 1960. Photo by Joan Ablon.

(*below*) Sisters, Tzutzbén, 2010. Photo by Charlene M. Woodcock.

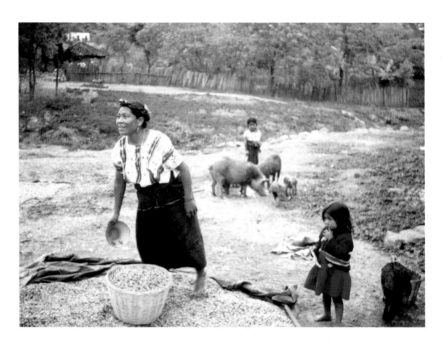

(*above*) Woman
sorting beans,
Pantelhó, 1977.
Photo by Joan
Ablon.

(*right*) Traditional
house, Chenalhó,
1993. Photo by
Joan Ablon.

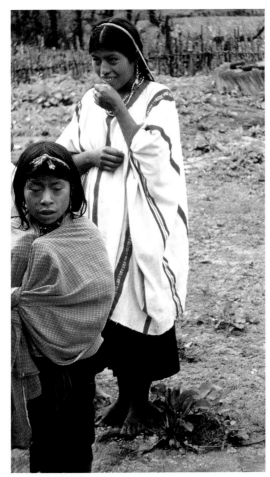

(*left*) Tzeltal woman and girl, 1960. Photo by Joan Ablon.

(*below*) Display of Tzotzil textiles, 1992. Photo by Joan Ablon.

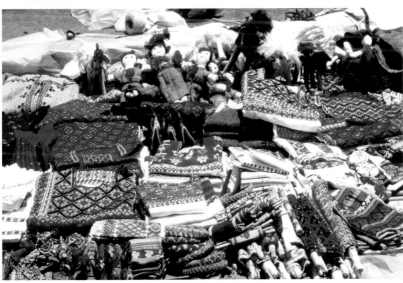

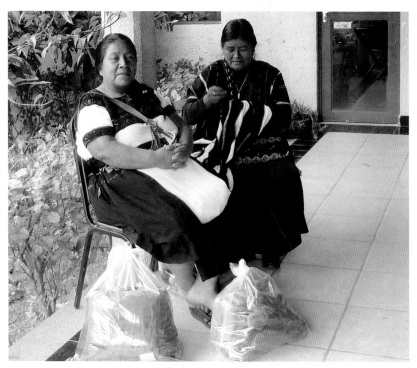

(*above*) Master weavers Magdalena López López and María Gómez López, 2016. Photo by Charlene M. Woodcock.

(*below*) *Muestrario* (sampler tapestry) by Magdalena López López, 2016. Photo by Marla Gutiérrez.

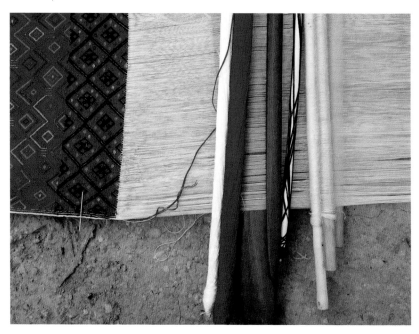

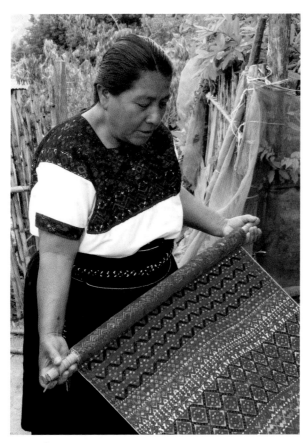

(*above*) Magdalena with muestrario, 2016. Photo by Marla Gutiérrez.

(*below*) Tzeltal huipiles, Yochib, 2016. Photo by Charlene M. Woodcock.

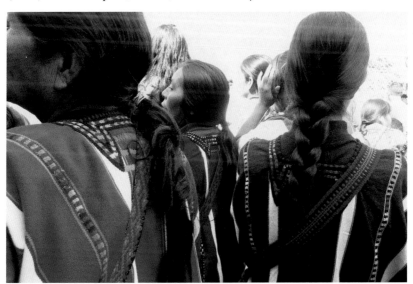

(*above*) Tzeltal family, 2016. Photo by Marla Gutiérrez.

(*right*) Celia Sántiz Ruiz at American Anthropology Association exhibit, 2008. Photo by Bill Woodcock III.

ILLNESS IN THE COMMUNITY

> When a child is born with problems, people in the community don't ask themselves if they can take their baby somewhere to be cured, they simply accept it and give up.

Martha Gómez, Yochib

In the community there is a woman with epilepsy, and sometimes she loses consciousness. She wasn't like that before. Her mother told me that the girl was a healthy baby; but her father drank so much that one day he died of alcoholism. Then the mother of the girl went to the house of her parents-in-law, but because the only heir was the baby girl and not a boy, they threw the woman and the baby girl out of the house.

That happened in the past; if the husband died and his wife didn't have a boy to inherit the land, the husband's parents would throw her out of the family house and leave her with nothing. Women had to return to their parents' house, and sometimes they weren't wanted at home. That happened in this case. "Go back to your house; you have nothing to do here now that my son is dead," said the in-laws, "but you return alone; the girl stays with us." And so they took her daughter. The girl was very young and didn't yet know what was going on. When she was six or seven years old, the grandparents forced her to do the housework as if she were an adult, and if she made a mistake they hit her on the head with a stick, threw her to the floor or against the wall, or kicked her. She was a healthy girl when she was born but with that abuse she began to feel bad. On one occasion, the grandfather came home so drunk that he pulled the little girl out of the bed where she was sleeping and hit her on the head with a stick. The girl got a high fever, and she was sick for two or three weeks. They tried to cure her, but since then she has been sick and cannot breathe well. Her illness came from the blows to the head her grandfather gave her. That's why she developed epilepsy. She was damaged permanently. When her grandparents died she was left homeless; she has nowhere to stay. Sometimes the doctor at the clinic gives her food and clothes and lets her sleep in the corridor. She carries all her little things with her. She suffers a lot, and even though she has relatives

they don't want anything to do with her. When she has convulsions people are afraid because they think she will infect their children. However, there are kindhearted people who give her a little pozol. Some women who go to the clinic bring her beans and tortillas, and in this way she passes her days.

In this area of Yochib it's not only this woman who suffers; there are also young men who are crazy, but it's their fault because they use bad herbs (marijuana). They are not sick, unlike the other woman who is sick. Sometimes she doesn't know where she is going to go; sometimes there are families who let her spend the night at their house.

In some places where this woman asked for a room, people molested her. They say she was sexually abused by some bad-hearted men and she got pregnant. The doctor cared for her during the pregnancy and she delivered a healthy baby boy. They sent it to Ocosingo, where there are families willing to adopt and raise children.

Sometimes when the woman feels good she talks to us. "I remember my son; I didn't want to give my son up for adoption. They deceived me so that I would give him up, and he was the only one who could help me get up when I fainted." she said. But that was the reason why they didn't leave her son with her: because she could drop him in a fall.

Here in the community clinic, the doctors stay just one year and then they leave. Doctor Yadira has already gone. She was the one who took care of the epileptic woman almost all the time; she gave her food, and she even bathed her. She was a very good doctor; it's too bad that she's not still here.

Another problem with the doctors of the clinic is that they don't understand Tzeltal and, like the majority of women in the community, few of us know how to speak Spanish. I think that we need a translator.

The elder women are the ones who always leave the clinic without medications and without knowing what illness they have. If we knew a little bit of Spanish, we could explain what we feel and where we have pain so that they could give us medications. Since most of us don't know Spanish, no matter what illness we have, doctors give us painkillers. The problem in the community is that there are not enough medications for everyone, so not all of us receive them. This is not the doctor's fault but

the government's fault. It's the government that doesn't provide enough medicines for the clinics. The doctors are just workers.

In the clinic there is always a nurse who writes down our name and calls us when it's our turn to talk to the doctor, but she doesn't come in with us to help us explain our illness. We enter alone, and no one translates for us.

In reality the community clinic is not very useful; they can't help us because we don't speak the same language. They don't treat us equally. Sometimes they even forget our appointments so that we have to go twice to the clinic.

María Gómez, Yochib

Apart from that woman who suffers so much, we also have several mute men and women. Some of the men are married and are strong and well regarded; they are people of character, they are not mentally retarded. In the area of Santisetik [where those with the surname Sántiz live], there are two brothers who were born deaf. There are three brothers in the family, and only the oldest one speaks; the other two are mute. Both of the [deaf men] are married and have adult children who speak normally.

I don't know how they talk with their wives, how they ask for food or whatever they need; perhaps with signs. Maybe they courted their wives in sign language.

There is another man in the community who is mute. He is not married, and he is a strong and healthy man who goes everywhere looking for work; he goes to the plantations.

There are many people in the community with eye problems or who don't have arms. Some children were born that way, but we don't know why. There is an old man in the community who has no nose, so his face looks very strange. He was married and he had a daughter with mental illness. Sometimes the girl would go out of the house aimlessly wandering until someone recognized her and told the family where she was. The girl died two years ago; she didn't grow to adulthood. There are many children with cleft lip, and others that were born with extra fingers or toes, or with their hands in a ball.

When a child is born with problems, people in the community don't ask themselves if they can take their baby somewhere to be cured, they simply accept it and give up.

There is a woman who has a son with swollen lips. The woman and her husband look healthy, but the son is not. The woman worries and looks for a doctor to ask what can be done. When the baby was born he had a little ball inside the lip and with time the ball has grown. Some think that children have health problems because we take pills for the flu during our pregnancy or because we have taken contraceptive pills for a long time. We have discussed this with the partero.

The partero is very careful. He asks us if we are pregnant when we are sick, and if so he looks for the appropriate medications. He asks other doctors so that there will be no problems. He has taken courses in other places, so he knows how to do things properly.

In the clinic they don't give us medicine; the doctors give us the prescription, and then we have to buy it at the pharmacy.

A long time ago, I was sick with a fever and went to the clinic, but they didn't give me any medicine. I think they had medicines in the clinic, but they didn't want to give them to me. They decide to whom they will give their medications.

I have been to the clinic several times, and even though I explained to the doctor that I had headache or pain in another part of my body, he couldn't understand me.

Zoila Sántiz, Yochib

The most common sicknesses in the community are fever, diarrhea, cough, and vomiting. It's the little children who have vomiting and diarrhea almost all the time.

They get sick because they don't wash their hands before they eat. And we adults have cough or headache.

Pascuala Pérez, Yochib

Sometimes people get sick; they die and we don't know why.

Rosa Gómez, Yochib

I only go to the doctor when I have an appointment for a vaccination. I don't know exactly what the vaccines are for, but I go because they tell us that it's important for the children. They also tell us the names of the vaccines, but I don't remember them.

When I feel sick I go to the clinic to ask for some medicine. But what medicine are they going to give us? They don't have anything. Sometimes they give us some pills, but only when there is someone at the clinic! The truth is, they don't examine us properly; they simply give us a pill when we have headache. That's all.

HEALERS IN THE COMMUNITY AND THE USE OF HEALING PLANTS

Our fathers had to obey our grandfathers, our grandfathers the elders, and the elders obeyed the healers.

María Gómez, Yochib

I don't know much about *curanderos* [healers], but our grandparents did; in the past people were cured by the religious leaders and the curanderos. In the past there were no medicines so people were treated with herbs. My mother lost four children. She used to say that the herbs didn't work; she only had faith in the curanderos. Some curanderos had the sick person, or a relative as representative, kneel and then hit him with an animal skin.

If a little boy or girl was seriously ill, the curanderos hit them with the animal skin while the parents on their knees confessed their sins. The curandero said to them: "if you don't confess all your sins your child is going to die," so my mother told me. In the past, people were more kind and respectful. Nowadays we don't respect anyone, not even the elders of the community.

Our fathers had to obey our grandfathers, our grandfathers the elders, and the elders obeyed the healers. Those were different times.

My mother knows a lot about the healers because she lived then and four of her children died.

I use some herbs to cure myself. For instance, I use a very bitter plant called *ch'ajk'il* to relieve stomachache and diarrhea.

Martha Gómez, Yochib

I don't go to the healers because I don't believe in these things, but I know other women who have taken their children to them.

When children aren't healed with the modern medicines, it's said that they have a strange illness; an enemy of the family has cast the "the evil eye." In these cases, they take the children to the healers.

Even if I don't have enough money to afford them I prefer modern medicines. I save [money] little by little or sometimes even borrow the money. I have never gone to the healers.

Nevertheless, sometimes I do use some plants to feel better. For example, for stomachache I know several medicinal plants, one called *yacan k'ulub* [*Verbena litoralis*]; its taste is very bitter.

There is another called *sun* that has two varieties: one has yellow flowers and green stems and the other has a kind of nap. I boil three tender tips of these two plants and then mix them with the yacan k'ulub and those relieve my stomachache.

For dysentery we boil leaves of *lulú té* [loquat tree]. The peel of guava and mango are boiled to make a medicine to cure stomachache.

And for a cough, we cut two tips of the bitter peach tree, leaves of passionflower, and some tips of cypress, and we boil it all together and drink it like tea without sugar. This is for a very advanced cough that can turn into *sak obal* [tuberculosis].

There are many plants! In Pak'bilná, a community in the municipio of Oxchuc, there are other types of healing plants used by the people of the community. Once I went to Pak'bilná, and there I learned the properties of the trees and plants of the area. There is a tree that looks like the guava, it's tall and vigorous, and they say its bark can cure many sicknesses.

Our grandfathers or fathers used to say, when they had a stomachache or headache, "I'm going to cut some herbs." Because we don't have

money to buy medicines, we have learned from our parents and grand-parents what plants we can use to recover our health. In our grandpar-ents' time there weren't medicine pills; that's why they knew different healing plants to relieve their pains. Now that there are pills, we know few curative plants, but in the past there was a plant for every illness.

Rosa López, Yochib

I go to the healers of the community. Once, one of my sons nearly died and I went to the healer to ask if someone had cast an evil eye over him, and he said yes. I burned some candles over him and he was cured. I got tired of going to the doctors and of them giving my son injections. The truth was that someone had cast an evil eye. When there is an illness that can't be cured even with injections, then we say that it comes from the devil.

There is a healer next to my house. In general, healers are men, not women. There are many in this community. I took my son to a healer. He didn't do bad things; he talks to God. He isn't one of those who only sows and lights candles. This man talks to God and asks for the health of people. He didn't give any pills or herbs to my son. He only asked me if my son had been frightened or fallen, and he put his hand on my son's forehead and cured his terror. My son got sick because his soul was terrified, and no matter how many injections the doctor gave him, they couldn't heal him. In the past, the people only went to *brujos* [shamans]; they struck people (*nujk'ul*) if they didn't confess their sins. This was the form of healing.

My mother told us, "If you want your son to recover, you have to con-fess all the bad things you have done." The healer has his *lab* [power] and asks you what you have done wrong so that he will be able to cure the illness. My mother always went to this healer. She believes that one of her sons died because my father didn't tell everything that he had done wrong in earlier years (my father drank hard liquor).

My father didn't confess his sins. I think that it's very difficult to con-fess everything that we have done wrong. I'm sure that people were very ashamed to tell everything and that's why they just told half of the truth.

Now that there are medicines, fewer people go to the healers. In my case, I always go first to the doctor and if I find that I or my children don't recover, then I go to the healers, to see what happens [laughter].

The healers have also changed over the years. They don't ask people what bad things they have done anymore; they just heal people with the Word of God.

They talk to God and ask him to cure us. Now, they communicate with God but in the past they talked to the devil. They used to talk to the devil that was inside the person. I guess that's why they asked people all the bad things they had done, if they robbed, killed, or beat someone. They call this *ilel* [the gift of a person who is able to heal]. I don't know anything about ilel, only that my son was cured of his terror.

I think it's good that in the community there are both doctors who know about injections and also healers who know of the ilel, because they help us cure ourselves. Perhaps those who have a God see evil, but as I don't have any religion, I don't have a problem.

Pascuala Patishtán, Bautista Chico

My parents don't get sick very often and they don't use medicinal plants, but if for some reason we use some plants, we cut them on the mountain; we don't buy them. What is valuable is faith.

In my case, I don't use medicinal plants. I only trust God; when there is faith, you don't need plants.

Verónica Gómez, Jolxic

In my community we use a plant that we have called *seguro* [sure] because it is sure to relieve pain. We use it for gastritis, rheumatism, and other ills, and it is also used to dye yarn.

We simply make a tea out of the leaves; we don't use the stems. In the health training course I took, they told us to measure the dose because it could be dangerous and sure to kill us if we used too much. A pregnant woman must not take that plant because it causes an abortion. That's why people can't consume plants without knowing what they are for; it's important to measure the doses.

Once a man of the community consumed a plant called *mul itaj* [black-berry] and he took a big dose—this plant has many vitamins—assuming that the more he took the sooner he would recover. But he was wrong; instead of healing sooner, he got worse; he began foaming at the mouth and fell to the floor. That's why each plant has its dose, and even though we know the plants we must not change the dose.

Our ancestors couldn't buy medicines in the pharmacies, they healed themselves with plants. The spiritual aspect was very important for them, because they had their healers; they didn't use pills.

If they felt sick, they made a ritual according to what the healer told them. If someone in the community had a fall and they saw he wasn't eating, they took him to the healer to raise his spirit. The healer killed a black chicken and called the spirit with a *tecomate* [gourd]. In the past people were cured with the tecomate; they didn't use medicines. When they saw that the ilel wasn't enough, they looked for herbs, because our grandparents knew many healing plants. They boiled the plants and drank them or bathed with them, depending on the illness. That's how people were cured in the past. They were stronger and lived longer. My grandmother already has lived more than one hundred years. In the past people had better lives. My grandmother is getting weaker now because she is using modern medicines.

SUICIDE

> Most of the women kill themselves because they did something wrong or because their husbands abandon them for another woman. . . . Men don't kill themselves. They are seen to be very strong; they can do whatever they want because they are men. I don't think they ever feel sad or worry that they did something wrong; they quickly forget.

Zoila Sántiz, Yochib

In this community some people have committed suicide. I think they kill themselves because they are idle or depressed. There was a woman who

said she had many enemies and nobody loved her; she took a rope and hanged herself in the coffee plantation. She fought a lot with her husband, and she couldn't bear the situation any longer, and that's why she took the rope, tied it to her neck, and hanged herself from a coffee tree. Her husband said nothing. Afterwards, people called the judge so that he could see where she was hanged. This happened three or four years ago.

María Gómez, Yochib

Sometimes there are women who begin to flirt with other men. If the husband finds out, he beats his wife; the women are very frightened and try to kill themselves.

Husbands don't forgive their wives, and therefore women commit suicide. Then, the husband buries the woman who was his wife as if she had no importance at all, he shows no sadness, he doesn't cry. He believes that she wasn't a worthwhile woman. We are told not to do what that woman did—flirt with another man—because no one mourned her. What's more, she killed herself because she knew she had acted badly.

It seems that today nothing matters to the women or to the men. Men make love with the young women; and our husbands, they go after both married and single women. If you don't object seriously, other men will also try to seduce you.

Petrona Méndez, Yochib

I heard a long time ago that a woman killed herself because she had been seeing another man. People said that she had an affair with another man for more than a year and she wasn't able to confess to her husband that she was in love with another man. She was sad and her husband said to her, "Tell me what you want; tell me what's going on, you look sad all the time." But she answered, "Nothing's wrong, I'm fine." And although the man insisted, saying, "Tell me what you have. Are you sick? Why are you this way?" she always answered that she was okay. Her husband kept on asking her, but she never told him the truth although she was very sad. She didn't want to talk, eat, or do anything; she kept her thoughts to herself. Her husband said, "Please, tell me if I've done some-

thing wrong, we both believe in God, and you know that anything that you tell me I won't tell anyone else. I am your husband." And then she decided to speak and she said, "I'm going to tell you what happened. I've slept with another man." The husband was shocked at his wife's confession and said, "How could you do such a thing when we both believe in God?" And she said, "I don't know how I did it, I don't understand what was going through my mind, but it has been more than a year that I did this and you didn't know anything. I don't know why I went with another man."

Then the husband said, "I'm going to forgive you because it wasn't your fault alone, it was also mine. All I ask is that you not do it again. You have everything you need; I give you clothes, food, I look for work in other places, I don't know why you looked for another man."

The woman couldn't stop crying, it seemed like she would die from crying so much. After several days she killed herself.

Even though her husband had forgiven her and the situation was as if nothing had happened, she killed herself. I think that it was her conscience that gave her no peace.

Chamula cemetery, 1992. Photo by Joan Ablon.

Most of the women kill themselves because they did something wrong or because their husbands abandon them for another woman. Sometimes [husbands] don't support us. Some women are strong—and who knows where they get their strength—but others can't endure some situations. Women are all different. Some have a soft heart and cry if others do or say something bad to [them]; but for others, even if bad things happen to them they are strong and proud.

We don't know what this woman was like. Maybe she couldn't bear that her husband forgave her, and she killed herself out of shame. No one knew a thing about this story, only the husband. We learned about it after she died.

Men don't kill themselves. They are seen to be very strong; they can do whatever they want because they are men. I don't think they ever feel sad or worried that they did something wrong; they quickly forget.

INEQUALITY BETWEEN MEN AND WOMEN

Men say ugly things to us—perhaps we disgust them; we don't know why. But it's not good that they mistreat us.

Rosa González, Jolxic

When I was growing up, my mother suffered a lot because my father scolded her. The reason was that we were all girls; she only had one boy, my older brother. After he was born the others were girls.

From that moment on, the suffering of my mother began, because our father beat her; he didn't want to be the father of girls. He didn't want us because we couldn't help him with the fieldwork; for that, he wanted boys.

Women in our community can't work in the field with our fathers even when we're grown. If a woman does that, people begin to speak badly about her. If a girl helps her father, people begin to say that the man is in a relationship with his daughter or that she is now his wife because she accompanies him in his work all the time.

I went with my father to carry wood and water, and I went with him to the field when I was little because I didn't know anything about the world. But when I grew up I began to understand the rules of our community and I didn't go anymore because I didn't want to have a bad reputation.

Boys are really appreciated and loved by their fathers because in the future they will work together in the milpa.

I feel that my father despised me for being a woman. My father began to beat my mother very often because she had only one son. He used to say that we were a lot of stupid women. "You have piled up a lot of women," he said when he hit my mother.

We women cry from sadness, but men don't seem to feel anything in their hearts.

Things have changed a lot; in the past women gave themselves to men. Now men have to pay for them, even older women. And women are freer; some even have relationships with their brothers-in-law.

Martha Gómez, Yochib

I wasn't allowed to go to another place to work or study, and that's why I didn't learn anything. Women are not helped to find their way.

My father used to say that if we left the house it was only to find a husband. I don't agree with that at all.

Petrona Sántiz, Yochib

Men say ugly things to us—perhaps we disgust them; we don't know why. But it's not good that they mistreat us. They are the ones who should spoil us [laughter].

It's true what I say: if they knew how to think, if they would reason a little, it would be different. However, it's just the opposite. They treat women badly, they say, "Let's go! Get going!" And what can we do? We go, and we feel like we're going to die from crying so much.

Martina Hernández, Tzutzbén

If we go out, our husbands say we have found another husband.

At first, everything is beautiful, all is well. But from the moment we start living together, things change: the scoldings and beatings begin—more if there is a baby. *You have to think about how you will survive.* They leave all the responsibility to us, they don't think of their children or their responsibilities. And it's worse if there is another woman. He goes to see her all the time; he's distracted, and he forgets about his wife and doesn't care if she is suffering.

If a man sees his wife start to get worn and thin after she has a baby, he doesn't see her the same way, and he begins to look for another woman. They begin to say, "There are other women better than you; you're not the only woman."

Even if they love you with their whole heart, in a moment they change; and in spite of having decided to marry a woman, in a different moment they decide to leave her and look for another woman, and then they do the same thing to this new woman—and so it goes.

There is another unfair tradition in our community, and it is that only men can inherit land from their fathers; women don't receive anything. I would like to have land, because without land I don't have a place to build my house; even a little parcel would be something.

I didn't inherit land from my parents. And sometimes even when the parents give their daughter some land, the brothers oppose it, and they take it away from her to give to their sons.

María Gómez, Yochib

There are some women in the community who are very clever and know how to sell their bodies and manage the money until they can buy a television. Sometimes their husbands are in agreement. They are going to use the television and radio and other things the family can buy, [so] they are content. Sometimes the husbands behave as if they don't know where the money comes from. When they don't work, they encourage their wives to continue doing whatever they do.

They say that the women who do these things have had an operation so that they can't have children. I don't think that's true: they make the excuse of the operation so that they can hide what they do. I believe that these women sell their bodies because they like doing it: I know some who didn't have the operation, and they are doing it.

It's true that sometimes we don't have enough money to buy beans. We need everything, but it's better to look for work in other places to make a little money, like those of us who work in the cooperative of artisans where we sell our work. They pay us, and we can buy sugar, beans, and soap; it's good work. If I knew that what I did to make money wasn't good, I would feel sad.

Petrona López, Bayalemó

Men can do whatever they want, but women can't. For example, there are few married women who go with other men or try to seduce other men. However, there are many married men that lie to their wives and have lovers.

Husbands think badly of their wives even though they've done nothing wrong; they don't see the good in their wives, only the negative things.

Men always scold them even though women take good care of their husbands—they wash their clothes and prepare the meals, serve them every moment. Men don't think about the suffering of their wives.

When men fall in love with you they find you pretty and everything is fine, but then you no longer have time to take care of yourself. You're too busy to brush your hair, to fix yourself up, your clothes aren't clean, because you have so much work to do. Then they change their attitude. They say that you're useless and they don't respect you anymore; they just make fun of you. In the end, they leave.

There are few men who take their wives into consideration; the majority of families find themselves in this situation.

In the community almost every woman is married. When a woman stays single, her life is very difficult; she stays at home with her parents. They support her because she can't make a living on her own.

If one day the parents die, the young woman has no support anymore. She has no one to sow the cornfield, plough the field; she has no one to protect her.

Men spend their time drinking. I think that's very bad. It's not good to drink so much. It's shameful when there's an uproar at home; they behave very badly, they say ugly things, they hit their wives and children, and sometimes they even go to other houses looking for a fight. I wouldn't like to have to put up with a man who drinks every day.

María Luisa Ruiz, Oventik Chico

Most of the men of the community drink; they start drinking very early. The fathers teach the boys to drink, and they grow up with the idea that they have to drink. Other men learn to drink at school. Some men change their habits when they see that their lives are going badly, but this doesn't happen very often.

In contrast, it's unusual to see a woman drinking. Of course, there are several women in the community who drink, but it's not common. I have never seen women drinking with their husbands.

Women drink only during a party or a celebration when someone in the community takes on a position of responsibility.

Actually, women are the ones who suffer when men drink. We are the ones who live with the consequences; when men go to town to drink, women stay awake waiting for them to come back home.

Rosalinda Sántiz, Bayalemó

One of the differences between men and women in the communities is that women have no right to be landowners. When the parents die, only men inherit the family lands. When a man and woman get married, the house and land are not under both of their names but the man's only. If the man dies or something happens to him, the woman is left with nothing. The man's family throws the woman off the land.

It's very difficult for a woman to own land, and when she does anyone can make her leave it, even her brothers.

Manuela Hernández, Tzutzbén

I don't think it's good that women don't have the right to own land. For example, if an older woman loses her husband, she has no milpa, she has no way to obtain food; if her children don't take care of her, she is left alone and unprotected. In my case, we are three sisters. We had three brothers but they died, and we inherited our parents' lands. We divided the land in equal parts. If one of my brothers had been alive, we would have received nothing because that's the tradition of our ancestors. Women don't inherit land, only men do. What's more, people think that once a woman is married she doesn't need land. This is not just.

Pascuala Patishtán, Bautista Chico

In my family the land was divided in equal parts for both men and women. We all inherited. As for the inheritance, we had no problems; that's why we pray for our parents' souls in the festival of Todos Santos [All Saints Day].

It's not that we inherited a large amount of land but that we shared it equally. Women have land and a place to live when they get married, but if they are widowed or divorced they are left with nothing. Many times they stay with a violent husband who beats them because they have nowhere else to go, neither land nor house.

In my community almost all women inherit land, so that if one day they are separated, they will still have a place to live.

Juana Gómez, Yochib

My husband went out to work to Cancuc, near Chiloljá. He told me a story of a woman who was married to a man who had a car. This man drove to other places for his work, and when he left, he told his wife what day he would come back so that she could expect him. We women usually wait for our husbands to come back home from a trip, and we make tortillas and prepare food for them.

This woman fell in love with another man. Her neighbors realized it because when her husband was away for his work, another man came to the house at night. And one day, the neighbors said to the husband, "Your wife is committing a wrong, she is not a good woman." He said his wife was never in a bad mood—she always smiled and hugged and kissed him. He didn't know what to do with so much attention.

He couldn't believe what the neighbors told him but it left him in doubt, so he told his wife that he was leaving for San Cristóbal de las Casas for work, and he told her what day he would return. The man hid among the trees to watch his wife, and then he realized that what the neighbors told him was true. The lovers were in the house, so he went there and told his wife to open the door, and she said "I can't" while she was putting on her nagua and then, "wait, I'm going to open the door."

When she opened the door, the lover tried to run away, but the husband grabbed him and took him inside the house, where he killed him. They put the corpse into a bag. No one knows where he threw it.

He didn't do anything to his wife, did not even ask her for an explanation. He wasn´t angry with her. People said that they seemed happy. The next day the man got up early [and] acted like he remembered nothing. In the afternoon he was calm.

Three days later, he told his wife to bury the corpse, and so she did.

"I know that I crossed the line, please forgive me," [the wife said] and he said, "That's okay, I forgive you." But he didn't forgive her at all. "Let's go to the coffee plantation," he said.

And [on arriving at] the coffee plantation, the man took a branch of the *chalum* tree (the woman didn't imagine that she would be buried in this place, under that tree). Then the man brought a bag and began to ask his wife, "Why did you do such a thing to me? Do you think that I am stupid? Do you think that I am useless? Tell me, what was my fault?" And the woman answered, "You gave me everything, please forgive me." "Feel your forgiveness," he said, while he was dismembering her body. All her body was in pieces! He put the pieces into the bag and buried her. The man fled to other lands, leaving his children alone at home. Over a few weeks, the parents-in-law of this man talked and decided that the man had to return because of what he did to their daughter. The parents

found him. He told them the reason for his act, and they accepted the death of their daughter and her lover.

When my husband told me this story I trembled with fear, and then he asked me if I was also doing these secret things.

I said to him, "If you want to watch me, spy on me, because if I am doing something you'll know; there are things that one can't hide." I answered him that way because I was very angry. I am not doing bad things.

My husband told me that he would have done the same thing as the man in the story: "I wouldn't forgive you because women don't under-stand reason, they don't know how to think."

After telling me all this, my husband was in a bad mood. He said to me that he was going away for a few days, but it was a lie, because he went to the mountain and came back at midnight. He had told me that he would return the next morning, thinking that I was with another man. We suf-fer for what other women do. Men think that all women behave this way, so that we are even afraid of walking alone.

Ernestina López, Bayalemó

Once I was talking with my parents, and I told them that I didn't agree that only men could inherit the family land but as women we were left nothing. I said to them, "I don't agree that only the men receive the lands." My father thought about it, and he said to me that I was right and that he would arrange it so that both men and women of the family could inherit the land. And so he did.

The most usual thing in the communities is that the fathers offer their daughters as objects. They say, "I have a daughter; if you want her, here she is. If you give me alcohol, I'll give you my daughter."

OUR DREAMS

Nowadays, women decide whether they want to continue studying or to look for a job, or even whether or not they want to get mar-ried or get pregnant and have babies.

Rosalinda Sántiz, Bayalemó

I would like that one day my husband would respect me, would support my working outside the house, and would help with the housework as well. If I left to [go to] work, he would stay and do the housework. I know that's not going to happen, but I would like it very much.

Petrona López, Bayalemó

I would like to have a good and tranquil life. I wouldn't like my husband to mistreat me. I know that during marriage there are some difficulties, but I wouldn't like to be with a man who hits me and shouts at me. I don't want to be married to a man who doesn't let me leave the house. I don't know what my husband will be like.

I don't know why women get married so young. I would like to be able to choose whether I want to get married or not. In the community there are very few women who aren't married.

It would be good if men would help us when we don't have enough time to do everything. We should help and support each other, but that's not how it is. Men say, "Why should I help you? I'm not a woman." They won't try it. We also want men to share in the housework!

I think things have changed a little bit. In the past we couldn't leave our houses, but nowadays we can take part in different community events. I would also like for women to own our lands, so that we wouldn't be left with nothing.

Martha Gómez, Yochib

Life has changed. Now young women go where they want, but before it wasn't permitted. Nowadays, women decide whether they want to continue studying or to look for a job, or even whether or not they want to get married or get pregnant and have babies. It's not the parents' fault if [the women] don't know how to think and do good things.

Martina Hernández, Tzutzbén

Each community has its own customs. I would like women to be able to decide whether or not we want to have many children. I prefer to have few children, four at most.

It's difficult for us if we don't own lands, and I wonder why this has always been the tradition. It would be much better if both men and women had equal rights to own lands.

Furthermore, I would like men not to drink so much. Although drinking is part of our tradition, I don't like the way men behave when they are drunk. I want alcohol to disappear, that it not be sold!

There are men who drink daily and don't leave off even for a day. I don't like this and want it to change; better, I want this *pox* [hard liquor, aguardiente] to disappear.

I would like, when men go to ask for a young woman's hand, that they not offer alcohol. These situations are difficult; even if the girl doesn't want to get married, if her father likes to drink he accepts, and she is forced to get married. We women should be able to decide about our future. We should have the right to choose who we want to marry and when we want to get married.

Magdalena López, Bayalemó

I hope that one day [we] women will have our rights. I think that men and women are capable of resolving problems. What a man does, a woman can also do, but she has to wait for her husband's permission. If a woman arrived home to tell her husband that she had been elected for a public position, it's possible that her husband would kick her out of the house. That's proof that women don't have rights in the community.

Ernestina López, Bayalemó

Ideally, both men and women would have the same rights, and men and women would have our own lands. But sometimes we prohibit ourselves from doing things. For example, if a sister asks for her share of land, the

Young videographer, San Cristóbal, 2014. Photo by Charlene M. Woodcock.

other sister may say that's not a good thing and initiate a dispute between the sisters.

I would like men to stop drinking as well, because many of them die from it. I think it serves no purpose to drink every day and harm your body.

I would also like fathers not to force their daughters to marry when they don't want to. When young women don't want to get married, if their father has already accepted the alcohol, they use beatings to force their daughter to marry. This isn't done very much anymore, but some families still follow this custom.

I think men and women should be treated equally, at home among our parents and brothers and sisters, and at school by our teachers and classmates.

RELIGIONS IN THE COMMUNITY

When I was young baptism existed, but our grandparents used to say that in their time there were gods that were inside boxes, and they were the ones who baptized children.

María Gómez, Yochib

In my community there are many religions. There are Catholics, Evangelicals, and others who sing. In the past these religions weren't here. I believe that about two years ago they began to appear. Before that there was only the Catholic religion in our community.

José López, Elder of Bayalemó

We know that God is in heaven and the images we see are like his photographs. We trust him. We know he takes care of us wherever we are working.

People can pray to ask God for a longer life. Even if it's not a festival day, they can go to church every day, or every Sunday. My family and I go to church on Sundays to Mass, and after the Mass is finished we light

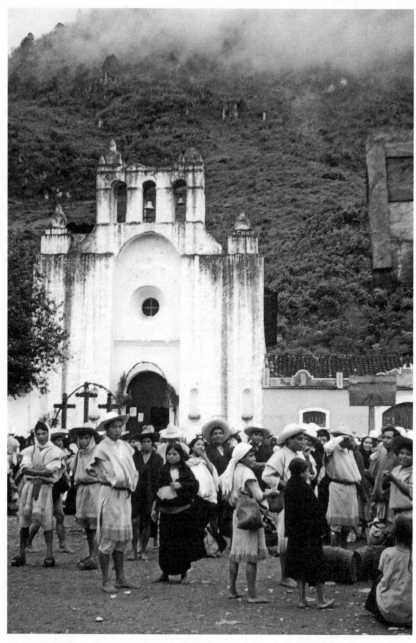

Chenalhó church, 1959. Photo by Joan Ablon.

candles to thank God. In the past nobody got married in the church. People began to get married [there] about twenty years ago when religion was brought to the communities.

When religion [the Catholic Word of God practice] was introduced in the communities, the first catechists were trained to teach the word of God and tell the community that it was very important to get married in the church. We told the youths that they had to get married first, and then live together.

In the past, we got together when the parents gave their permission for the girl to go with the boy that the parents liked. Sometimes the parents decided without even asking the girl.

When the father accepted a drink from the young man who came to the girl's house to propose, the agreement was concluded; even if the girl didn't want to get married, she was obliged to go with him.

The catechists have caused change in the community. The parents no longer force their daughters to marry. They say, "If you force your daughter, she's not going to marry of her own free will, she's not going to be happy and may separate later because she doesn't love her husband." Thus, the catechists scold the fathers who sell their daughter for pox.

Religions teach us not to drink pox. "It's not right that you drink so much pox," the catechists tell us. "Let's replace the pox with other gifts."

There are some people who have convinced themselves that it's not good to drink pox, but others continue. Nowadays, in the parties and ceremonies, people serve refrescos.

When I was young, baptism existed, but our grandparents used to say that in their time there were gods that were inside boxes, and they were the ones who baptized children. They called them talking boxes; they were used to turn the indigenous people to Catholicism. In the past, a person went into a box, and therefore people thought that they encountered gods inside; they turned to the talking box to resolve conflicts and to ask for their health among other things.

There are still boxes in some areas. Who knows how they got them or where the saints came from. The boxes are about the size of a television and inside there is a saint that speaks. When we ask about our illnesses, he answers "you suffer this." People who possess these boxes consider themselves servants of this saint.

I don't know exactly what they were, I only know that they spoke from inside the box and they could give us more years of life. If we were sick or about to die, the gods of the boxes could extend our life.

People asked them for more years of life and they also received baptism. Even though there were Catholic priests at this time, people went to these gods, perhaps because they didn't cost as much money. This was a tradition some years ago, but now no one goes to these gods anymore; they are baptized by the priests in the church. People now believe in the Word of God that the catechists preach.

Martha Gómez, Yochib

There is also the Seventh-day religion; they meet every Saturday, and there is also the Presbyterian [church]. The new religious people now are the Adventists.

For some years now, many different people have come to the communities talking about the Word of God. Many people like it and join the religion; then they build their church.

Those that have come that have very few followers are of the Pentecostal religion. They came three or four years ago.

So far there have been no problems due to the religions in the community. I have been told that in other communities they don't allow new religions to be introduced into the community; they expel the [missionaries] or kill them. But that doesn't happen in our community; there is no discord among us. For example, the people of the Pentecostal religion ask permission of the committee to use the school and make their campaign to inform people about that religion. They give speeches and they play films. The committee has to give permission to all the religions so that people can choose which to join without being forced.

Manuela Hernández, Tzutzbén

In every area there is a church, but there are several religions; for instance, Catholics, Presbyterians, and Seventh-day Adventists, and so on. In the church there are *mayordomos* [caretakers] who are responsible

for keeping the building clean, changing the flowers, and [doing] every-thing needed in the church. The mayordomos are elected and change every year.

They elect two mayordomos, and altogether there are four persons, because their wives assist them and are also taken into account.

Every year they elect the mayordomos from among all the members of the church.

María López, Bayalemó

For the believers the church is very important; every time there is a cele-bration the inhabitants of the area meet there.

Every Sunday there are celebrations. The believers meet and go to the church where they hear the Word of God according to the Bible, taught by the catechists. In every area there are catechists, and they all work in their own way.

In all the churches there is the Blessed Sacrament along with other saints. We pray to God to ask for what we need in our daily life, such as corn and beans. That's how we venerate our Lord.

During the Sunday celebrations a person is chosen to lead the prayer, someone who has been an authority or has fulfilled a traditional respon-sibility, someone with experience who knows the traditions of the com-munity. This person has to set an example of how to pray to God. This way, the youth of the new generations of the community learn. Partici-pating in the prayer are the catechists, the choir, the ministers, and men, women, and the young people of the community.

They tell us we have to care for and respect the church because it's our sacred place. The mayordomos are elected to guard the church, take care of it, and make the other believers care for it as well.

The ministers fulfill a very important position lasting three years. They take charge of meeting people in the church and giving Communion. If there are no ministers, we can't be given Communion. There are four ministers for each area, together with their wives. The ministers and cat-echists are the ones who preach the Word of God.

If a minister fulfills his position properly for the three years, he is given a more important position, that of deacon.

Pascuala Patishtán, Bautista Chico

Now religion in the communities is complicated. Some of us are Catholics, but there are also Seventh-day Adventists and other religions.

What I have observed is that all the religions seem to be like the Catholic one; we all celebrate the sacred day on Sunday.

People get confused with all the religions. They go from one religion to another. But I think that there is no one religion that is better than another, because the word of God is the same.

If someone says that religion is useless, I say that we are the ones who are useless because we don't have faith.

It's like when you have a prideful sheep that, although you feed him well, goes looking for even better food, *Ch' kak mok* [a sheep that tries to leave its corral].

Pascuala Díaz, Bayalemó

Women can also be catechists, servants of God. The work is difficult for us because we also have more responsibilities at home that keep us from leaving. Women can have a position when they are single, but once they get married it's impossible.

Magdalena López, Bayalemó

The catechists are not elected by the believers; they are volunteers that decide to preach the Word of God. They don't choose the topics they preach on every Sunday; the topics are coordinated in the parish.

It's very difficult work to be a catechist; they have to take courses. A catechist has to decide if he wants to preach the Word of God every week.

The position that is chosen by the believers is the minister. At least in our area, the minister is elected, and if he doesn't want to fulfill the position, we beg him because it's very difficult to find someone who wants to do it. The minister is a person with a good attitude and kind heart and who has done nothing bad. It has to be so, because he has to respect the Body and Blood of God every Sunday.

One who has done bad things in his life is not a good minister. If the minister and his wife fulfill all the requirements, they have to take a course and attend meetings. The minister who works well rises to another position, that of the subdeacon and then the deacon. That's the trajectory of a minister.

Women don't have positions in the church, perhaps because once a woman is married, it's very difficult for her to take part in the activities of the church. The only ones that do so are the wives of the mayordomos.

When someone in the area wants to take First Communion or confirmation, the catechists and ministers conduct the ceremony. There are [some] catechists that work with children and others that work with adults.

Confirmation and First Communion are very important events. People who are not prepared cannot receive them. It's not enough to be able to pray the Our Father and bless oneself. It's necessary to be well prepared, and so the catechist teaches the younger ones. When the young people are ready, they invite the priest and the subdeacon.

The young people have to bring their godparents for their First Communion or confirmation. The duty of the godparents is to guide the youths and take them to church. Now things have changed. In the past, it was enough if you knew how to bless yourself, but the rules have changed in the parish.

In the community there are Catholics that don't depend on the parish because they don't consider it their duty. There is a division of roles.

We are in agreement that it's the subdeacon who celebrates baptisms, but many people in our area want the priest to celebrate baptisms and marriages. This is the situation in my community; many people don't agree about the roles of the priests, subdeacons, and deacon, and this is creating division among us.

In the community there are other religions, such as the Presbyterians. They want to draw us to their religion by telling us that we believe in other Gods and that our images are false ones. "They're useless, they're nothing, they're simply pieces of wood or cement. You worship a piece of cement, of rotten wood," that's what they say to us.

Some of our people have been convinced, even though they were former authorities or mayors. Some of them later realized that they were deceived and they returned to the Catholic religion.

The other religions don't respect our saints, and they want to throw them away. That's why we don't have good relations. They don't understand that we all believe in the same God, but in different ways. The people of other religions speak badly of ours. Religions and political parties are the causes of division in our community.

OUR ANCIENT CUSTOMS

Elder women of the community are the ones who know the most.
My grandmother said the same about her grandmothers.

Rosa López, Tzutzbén

In the past there was no plastic wrap, but the banana leaf was very good for making tortillas. Once the tortillas were made in the banana leaf, we wet it so that it wouldn't break down. When the banana leaf comes apart we take another one.

People in the community began to use plastic when I was fourteen years old. With plastic the tortillas are softer. Since plastic appeared in our community we haven't used banana leaves anymore. I remember that plastic was used for the first time when I was fourteen years old because I got married at the age of sixteen and I am now fifty-five years old.

Vegetable oil is relatively new as well. Before, we used lard and we all bought it during the pig slaughter. We began to use vegetable oil twenty-five or thirty years ago.

María Gómez, Yochib

In the past, they made tortillas with banana leaves but I have never seen it. I grew up after that and I have never used a metate because we have a grinder.

My grandmother told me that they were very poor, so they couldn't afford tortillas; they just made a little atole and had some beans. They didn't have enough money to buy corn; they just ate *xbujk*, which is the

Tzeltal huipil, Oxchuc, 1960. Photo by Joan Ablon.

root of a plant. They made tortillas of banana because there wasn't money to buy corn, and although they sowed, they didn't have a good harvest.

My mother says that they only had one plate; it was very big and the whole family ate from it. They filled it with beans, and that was what they ate together, children and adults.

There are people in the community who tell of how they lived in the past, with many details. We can spend whole days listening. They tell us that then they didn't wear shoes, unlike now, when even babies wear shoes. In the past they used *doblador* [dried corn leaves] to make something like shoes. I can't describe them very well because I didn't see them, but our grandmothers can explain very well.

Older people of the community still keep the customs of the past, and the food as well. For example, they still eat field rats. We have tried to eat them but we can't; they're disgusting. Nevertheless, for the elderly people these rats are part of their diet, and they eat them when they can hunt them or when someone sells them. It depends on the season; sometimes they are found easily but other times they are not. They also eat squirrels and rabbits.

Francisca Pérez, Chichelalhó

In the past, people didn't use soap; they used a plant called *ch'upak*. There were no cooking utensils, like pots and pans. The spoons were made of wood, they didn't have pewter; and the frying pans were made of clay, since they didn't have iron. All the vessels for carrying water and for cooking corn were made of fired clay.

Elder women of the community are the ones who know the most. My grandmother said the same about her grandmothers.

Martha Gómez, Yochib

In the past there were no hair ribbons, and our grandmothers say they used corn leaves to tie their hair.

I never ground corn in the *chá* [metate]. I am from the time of Coca-Cola and Fanta. . . . [laughter].

Before, there were no beds. People used dried banana leaves, and later they used plastic. They put it on the floor, and the whole family piled up there to sleep. Now things have changed; some families have wooden beds and mattresses, but there are still very poor people who only use *petates* [rolls of woven palm leaves].

Our forebears made their own clothes, but we actually don't do this anymore. This tradition is lost. We don't know how to spin the yarn. We weave, but we have the yarn available to buy. It's our problem if we don't want to weave.

In the past people used a blanket for clothing if they didn't have money, and they used it until it was just shreds over their body; only then did they buy a new one.

The ones who had a little bit of money wove their clothes. They also spun the yarn. I think they bought white yarn and dyed it with tree bark that creates a red color (a less intense color than the one we buy in the stores now).

In our community we don't use blankets now. We don't know how to dye the yarn, we've lost this knowledge; we buy everything. But it's also true that our grandmothers didn't have the good things that we have today. For example, we weave and embroider and can sell our work. Perhaps they would have liked to live in our generation. Perhaps they would say, "These things didn't exist when I lived." They didn't live to see how we are living, able to wear a sweater, a blouse, necklaces. They did wear necklaces, but they were made of seeds, not plastic. They drilled a hole in the seed and passed the needle with a thread through it; these seeds are known as "the tears of Saint Peter," and they also put them on children.

They also made their spoons from the same material as their cups, only they looked for the more elongated gourds; they split them in the middle so that they could use them as spoons.

Nowadays the griddles are made of iron, but in the past they were made of clay. We still use cooking utensils of clay because the food cooks better in them; the tortillas burn on the iron griddles. We use wood with the clay griddle; everything cooks better, the tortillas don't burn and they look nice.

Manuela Hernández, Tzutzbén

That was the tradition of our forebears. They wove and embroidered all their clothes, that was their tradition. And in some form, we continue today; we too weave and embroider.

Celia Sántiz, Bayalemó

According to my mother, our forebears bought balls of cotton [probably from a Gossypium tree or bush] in town to spin into thread. My mother said they used only cotton, not wool. They had to spin it themselves because in the past there were no factories to spin yarn. My mother doesn't know how to spin cotton, but her parents did.

Pascuala Patishtán, Bautista Chico

In the past there were no plates, there were only *sets'*. The sets' are made of clay and are similar to ollas but were used to serve food instead of for cooking. They are also called *pulato*. People said that our ancestors made their own plates, pans, and pots. They didn't buy them; each family knew how to make them. My mother also said that in the past there were only two plates on the table, and the whole family ate from the same plate. Before, there were no buckets, there were only pots made of clay for the beans, the corn for tortillas, and pozol.

She told me that they bought the *tunim* [cotton], and they beat it with a stick to expel all the seeds, and then they spun it into yarn with the *petet* [spindle] in order to weave their clothes. It was a lot of work, and if they wanted colored thread, they had to dye it with the bark of the *nakté* [oak]. The color is a very intense red. They also wove napkins for the tortillas.

There were no shawls, so they covered themselves with capes. The capes were similar to the ones that are sold in the San Juan Chamula market. They are made of sheep's wool, the same as the blankets.

At that time there was no plastic to cover them from the rain, so they used a kind of palm to stay dry, but it wasn't very [waterproof], so they always got wet.

My mother has told me that in the past they didn't have to work for money because corn and beans grew very well—better than today, when they only grow with fertilizers.

Zoila Sántiz, Yochib

In the past people used different words. Today we say "peso" when we talk about money; in the past they said centavos or *tostón* [a half peso]: "pesu o mero." They were very poor people who could only make their clothes with *manta* [coarse cotton cloth]; they couldn't buy yarn as we do today. Women used a fiber like jute to sew their clothes.

They bought the cotton cloth from the mestizos that sold things and went from one community to another.

In the past they also ate fox, because it was tasty. The meat of the fox has a very strong odor, so they had to smoke the meat for at least a week before they could eat it. They made a tasty soup out of it. I have eaten fox meat, and I like it very much.

What we tell now are the experiences of our mothers and grandmothers. We don't live this way now. I don't grind with a metate, and we don't eat from the same plate all together anymore. But I did have to carry water from the river in jugs because there weren't one-liter water canteens as there are today.

I have seen two types of jugs: those called *tsontealjá* and others called *tenam*. We bought them in Cancuc or in Oxchuc.

Petrona Méndez, Yochib

My grandmother told me that they had to walk to San Cristóbal because there were no cars and no highways. She told us that they had to walk in stages, and they also had to ask for a room to sleep in when it was too dark to continue walking. They woke up early in the morning the next day, and started walking again. It took them two days and two nights, and sometimes more, to reach San Cristóbal. They had to carry with them pozol, beans, and vegetables wrapped in bags. When they tell us about how life was for men and women of that time, it makes us very sad, it almost makes us cry.

Rosa López, Yochib

My grandmother told me that there were no grinders in her time; they ground corn in the metate. The metates are made of stone. People still use them today, but now they are made of another material that doesn't last as long and breaks down more easily. My grandmother still keeps her metate, and she likes to use it to grind the pozol.

Juana Gómez, Yochib

In the past the families lived in one big house. For example, if you were named Gómez, then you joined others named Gómez to live on the same large piece of land. The families lived in big groups, and we could hear people say: "on that land live the Sántiz or the Gómez or the Chimbakes." The big family groups not only lived together but also worked

Traditional house, San Andrés, 1960. Photo by Joan Ablon.

the land together. In the past, people helped each other even if they weren't from the same blood family, just the same surname; for them, all were brothers.

There are several customs that we have lost: eating all together, making and drinking the sour atole, gathering and eating bananas. The [ancestors] didn't know rice or soup; they just ate beans and atole. They drank sour atole and they ate *pats'* [tamale of beans ground with corn] and *petules* [bean tamale]. This is still a custom in our community. When it's the season to sow corn and beans, we eat this traditional food and keep this tradition so that we don't lose it.

In the past there wasn't running water, so we had to go to the river to take a bath, to bathe our children, and to carry jugs of water to our house. Now we have running water and don't have to go to the river for water anymore.

José López, Bayalemó

To sow the seeds, we used a *luk* [sickle]. It's a stick with a curved iron tip that is used to cut the plant, and the same tool is used to sow the seeds. We also used a pick.

The harvest time is in Tz'um [January], and we save the seed for the next season; in Tzotzil we call these seeds *soyil* [reserve seed].

We saved the seed by hanging the whole ears of corn from the roof to dry until March, the sowing season, and then we prepared everything: we put the seeds on the floor and mixed them with *ocote* wax and soot, the way we prepare pozol, leaving the seeds covered in wax and ashes. This preparation protects the seeds from damage by insects or disease, and from raccoons that otherwise would eat up all the seeds.

In the past, we didn't put anything on the seed to protect it, we just piled the harvest in a large barn. It was later that we began to prepare the seed before we sowed it. Today we put on something with a very strong smell to prevent the insects from growing in the harvest. When I was a boy this product didn't exist.

In the past we only sowed corn, beans, zucchini, and *chilacayote* [a type of squash], and we still sow all of these. We can't produce many things because this is a cold land [the Chiapas highlands], so we just sow

zucchini, not pumpkins. The problem is that the land is not as fertile as it was thirty, forty, or fifty years ago, when there were big trees. Today the land doesn't produce the zucchini and chilacayote well. The land is dry or full of stones, the topsoil "went down the river"!

In the past the land was more fertile. Nowadays we only sow to sustain ourselves, but when I was young we sowed enough corn to sell some. We carried the corn on horses because there was no highway as we have today, only paths. We rented horses or we carried the corn ourselves to sell in town.

In the past the corn was better than it is today because the land was more fertile. Without fertilizers the corn grew very tall, so tall that we weren't able to cut all the cobs of corn. Today, even though we put fertilizer on the field, the milpa doesn't produce as well as it did before.

Magdalena López, Bayalemó

Nowadays life is not beautiful. I am going to tell you a little of what I know.

Before, we didn't use chemical fertilizers on the milpa. Our grandfathers didn't know anything about fertilizers or weed killers, and our grandmothers didn't know how to sell their textiles. People didn't depend on other people; they lived by their own work, and they didn't use chemicals to sow the cornfield.

My father sowed corn, and when we wanted vegetables he would sow them, and that is what we ate. No more. We no longer harvest them. The vegetables don't grow well, the land is worn-out, used up, and it doesn't give us good corn and beans.

In the past when men went to sow they took their pozol to eat; they also cooked their beans in the milpa. Today, they take jumbo soft drinks. Life was very happy, we lived well, and we had no worries about our milpa. We went there to work every day, we didn't have to buy corn. Now the milpa doesn't produce as it did before.

My father raised chickens, turkeys, and pigs, and if he needed money he sold the animals. That's how we lived. Life then was very good, we lived well.

Today, if we want to ask for something, or if we need to talk to someone, we have to pay with soft drinks. In the community now we have to buy everything with cash, barter doesn't exist anymore. We buy everything—our food, our clothing, cooking utensils. In the past we didn't use money; we planted our milpa, we raised our vegetables, we produced everything we needed.

In the past, we took the vegetables we produced to the market on Sundays. If we wanted avocados, bananas, or *matasanos* [a plant local to Chiapas] we didn't pay anything, we exchanged the products with people from other communities like Santa Marta, Magdalena, or Santiago. In those places they raised sugarcane, bananas, and other things. Here, where it's colder, we raise turnips, potatoes, and zucchini. In the past nobody bought vegetables, we didn't need money. Everyone exchanged the products; we called it *tukul* [barter]. The people from the communities of Santiago and Magdalena exchanged their limes for our vegetables. That's why in the past, life was better than [it is] today; now, we have to take money with us for everything, nobody wants to exchange products anymore.

We see very little barter, but some people still do it: they exchange tortillas for vegetables, bananas, or sugarcane. Nowadays, young people carry their backpacks instead of carrying their net bags full of vegetables to exchange as they did in the past. In the past, we had a beautiful life. For example, when the workers cleared the milpa we paid them with corn or beans, but today we have to give them money. It wasn't necessary to have money because people saved corn and beans, and that was enough to sow the milpa each year. We didn't need money because we produced everything we needed: clothing, pots, healing plants, corn, and beans. Now we are accustomed to buying everything. Now the "intelligent people" can make everything in the famous factories.

Young people today think very differently. They buy manufactured things that are more expensive. For instance, a big handmade clay pot costs twenty or thirty pesos, but a metal pot costs around 120 or 150 pesos. With that amount of money we could buy six big clay pots.

You can find clay pots for cooking beans that cost four or five pesos, but they don't often sell them anymore. Now, they sell more of the others,

although we don't have money. When the new pots wear out, they rust, and we still eat what we cooked in them. The pots of clay last many years, we throw them away when they are broken; however, they don't rust, they don't have a bad odor, they are very pretty, and they are very good for cooking chilacayote, vegetables, beans, and so on. But now everything has changed. For some years now, when we wanted to ask for a loan of money or corn, we had to give alcohol; even to ask for the hand of a girl to marry. Today, we have to give soft drinks for everything.

In the past, when people got drunk on pox they inspired themselves to better behavior by giving advice; they don't do that when they take soft drinks. Besides, people now are more independent, they do what they want.

Whether in cans or plastic bottles, soft drinks are very expensive. We don't have money for buying soft drinks, and when we have a little money we spend it in a few days.

I see that life is getting worse, even though the government says things are improving and there is more government support. The food we buy makes us sick; the canned beans and chiles aren't nutritious, and this type of food brings illnesses. This didn't happen in the past because we produced everything ourselves; the food we consumed was natural, but now people like to buy canned products because they're already prepared.

A long time ago, we didn't build our houses of adobe, we made them with straw. When men went to cut the straw, they helped each other; the payment was to help the others to build their houses. We didn't need money to build a house; we didn't have to pay masons as we do today.

When construction of a house was complete, it was traditional to say a prayer, light candles, and offer flowers; they prayed to God that the house would last a long time for the family that would live there. They killed many chickens, and all those who helped build the house came together for a meal. In the past, you didn't enter a house to live until the ritual was done. The saddest thing is that now no one wants to help build a house, they just want money, they ask for the money before they begin to work, and they spend it all. The houses of our grandparents were large, because they cooked and slept there. They lived there for many years—the houses lasted some twenty or thirty years. Although the wind might damage the roof a little, it could be repaired and it lasted very well.

Young people today don't know anything about our traditions; I know these things because my father and grandparents are still alive, and they tell me these stories. When my father begins to talk about the past, he knows how to explain very well how people lived in the past, and he knows many stories that his parents told him, stories that go back one hundred or two hundred years. My father is seventy years old, and my grandmother is still alive; she is more than one hundred years old. My uncles lived for more than one hundred years; they died two years ago.

My uncle was a mayordomo [estate manager], and his father died when he was very old. We don't live so long today.

Our forebears used fingers and toes to count. They didn't know reading or writing, but they could count the dates very well and count money with exactitude, and knew how much was a *jun tak' in* [twenty cents] and *chib tak' in* [seventy-five cents]. We don't know now how to calculate dates with the old system, because our forebears used a different calendar system. The months lasted twenty days instead of thirty days, and the measures were of *jbok* (twenty at a time, like the fingers of hands and feet).

Now we count in Spanish even though we don't understand the language. My father has preserved much of the knowledge of our grandparents, and he knows when one must sow corn. He says, "It's already *muk'ta sak*, it's time to sow my corn."

Elder people of the community name the months in Tzotzil, but we younger people don't know anything. We went to school and we didn't learn anything. On the contrary, we have lost the wisdom of our grandparents.

Now young people are ashamed of speaking Tzotzil, they just want to speak Spanish. The amount of money lent in the past and today has changed. Before, people borrowed the amounts of *cha'vinik* [forty cents] [or] *ktom'* [twenty cents]; later, you could ask to borrow one peso [or] a *tostom* [fifty cents]. Today, people borrow bigger amounts of money, five thousand pesos, ten thousand pesos, and even one hundred thousand pesos.

My father and my uncles raised pigs and cows. They sold the meat of the animals and they measured the size of the piece of meat with their fist. If someone ordered jun tak'in [twenty centavos] of meat, it

was enough. There were various fists of meat, they didn't measure by the kilo. Now, the meat is measured in kilos. Customers can be robbed by this measure because the scales are changed, and no one gives a full kilo. In the past we were more honest.

We have forgotten our old customs. Today, they announce the time on the radio, so we don't need to go outside and look at the sun as we did before. That's why we have forgotten how to forecast the weather. Every few minutes we look at our watch and we make ourselves stupid. We think that because we have a watch we are more intelligent, but that's not the case.

María López, Bayalemó

Life has changed. Now we only use chemical fertilizer and herbicides in the fields. Men use these things because they're glad to work less—before, they had to work the whole day with the hoe, and it was slow going. The bad thing is that it's destroying the land. When we sow chilacayote, the seeds don't bear fruits, but when we put on chemical fertilizer they grow. The soil is dead, and we're dependent on the chemicals that destroyed the soil.

What I see in the present day is that we are not as strong as our grandfathers and grandmothers—we die younger, our hair turns gray, we don't live well, and we're thinner. Our ancestors lived for many years, they were of strong blood.

I see that we live badly. We drink sweet soft drinks, we eat things that come from factories. Everything is now treated with chemicals—vegetables, squash, corn—and who knows if they have been prepared hygienically? That's why we are weak and we fall sick so easily with stomachache, headache, muscle pain, and everything we suffer from. We no longer know how to cure ourselves; we buy medicines in the pharmacies even though they're useless. If we don't buy them, we fear we'll die.

Over time I think that life has worsened. Who knows what more could happen? In the past we used pots and griddles made of clay, but now the griddles are made of metal. The advantage of the griddles of today is that they can be used to warm several things at the same time.

Pascuala Patishtán, Bautista Chico

Our grandfathers and grandmothers were very strong. It is said that sicknesses were introduced to the communities when the highway from Tuxtla Gutiérrez [a city in the lowlands] was built. In the past no one complained about bone pain or other types of pains. They say that when the highway was built, the construction workers destroyed a hill, and that was when the illnesses came. With the destruction of the hill, the coyotes came to the communities, and they began to eat the chickens and sheep. Before that the chickens and sheep were not disturbed; nothing harmed them. My mother said here they were left alone.

My father said, "If the old ones struck the machete on their shin it sent out sparks of fire; now if they strike it, it leaves sparks of blood."

My mother says that her uncle worked very hard; he looked for ten people to prepare the field and produced corn and beans for all of them. It wasn't necessary to use chemical fertilizers or weed killers.

In the past, our parents made their own clay pots and *comal* [griddle]. They also used a *bochil lum* [clay plate] to serve squash.

They didn't have to buy lime [for treating dried corn, which improves its nutritional value and reduces the toxins in moldy corn], because there was a person chosen by the community who burned it and watched over the process for three days. This person couldn't return home during the lime-burning process; thus, during these days he couldn't see his wife, because it might make him ruin the lime. Lime is a sacred thing; a person is elected each year to bear this responsibility.

For the process of lime preparation, they use special lime stones and need wood to burn them. Once the lime is processed, it is divided among the authorities of the community, and what remains is sold. They have a measurement called *vara te'* that is used when it's sold. The lime is mixed with water, and the lime that is not used is buried so that it doesn't get ruined.

The plates were once made of wood. I still use some of them along with those that we use nowadays. They also used wooden spoons.

Before, they didn't carry the water in urns, they used jugs. It was our forefathers who made the clay jugs to carry the water from the river. They

made jugs of different sizes so that both children and adults could carry the water.

They also sold the jugs. It was important to choose the best clay, because if they weren't made of good-quality clay, the jugs cracked when put in the fire.

Bad clay has foreign matter that cuts the hands when one kneads it, so it was ground first, and seeds and rocks taken out of it. They say it's necessary to mix the clay three times so that it produces a good product. I didn't have to grind it very often because I was still young, but my brothers did.

Good clay is not easy to obtain; it was necessary to go very far from the community for it. And one had to dig very deep to find it, because it's not on the surface. It's difficult to get clay for bowls, comales, and jugs.

My mother made the tortillas by hand. I still remember how she stretched the masa dough over her hands to make the tortillas. It seemed easy for her, but when I tried to do it, I couldn't.

My mother didn't use plastic bags for her tortillas. She went to the fiestas and helped other women with the tortillas. They ground the corn in the metate and cooked the tortillas on a comal daubed with lime. They made tortillas for the Alférez and Pasión festivals. Women seated themselves around the comal with their masa dough to make tortillas. Later, they began to cover the tortillas with banana leaves. The bad thing about this was that the tortillas stuck to the leaves, and that's why they began to use plastic bags.

A long time ago, our community exchanged products with the community of Ya'al Citom, located in the municipality of Chamula. This country is at a lower altitude and is warmer. In this region they produce avocados; they don't produce green vegetables. When there was no money to buy avocados, our people filled their bags with vegetables and went to this community and returned home with bags filled with avocados. I don't know if they still do it. Our grandparents called money *karera*. The karera coin was the size of the fifty centavo coin of today. I don't remember what figure was on it. Our grandparents kept the coins, but the children played with them. There was another coin called a *mexi-*

cano that had the figure of the sun on it. And I just remembered, the karera had a flower on it.

At that time my grandparents and parents had no clocks; however, they knew what time it was. They woke very early, and they calculated the hour by the movement of the stars. They knew dawn was about to break because they saw the stars *curus k'anal* [Star Cross] and *mol k'anal* [Star of the Superior Elder]. When these stars were overhead, our parents and grandparents woke up.

They say that the stars *xolom* and *jukulpat* are the ones that watch over us. My father told me he calculated the time just by looking at the stars. "Wake up, the sun is coming up," he said to me; he had already ground the corn, and I had to make the tortillas. Our parents and grandparents didn't sleep as much as we do today, they got up very early and went to work.

They worked all morning until twelve o'clock, when they told us it was time to rest. They put the hoe on the ground, and when the sun fell exactly in the center, that meant it was twelve; the sun was directly overhead. So, too, with the calendar; they had their own calendar; they didn't use the mestizo calendar. Unfortunately, today we have lost the calendar, we are losing these customs of the past.

My mother lived in a very big house made of wood and with a roof of straw. It had a gallery around a patio. Her father built the house. Our ancestors organized themselves to build the houses of the community and measure the amount of straw that they needed for the roof of each house. They used the measure called *jbok'* [equivalent to four hundred pieces]. That is the way they planned how many bunches they had to cut for the roof, the same way they measured corn. There was another measure called *janika*. I hadn't heard of janika, but I investigated and found out that it was equivalent to twelve liters. I think that in Spanish it's called *fanega*. Nowadays, nobody uses these measures.

In the past we carried things tied with leather ropes; we didn't use plastic ropes. When they killed a cow, they used every part of the animal. Nothing was thrown away; they even used the penis of the bull.

Manuela Hernández, Tzutzbén

In the past we didn't have running water. We drank water from the streams, which we carried home in big jars called *ja'be*. The vocabulary of today has changed; now we call them *lupo'* or *lup yoxo*.

We used a bag made of an armadillo shell to carry the seeds, because there are many armadillos on the land. It was called *pat con*, or *pat tuluk*; it was very convenient. Women used to carry the bean seeds in a gourd bowl; now we use plastic utensils.

Our fathers sold us, their daughters, for pox. The fathers sealed an agreement of marriage by accepting a drink of pox. That was the custom in the past.

We used to cook food in pots made of clay. The *chamulas* [inhabitants of San Juan Chamula] made the clay pots. My mother bought them.

There were some pots called *baxil bin*. This pot heats the food very well. Today, we use iron pots; almost nobody uses clay pots or sets'. They also used the *lech*, a traditional spoon made of clay like the sets'. When a lech broke they used it to stir the atole we drink on the day of Todos Santos.

For the beans and the vegetables, they used another lech, made of wood. Each type of food had its own lech. Today, everything has changed. The lech and sets' don't exist anymore. There are only galvanized pots, and plates and spoons of metal, whereas before we ate from little clay plates. We now consume canned products. They are very tasty. Canned chile is better than fresh, that's why we buy it. Our grandparents didn't consume these products. What we buy most are canned chiles, not beans.

Juana Jiménez, Bautista Chico

Our ancestors' clothing was made by hand. My grandmother taught me to spin. Now, since the government sells us yarn for whatever we want, we've become lazy. We weave but we don't spin the yarn.

Everything has changed very much. Before, all the clothes were made of sheep's wool; our grandparents didn't wear the clothes we wear today.

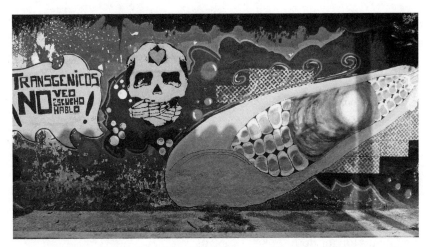

Anti-GMO mural, San Cristóbal, 2014. Photo by Charlene M. Woodcock.

I think that the government is very intelligent because they appear to be helping us but actually they make us lazier.

When we were children and we behaved badly, we were punished by having to grind corn in the metate. There weren't any *tortillerias* [shops that make and sell tortillas].

OUR CUSTOMS TODAY

When a woman who has no children gets sick, then other women in the community go to her house to help her with the housework: they sweep the house, wash, feed the pigs, and other things.

Francisca Pérez, Chichelalhó

One of our customs is to accompany our neighbors when it's time to sleep. We call this tradition *xchinic ta wayel*. For instance, when the man of a family has left the community to work far away and he will return late, the neighbors stay with the wife and children of that family so that they don't spend the night alone. During the day we return to our usual

activities at home. It happens within families that widowed women or women without children are given a nephew so that they can raise the child as if it were their own. Clearly, there is no payment for this.

Martha Gómez, Yochib

It's still a tradition to accompany a family to sleep when the man of that family has gone to work in another place. For instance, they stay with their daughter so that she won't be alone. If the daughter has married in another place, or the son is in another community, their relatives, an uncle or someone else known to them, stays with them at night. It is the older people of the community who continue this custom; the young people no longer do it.

Martina Hernández, Tzutzbén

When someone in the community is gravely ill, someone stays with this person during the night; they don't sleep if they're going to take care of the sick person. Some people bring tortillas, wood, and cash with them. If the sick person dies, together we make the coffin for that person. During the wake, all the community is there, and men and women help with what they can.

Afterwards, all the community attends the novena, nine days of prayers, and during these nine days people continue to arrive and stay to sleep.

Another custom is for all the men to participate in cleaning the paths.

If a woman is abandoned, the community will help her only if she is sick; they will bring food and water until she recovers from the illness.

María Luisa Ruiz, Oventik Chico

It's a custom in the community when a mother can't breast-feed her baby to look for another woman to do it. For example, my mother fell ill often and for long periods. If she was sick when she delivered, the older daughters, my sister and I, went to find a woman with milk who could nurse

the baby when my mother could not. Women who help other mothers to nurse their babies do it as a kindness, not for payment. They do it until the mother has completely recovered and is able to feed her baby alone. Many women came to visit my mother when she was sick, and they nursed her baby.

If a mother dies and leaves small children, the relatives share the responsibility for them. If there are older sisters, they take care of their younger siblings. In the event that the little ones have no one to take care of them, there is always someone in the community that decides to adopt them. Some children stay with their grandparents.

Ernestina López, Bayalemó

It happens sometimes that when a woman has delivered twins, she keeps one baby and gives away the other one.

Zoila Sántiz, Yochib

It's a tradition in our community to take baths in the *pus*, also known as the temascal. It's a bathtub made of clay with stones in it; the stones are heated, and when cold water is poured over them, steam is emitted. The older people of the community continue to use the temascal; the younger ones go to the river to bathe.

The use of the temascal hasn't been lost completely, because people consider it a healing remedy. When women have menstrual pain or a stomachache, they heat the temascal to take a hot bath, and the steam soothes the pain. It's also used by women after they give birth; if they bathe in cold water, they get sick.

José López, Bayalemó

When we seed our milpa, we have to pray in the church. We bring our candles to ask God for help and give thanks that the day for sowing has come. We explain our petition and tell him that we need the milpa because that is our living. We tell him that we cut the trees, the reeds, and the grass not because we have gone mad, but because we need the

land for corn. We replace those plants with corn, beans, pumpkin, and chilacayote. "With these we dress the earth."

We tell God that we live on the Mother Earth; from her we take our food and water. That's why we say to him, "God, the truth is that we can't go without food, neither at dawn nor at sunset. We can't withstand hunger and thirst; with our *compañera*, with our sons, with our daughters, with our chickens, our turkeys, our ducks, and with all you have given us, for that we ask, Lord, that you give us corn and beans, money from your sacred box, help us Lord."

That is how we pray during the planting season. We pray that nothing bad will happen to our corn, that it doesn't fall down: "God, take care of our milpa; I can only weed it, I can't make it grow, only you can do that." When we pray, we have to bring our candles. "We don't want hunger, because when we are hungry we can't go to sleep. We want to feel fulfilled, to have our corn and beans, and in this way we don't feel how a day and a year pass, Lord." We pray because if we stop praying, we won't endure.

Some people have given up this custom, but one must think that we don't give up eating, and for that reason we must not give up on God, because it is only God who supports us, who gives us strength, and we must ask him for what we need.

When I don't have money I ask God. I say to him, "I have no money, Lord, that's why I am crying, because my bag is empty. Would you please give me money?" He gives me a little money, not much, some six hundred pesos.

We can't bear to be looking for work in other places, on the coffee plantations. We can't endure poverty anymore.

On the planting day, it is our custom to prepare a special meal. On that day we don't eat vegetables, we eat chicken, and sometimes we invite other people of the community to [help us] sow and to share the chicken.

With the first sowing, we bury the leg of the cooked chicken with the first seed that we sow; they say that way the seed will also have something to eat. That's why we eat chicken in the morning and at midday only beans.

We eat together, men and women, because the women sow the beans, and the men sow the corn, but sometimes we sow together.

In our community there is almost no tradition that people marry in the church. The majority get married in the traditional way, according to our customs. A few people, those who have money, get married in the church.

Petrona López, Bayalemó

When a woman who has no children gets sick, then other women in the community go to her house to help her with the housework: they sweep the house, wash, feed the pigs, and other things. It's the same when a woman is pregnant or gives birth; because she is still weak, the women visit and help her.

We also have something called *k'ex k'ak'al* [exchange, solidarity or mutual support, teamwork]. When a man has no money, he asks help from the community, for weeding or sowing the milpa. He says to them, "Help me, and when you have work I will help you as well." It is work paid with work, not with money.

We are losing this custom a little because nowadays people only want to be paid for favors with money.

People in the community still work together to build houses, clean the school, and take care of the river and the electric cables. This work is carried out by men, but women prepare the food and pozol for the community. When they go to sow, our custom is to cook chicken soup.

PAST BELIEFS

Women are afraid that the black man is going to take them to the cave where he lives and force them to live with him.

Martha Gómez, Yochib

My grandmother has told me about the beliefs of our community in the past. For instance, if a baby was born in the evening, the other children couldn't go outside to play. They had to stay at home, and their mothers hugged them close, because during that night the spirits went out, and

they would steal their souls and make them sick if their mothers didn't hide them.

Zoila Sántiz, Yochib

In our community we have many beliefs; the story of the "black man" is one of them. Women are afraid that the black man is going to take them to the cave where he lives and force them to live with him. It's said that he can go inside the house even if people don't open the door. It is also said that the black man only takes those women that he likes, and even if they fight back, they can't defeat him because he is very strong. He wraps them in a black blanket and carries them to the cave where he lives.

Later, people begin to look for the woman because no one knows what has happened, and they haven't seen her. The poor woman is with the black man in order to give him many children. We don't know how many children the woman has while she is with him.

When the woman comes back home, she can't have children anymore because her womb is cold, and she soon dies. We know the cave where they say the black man lives, but we don't know if he really exists.

José López, Bayalemó

In our community it is the belief that ceremonies always must be done on a Thursday or a Saturday because those are the only good days. If we want to light candles to pray for our milpa or for life, it must be done on those days and everything [must be] prepared on Monday or Tuesday.

WE DON'T WANT TO LOSE OUR CUSTOMS

We want to keep our rivers, and we don't want to lose our good customs, the festivals and the ceremonies of our communities!

Petrona López, Bayalemó

We have many customs that are related to nature. However, if the Plan Puebla Panamá* is approved, we are going to lose our lands and our customs as well. We will also lose the water of the rivers because foreigners are building dams that are very damaging to nature. One does not play with the rivers! One cannot close their natural courses! They [federal government planners] evict entire communities and then do not provide us with other land to live on. We want to keep our rivers, and we don't want to lose our good customs, the festivals and the ceremonies of our communities!

I don't want our Tzotzil language to be lost, either. This doesn't mean that I don't want to speak Spanish, I do want to continue learning it. I would like us to preserve our traditional clothing; perhaps there have been changes, but I don't want to lose our traditional dress.

María Luisa Ruiz, Oventik Chico

I don't want us to lose our language. We can learn to speak Spanish, but we don't need to stop speaking Tzotzil, because this is the language of our parents and our grandparents; this is what they have left us, our heritage.

Martina Hernández, Tzutzbén

I think that we must not lose our tradition of working collectively; we must not lose our families.

* The Plan Puebla Panamá, a multi-billion-dollar development project first proposed in 2001, was meant to connect southern Mexico to Colombia and the Central American countries in between, with a highway and maquiladoras to exploit the labor of the farmers and small landholders whose land it would displace. It has since evolved and been renamed Proyecto Mesoamérica (Mesoamerica Integration and Development Project). www.peoples oftheworld.org/planpueblapanama.jsp

The Importance of Our Textiles

In this chapter the women talk about the differences between the tradition of weaving in cotton, which the majority of them do, and that of the colder highland communities of Chamula and Bautista Chico, where weavers raise and care for sheep, shear and wash the wool, and spin it to weave and embroider clothing and blankets. Some of these weavers dye their wool with vegetal dyes. The tradition of spinning local native cotton is described in this chapter but is no longer practiced. The weavers of cotton now purchase commercially spun and dyed cotton thread.

Each community has its particular clothing design traditions, so women from different communities can be readily identified by their style of dress. As commercial clothing becomes increasingly available, the differences are becoming diluted but most of the weavers continue to wear the indigo-dyed cotton or wool skirts, handwoven sashes, and distinctive huipiles traditionally woven in their community. As the rural communities are increasingly drawn into a cash economy, and as commercial clothing and used clothing provided by charity groups have become more readily available, the men have mostly ceased to wear the traditional clothing except at fiestas and religious celebrations. The undermining of the weaving tradition has been an unfortunate side effect of charitable donations of used clothing to indigenous communities, both in Latin America and in Africa.

The weavers whose voices this book records are members of the Jolom Mayaetik cooperative, formed in 1996 (see the afterword for a history of the cooperative). As the cooperative has endured and prospered,

its members have gained increasing control over their own lives. They have succeeded in addressing some of the problems that darkened their lives, as described in the earlier chapters. Because of their lightheartedness, their delight in teasing and joking, an outsider encountering these women would not guess the difficulties some have experienced. Appendix A is a memoir of Rosa López, one of the founders of the cooperative whose life was prematurely and brutally cut short before the successes of the cooperative had begun to be realized. In the original Spanish edition of this book, her comments and stories were gathered into a separate section, followed by remembrances of her by other members of the cooperative. There is no doubt that some of the women's difficulties have been ameliorated. For example, as mentioned in chapter 2, during the two decades since they founded the cooperative, there has been a shift away from the use of hard liquor in many transactions in the indigenous communities and thus a reduction in drunkenness and domestic violence. The Zapatista Women's Revolutionary Law (appendix B) has been an influence on governance in Chiapas, as the increasing presence of women in leadership positions in civil society demonstrates. Some have chosen not to marry or have refused a marriage that would interfere with their independence. Others have married men who are in sympathy with greater independence for women. Their weaving brings these women satisfaction as well as income, but some struggle to find time for weaving amidst their family obligations. But it is encouraging that some of the most accomplished weavers are young mothers who have managed to find a balance in their lives that allows them to weave and to participate in their cooperative in addition to caring for their children and supporting their husbands' work.

THE FIRST TEXTILES

My mother told me I had to learn to weave; but I didn't obey her because I didn't like the idea of weaving.

Rosa González, Jolxic

My mother taught me to weave. At the beginning, it was very difficult for me. I couldn't lift the loom so the first thing I made was a play weaving. My mother told me, "You should first weave your blanket, and if you do it wrong, it doesn't matter, you can use it anyway." Then she taught me to wash it and make it the way she told me, and with that, I began to learn to weave.

Later, my mother taught me to weave my skirt, but it was more difficult than I expected. I didn't know how to do it. She scolded me and hit me with the stick that we used for weaving. I started again and I did it right, but then I made a mistake so she got upset and scolded me. It was hard work, but I learned how to do it.

Francisca Pérez, Chichelalhó

My mother told me I had to learn to weave; but I didn't obey her because I didn't like the idea of weaving, and she made me angry. When I was young, I thought that everything that my mother and grandmother told me was bad.

Pascuala Patishtán, Bautista Chico

My mother taught me the work of weaving and making yarn. First, I learned to spin and then to weave.

I was nine years old when I learned to spin and to weave. I would have learned it when I was younger but I had to take care of my little brothers so that my mother could work.

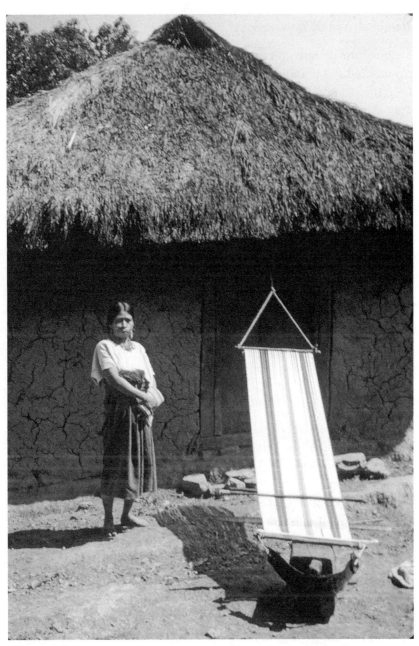

Pantelhó weaver with backstrap loom, 1977. Photo by Joan Ablon.

Rosalinda Sántiz, Bayalemó

I learned the designs and symbols of the weaving by copying the works of my mother and grandmothers. To create the colors I did the same. We keep the old work to use as a guide, and I try to achieve the same colors. Each symbol has a meaning but we don't know them anymore.

I sold my first work for three thousand of the former pesos. At that time, the currency hadn't changed yet, but for me it was a lot of money.

Manuela Hernández, Tzutzbén

I learned to weave from my mother. She used her loom to weave our clothes and her own. She spun sheep's wool.

I began to weave when my mother said to me, "You have to learn to weave so that you can make your clothes." I don't remember my age but I was very young. I learned to weave not because I wanted to, but because my mother asked me to. My first weaving didn't look very good, my shawl even less, but the good thing was that it was my own work. I was satisfied because my work improved.

Magdalena López, Bayalemó

I learned to weave differently. My mother had already died. The women of the community wove and embroidered with the aim of selling their work. No one taught me to weave because I had no mother. I saw these women weave and I had a great desire to learn.

I was seven years old when I learned to weave. Although I told my step-mother I wanted to learn, she didn't want to teach me, and she told me that if I really wanted to learn to weave I should go to my mother's grave and dig up her bones. That's what she told me; she didn't want to help me. When women threw away yarn, I used to pick it up, tie it together, and play with it. My father was moved when I told him that I could also do what these women did, so he bought me yarn.

I began to practice but it didn't come out well. I wove a white cloth, made a neck opening, and put it on. I couldn't weave very well, I was too young.

I had an older sister who never learned to weave, but I really wanted to learn. As I finished a piece of clothing I made another, and each time it was better. Then I began to pay attention to embroidery, and it didn't take me long to learn what we call *sat luch* [eye of the embroidery]. With two or three pieces of clothing I learned to embroider, and I made little blouses and I sold them. They weren't very good but they sold, so it didn't cost me much to learn in spite of having no one to teach me.

When I was eight or nine years old, I used to run home from school to weave, and my father sold the little blouses that I made in San Cristóbal.

I learned to weave and embroider by observing the other women. It's not that I became an expert, but I think that my strong desire to do it really helped me.

My father argued with my stepmother because she didn't want to teach me to weave. He told her that I was very intelligent and I could learn. Without intending to, I overtook my stepmother, and now I teach her how to weave all the new designs that we create in the cooperative because she doesn't know how to do them.

I began to learn to weave as a child because I watched my stepmother when she was weaving. I was always next to her, and that's how I learned to weave. She always told me, she said it ironically, that she couldn't teach me to weave because she was not my real mother. But I never gave up.

I got the loom that had belonged to my mother so that I could begin to practice weaving. That loom is worn-out now so I don't use it anymore, but I still keep it.

In the past, almost no one in my community knew how to embroider, but today the majority of women here learn to weave and embroider when they are very young. Although their mothers know how to weave and teach them the basic techniques, they look for other women to teach the girls more.

Pascuala Patishtán, Bautista Chico

My mother gave me old yarn so that I could learn to weave. It broke easily but my mother said it was a good way to learn because when I broke the

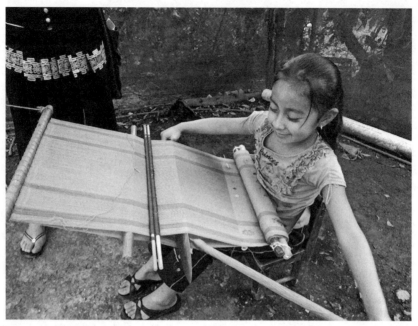

Magdalena López López's daughter, age nine, Bayalemó, 2015. Photo by
Charlene M. Woodcock.

yarn I would have to learn how to fasten it together again in such a way
that nobody would notice [the break].

Learning to weave was very difficult. If the yarn is good there is no
problem, but if it is badly spun, it breaks often.

When my mother realized that I was capable of weaving my nagua
she said to me, "I'm glad you've learned to weave; now why don't you try
making a *rebozo* [shawl] for your sister?" I started weaving it but the loom
was too big for me and it took a lot of effort to do it. My mother used to
tell me that I had to learn to weave because I wasn't going to live at home
forever. She said, "With time you will learn to weave the different sizes.
What if you end up living with a family that isn't wealthy, and they press
you about your work?"

And so I learned to weave. We didn't sell our craftwork; only when we
were in need did we weave things to sell. My mother used to say to us,
"Learn to weave so that you have clothes to wear." We were growing fast

and we needed clothes. "If you don't want to work, then cover your bottom with your hands." I believe that because of that [threat] we obeyed.

My mother told me that my grandmother didn't know how to weave. My grandfather was a farmer and he worked very hard, so my grandmother spent her time making tortillas, and when she finished that and making dinner, she went to see to the horse and brought it water; then she came home and made tortillas again. If she hadn't finished everything, my grandfather got angry and hit her with a whip. So my mother couldn't learn to weave from her mother.

My grandfather died when my mother was five years old. The family began to suffer from hunger because they couldn't get corn to make tortillas. An uncle invited them to his house to make tortillas, and he gave them food. His wife knew how to weave. My mother watched what her aunt did closely, and when she got a little older, she quickly learned to weave. "I think I learned well because no one scolded me," my mother said. With time she learned more and started practicing with grass and yarn. No one taught her; she learned on her own.

Juana Jiménez, Bautista Chico

I don't remember at what age I learned to weave. I wasn't raised by my mother because when my father died she married another man, and I was raised by my grandmother. She taught me to work.

First, I learned to spin. My grandmother told me that if I finished spinning I could eat, but if I didn't, I couldn't eat.

It was very difficult for me to learn. I had to weave everything evenly and if I didn't do it well my grandma scolded me: "How is it possible that you don't learn to do it properly? I am going to hit you with the *petet* [spindle]!" My grandma thought it was necessary to hit me so that I would learn.

She used to say, "Prepare your loom properly so that you don't suffer later because you didn't do it well." And she was right because if you don't prepare the loom correctly, the thread breaks very often.

When I was a little girl, my grandmother spent all the day weaving, she hardly slept. She got up very early in the morning to weave, and she woke me up at dawn.

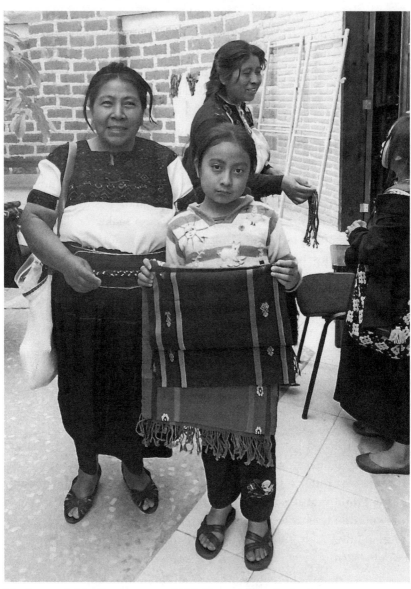

Mother and daughter weavers, 2015. Photo by Marla Gutiérrez.

The tortillas she gave me were few. She lived alone and it was hard for her to take care of me. My aunt advised me to learn to work so that I could help my grandmother. Even though at the beginning she hit me when I did something wrong, I liked learning to weave. I felt proud when I saw my achievement. In the past there were no sweaters like we have today. We had to weave woolen rebozos. When it was cold, we used to wear two to protect ourselves.

Celerina Ruiz, Oventik Chico

Neither my mother nor I knew how to weave. I wanted to learn, and my neighbors knew how, so I asked my mother if she would do me the favor of asking them to teach me to weave. They said yes because they are good people.

We arranged for me to go to their house each afternoon to learn. At that time I was twelve years old and studying in elementary school, so I was busy during the morning. Little by little, I learned.

It took me about a year to learn to weave. At the beginning I felt it was very difficult. I learned to dye yarn and everything else. The woman who taught me did it very well; she was my godmother at my baptism.

My first work was a tapestry, and it was very crooked. But my godmother knew where to sell arts and crafts, so I asked her for help, and she sold it for five or six pesos. With that money I bought more yarn. Then I prepared the warp by myself for my next work. I wove three pieces, little tapestries. My father knew San Cristóbal well, so he went there and sold my tapestries and returned home with money. I believe he sold them for fifteen pesos each, at the market next to Santo Domingo Cathedral.

Pascuala Pérez, Yochib

I learned to weave when I was about twelve years old. I didn't learn before because my father took me to work in the fields, to sow the milpa. He only sent me there, not my sisters.

We went to the hot country [the lowlands, where plantations are located] to sow corn; I don't remember in which municipality. At the

age of fourteen I wove my first bag, and I sold it here at the cooperative, Jolom Mayaetik.

THE WEAVING OF OUR GRANDMOTHERS

The serpent and the toad both came from the stone. The Maya carved everything in stone, and the very skilled women converted them into woven designs.

Magdalena López, Bayalemó

In the past the weaving process was very laborious. My grandmother told me that they spun cotton. They didn't buy thread like we do now; they had to prepare everything. I don't know where they got it; only that they had a place where they prepared the cotton, and then they wove the blouses and the men's clothing. We no longer have to do all that.

Now, we buy the cotton thread in the store; it is ready to use, and we only have to make balls and can weave it quickly. We cannot compare the work of our grandmothers with the work we do today. Life has changed, but I don't know if it has improved or worsened. Before, everything was more difficult. I agree with Pascuala: now we look for the easiest way. We use commercial yarn instead of spinning natural cotton and wool.

Our grandmothers used to weave the cotton cloth, but now it is possible to buy cloth made in a factory, and we just add the embroidery.

In the time of our grandmothers there weren't many embroidery designs. They just made the sat luch and the *be lukum* [literally, "way of the earthworm"]. Almost no one knew how to embroider well. The embroideries of the past used the traditional red or cherry color.

The embroidery designs have names, but we don't know some of their meanings. The names of the designs are *xch'uch'* [frog] and *xpokok* [toad], and they are so named because they have these forms.

There is also a raised design called uni santo [little saint], and another called *pepen luch* [butterfly]; that's what we call them, but we don't know what they signify. There is another design called *chon* [ser-

pent] and another called *kupomte'* [handsaw] because it looks like a row of thorns.

We learn to weave these designs, but we don't know their meanings. There is also a design they call *cruz* [a square cross, carved in prehispanic sculpture], but few know what that one signifies. It originated long before the arrival of Catholicism.

I learned to weave from my grandmother, so I know the names of some of the designs. We have samples of the designs used by the ancient Maya, and also the ceremonial clothing of Mother Rosario [the Virgin Mary] with woven designs in the shape of a bird, called *tuluk'* [turkey]. We cannot make up other names for the designs because we don't know what names we should give them.

We have named some designs for their form. If we have learned the names of some designs, it is because they were handed down from generation to generation. When someone learns a design, the rest of us copy her, and that's how we expand the weaving and embroidery tradition. There isn't anyone who knows the history of the designs. I am not capable of interpreting their meanings. But those I do know are sat luch, *max* [monkey], *pak'al luch* [embroidered weaving], *jun luch* [a weaving], and so on.

There is a cooperative of artisan women called Sna Jolobil [House of Weaving], where I found a thin little old book that mentions the names of other designs such as *ch'ix k'anal* [star with thorns], *bakil choy* [fish spine], and *tsib luch* [fern]. The names correspond to the shapes they imitate. The book was published long ago, but I still have it. I don't know where they found it; I have kept it in my house. Some of the woven designs that appear in the book are similar to ours; I don't remember what the others are called, but I think that they have just invented some of the names. They aren't well chosen.

Actually, we don't know where the designs came from or who created them. We don't know the origin of the seed that God has given us, we only know that these designs, which each of our communities has, are very beautiful.

My grandmother told me that the designs tell the story of the serpent and the serpent's path, and she also spoke about the turkey and the ancient symbols.

They say that at first the symbols were carved in stone, but because the first men and women were very intelligent, they were able to reproduce them in weaving designs. So it was, from stone to weaving.

The ancient Maya were very intelligent; they drew [carved] an enormous serpent and a toad, and represented them in a design. The serpent and the toad both came from the stone. The Maya carved everything in stone, and the very skilled women converted them into woven designs.

María López, Bayalemó

Some people ask us about the designs carved in the stones, if they are our calendar. They call this design various names, and I believe this design represents the stars because it's a very good one taken from the Maya stones.

In order to learn the designs, we keep the pieces that our mothers and grandmothers wove. Even if they are dirty and worn, we'll keep them so that we can transmit the knowledge from generation to generation.

Manuela Hernández, Tzutzbén

It's said that in the past they bought unspun cotton in baskets; the size of the basket was called *meru*. I don't know the exact size, but the [baskets] were sold in San Juan Chamula.

Our ancestors beat the cotton with two sticks in a petate to extract the seeds, and then they beat it until it extended to a measure of four fingers. Then they turned it over and beat it again until it reached the measure of a *job* (arm's length, or more than a meter). They had to achieve at least a meter of length each day or they were scolded. [After the raw cotton was beaten and extended, it was spun into fine yarn.]

It was difficult [work] because the thread had to be very thin in order to be used to weave clothing. When they used up and spun the contents of the basket, they had enough cotton to weave a blouse or pants. After this process they could string the warp of the loom. They put atole on the cotton yarn to strengthen it. Unlike today, when the yarn is already spun and dyed, in the past they had to do everything, using *tz'uj*, *nok* and *tulan* [oak bark] to dye the cotton. Like our ancestors, my mother [first]

used natural cotton fiber, but over time she has begun to use commercial cotton yarn and, little by little, has forgotten the cotton fiber. Since the Mexican government began the modernization process, people have stopped using cotton fiber, and instead use the commercial yarn the mestizos sell, which is easier to prepare.

THE HUIPIL OF THE VIRGIN

We believe that our Blessed Mother helps us through our dreams. She does not give us money, but she gives us strength to carry out our work.

Magdalena López, Bayalemó

We always go to the fiesta of Ixtapa. Everyone goes to church to offer flowers and candles to the Virgin. One day, my sister and I were sitting in church when we thought of the idea of making a huipil for the Virgin. We said nothing to our husbands, but we thought, "Yes, we have to do it! We're going to see if we can. The size doesn't matter. How can we measure [it]? We'll have to estimate the measurements."

We decided to make it for the next year's festival. We had to choose the design of the brocade [that would decorate the neck and sleeve openings], but we knew that our God and our Blessed Mother would help us choose it. Our vision would not be in vain.

Then we told our husbands what we had been thinking, and they said they thought it would be good to do.

We started our work six months before the festival. To begin, we needed to speak to God so that we would not fail and could fulfill our promise to the Virgin. We decided not to tell anyone else what we were doing until we had finished the work.

We thought about the size that we should make the huipil and bought all our materials. It was very long: I believe *lajun* [10 cm] by *jch'ix* [18 or 20 cm]; I don't remember exactly.

But before we began everything, we burned our candles and prayed. We each had our own candle and incense. We didn't say many words

out loud; we just made a prayer. When we finished burning our candles, we began to prepare our weaving. When we had the foundation of our weaving prepared, each of us wove half of the work; in the same way we made the sleeves.

We burned our candles and prayed again when we had half the weaving done. And we finished the work a few days before the festival. We fumed the huipil with incense because it was a special garment for the Virgin, not ordinary clothing like we make for other people.

During the weaving process we burned incense and offered our loom to our Blessed Mother every day. We asked for our thoughts to be realized. And so we made the huipil for the Virgin, well-fumed with incense and with much respect.

We just wove rows; we didn't count them because from the start we didn't worry about how much money we were going to spend. If we needed more thread, we bought it between the two of us. The size of the brocade is more than three jch' ix with four fingers, apart from the neck. [The brocade measures 50 cm from shoulder to chest, with a neck opening of 17.5 cm.]

The first symbol we wove was the *luch maya* [Maya design] carved in stone, and then the *sepajtik maya* [Maya round design]. We chose this type of design because it is the most highly valued. Because we wanted to offer the Virgin three huipiles in three years, we chose the most beautiful designs.

When we had just a little time left, our husbands helped us. We couldn't just deliver the huipil, we had to find an elder who could ask God to bless our work.

We saw that it would be difficult to finish the weaving in time because it was very long; sometimes we slept only three or four hours before dawn. It took much work to finish the weaving because it was very long. When we were almost finished, we drank bitter coffee to stay awake.

I stayed at my sister's house to work, and her husband also stayed awake at the end, to accompany me home.

We made a great effort. We had to summon all our will to fulfill our promise of finishing the huipil in one year. We prayed with an elder to ask God that our effort would not be in vain: "We ask that our Blessed

Mother reward us for our work, that she give to us as we have given to her."

At the ceremony there were eight of us—two elders and their wives, and the two of us with our husbands. We bought fireworks and brought incense, together with the offering to the Virgin, and the elders brought flowers and candles. We arrived at the church in Ixtapa the evening before the festival.

We left at nine o'clock in the morning. We carried the huipil wrapped in a cloak and surrounded with candles. Besides the blessing of a priest before we delivered it, one of the elders gave a prayer to God that nothing bad would happen to us as we walked to the church to offer the tapestry to the Virgin.

We burned the fireworks and played music on our procession to the church. When the musicians arrived we gave them drinks. And once we made the toast, we took the flowers and candles with the huipil in the center and we started walking. The person with the fireworks went first.

When we entered the house of our Blessed Mother, we walked and prayed together with music and fireworks. The musicians stayed at the church entrance.

We gave our offering to the sacristan of the church, and he decided with his helpers how to dress the Virgin.

Because we didn't know the Virgin's measurements, we took scissors, needles, and thread with us to adjust the neck opening if necessary. When they put the huipil on the Virgin, the neck opening didn't fit over her head; immediately we adjusted it, so that the head could go through the neck opening. It looked beautiful; we took photos, and we have them at our house. When we left the church, we lit the candles and prayed again. The elders tasked with carrying out the ceremony of the huipil offering to the Virgin lit candles to God. They prayed and asked for forgiveness for our faults, "Please, so that we will not be so poor here on earth, give us what we need as we give you this clothing."

We stayed in town that night because the next day during the fiesta we had a duty to burn candles that we had brought. The next day we went with the musicians and also with two pyrotechnicians who were in charge of the *castillos* and *toritos* fireworks.

Once this work was finished, about six or seven in the evening, they burned the fireworks in front of the church. Many people arrived; at the festival of our Blessed Mother there are many spectators. Men and women surrounded the church to see the fireworks.

After the spectacle the elders offered another round of candles. This prayer was to say to our Blessed Mother that all this work was done in her honor, to ask that she reward us for what we have expended.

The elders prayed during the night. When the festival was all over we had dinner, and the following day we went back home very early in the morning, around five or six o'clock. We did all of this three times, delivering our huipil offering to the Virgin at each fiesta for three years.

The last time we did the huipil offering was two years ago, because we decided that it was best to give three huipiles to our Blessed Mother. We couldn't afford to offer a huipil every year, and that's why we decided [on three] at the beginning. We knew that it would cost a lot of money each year. The fireworks are very expensive, and the transport to Ixtapa to deliver the huipil is very expensive too, because we don't have a car. And we had to pay for the food and drinks of the relatives that came with us. We paid all of those expenses between my sister and me, because it was us who offered the huipil to the Virgin.

We bought tortillas, refrescos, and whatever was consumed. After we delivered the huipil, we gave a meal to the elders, the pyrotechnicians, and the people who came with them. We didn't stop spending money until the ceremony ended. I believe we spent two or three thousand pesos each. The fireworks cost more than one thousand pesos, and besides that, we also paid the transport, food, flowers, candles, and other things.

My sister and I thought about whether we should do it again. We first offered the huipil in Ixtapa, so we thought of offering a huipil to the Virgin of our community of Bayalemó. We're considering offering two huipiles in two years, one to the Virgin of the Assumption and the other to the Virgin of Guadalupe.

Our second huipil is smaller. I thought we could make it in one month, if we worked at it daily.

When we began, we gave thanks to our God and fumed the materials with incense. In this instance it was different when the festival arrived;

the catechist or minister came with the believers to our house for the huipil. We offered them incense and candles.

In our church there were fewer expenses because it is nearby and we didn't need to pay for transport, although several people accompanied us. We also looked for an elder to come with us to this ceremony. He placed the huipil in a basket and he thanked God for allowing us to finish the huipil, as nothing bad happened to us in the process. Once he had prayed he also asked God to give us corn and beans and money, chickens, and turkeys.

When the moment arrived to dress the Virgin, the catechists put on the huipil or asked us to do it, and after that the elder offered candles and asked God to reward us for all that we had done.

We have fulfilled our promise, and we think that our Lord and our Blessed Virgin will reward us, since if we gave nothing, how would we receive?

Before we made the huipil of the Virgin, I had a dream where I was asked for a very long tapestry. It was a woman who came to give me the work. She said to me, "You are going to make this tapestry, and it will take a long time." "That's fine," I answered. I wasn't afraid in my dream, and I accepted the work. The Virgin of Ixtapa is the Virgin we venerate, because we want to learn to weave better, and also want a little bit of money here in our life on earth.

Sometime after we delivered the huipil to the Virgin, my sister told me she dreamed that Yolanda Castro came to her house and said to my sister that she and I would be given awards for the weaving we were doing.

A little time later Yolanda came and proposed that we weave a tapestry to show all the traditional designs. I agreed and thought, I believe that if I'm going to succeed, I can't make it alone. I trust my sister because she can remember designs that I don't know. She could do the patterns she knows, and I would do the same; we wouldn't repeat them, and we would both be paid, because it wouldn't be fair if only one received money. Then I told my sister of Yolanda's proposal, and she accepted too.

So that was how my sister dreamed of the work that Yolanda proposed to us. A similar thing happened with my husband. Before we went to the offering ceremony in Ixtapa, my husband said out loud while he was sleeping: "I understand your message, Blessed Mother, I

understand it." Thus, we believe that our God and our Blessed Mother are powerful.

We believe that our Blessed Mother helps us through our dreams. She does not give us money, but she gives us strength to carry out our work.

When we finish weaving a huipil for an offering, we have to wash it, but we cannot wash it in a river or stream; when we wash it, we perform a ceremony; we fume it and wash it on a table.

Because it is not a common piece of clothing, we cannot wash it like the other clothes or hang it with our clothes, we have to buy a new clothesline just for it. We also fume the rope with incense. We have to treat it with respect. We fume the huipil with incense while it is hanging, until it is dry, and then we keep it without any incense.

We spend ten or twenty pesos on each huipil we make, and so the expenses grow.

My sister and I were the first ones to make a huipil for the Virgin. Later, other women did so as well because they saw that it was a beautiful thing to do. Two years ago there was still someone offering clothes to the Virgin, but now no one does so. Petrona wove the clothes for San Lorenzo because she dreamed that the saint's clothes were very worn.

The sleeves of the first huipil we made for the Virgin each measured 50 centimeters long and 30 centimeters wide; and all together the huipil was 110 centimeters wide and 60 centimeters long. The brocade measures around 80 centimeters in the front and 80 centimeters in the back. The brocade on the front was more difficult to do because we needed to leave an aperture for the hands. There was also brocade around the neck measuring 18 centimeters. Altogether, the brocade measured 178 centimeters, plus 54 centimeters on the sleeves.

The first huipil took us six months to finish. We wove the sepajtik pattern, and we had to work at night as well. With this experience, we were able to finish the second huipil, for the Virgin of the Assumption in Ixtapa, in eight months. We used the Green Maya design, and we finished it one week before the festival. And on the third huipil we wove the Calendar design, and we also finished it in eight months. The symbols on the huipil of the Virgin had to be like those our grandmothers made.

We offered the huipil on the day prior to the festival, August 13; the fourteenth was the festival day, and we burned the fireworks; and on the fifteenth we returned home.

During the festival the catechists have to change the clothes of the Virgin all the time, because lots of people offer clothes to the Virgin, even the *kaxlanas* [mestizos]. It doesn't matter if the Virgin wears our clothes for only a few hours; she values all the work we have done. The sacristan keeps the clothes of the Virgin.

María López, Cabecera

We have learned to improve our work; who knows if it's the Virgin herself who speaks through us and our work. We pray to our Blessed Mother to give us intelligence and to provide us with food during our life here on the earth. Our sole concern is to offer clothes to the Virgin.

Our husbands help us with the expenses for the huipil of the Virgin because we couldn't afford them alone.

I believe that our Blessed Mother helps us to make the huipil, because when I was weaving the huipil for the Virgin of Guadalupe I still had a nursing baby, and he was crying, so I went to put him in bed to sleep. It was during the day, and I left the loom for a while to soothe my baby. And suddenly I heard the sticks of my loom moving, and I looked up to see what moved, and at that moment I said, "It's our Blessed Mother! She is here with me! What I am doing is not just play." That's why our faith continues.

THE BACKSTRAP LOOM

In the past I used just one loom, but today I use looms of different sizes.

Pascuala Patishtán, Bautista Chico

The stick of the loom for weaving is called *bik'it jalamte'* [small sword; *g* on loom illustration]. The stick that my mother used was used by her mother and her aunts. It's the one I now use.

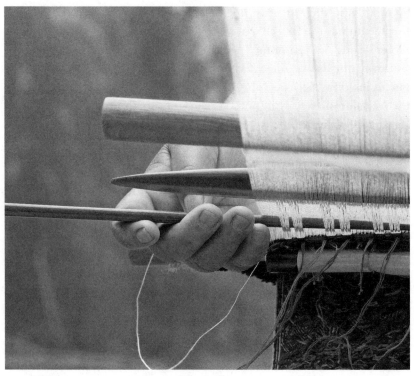

Loom detail, 2015. Photo by Marla Gutiérrez.

There is another stick that holds the loom; it is called *jit'ak'ubte'* [warp bar; *b* on loom illustration]. The stick can be made from different kinds of wood, but it has to be straight and stout. We create large textiles, so the stick can't be thin, or it will break when we pull on it. We use different kinds of wood to make the loom, such as *pomo, ch'ate'*, and *tiliv*. In the past I used just one loom, but today I use looms of different sizes because we have learned how to make bags of different sizes. We bought the bik'it jalamte' in town. Now they cost around seventy pesos; they sell them every Sunday. We also got the jit'ak'ubte' and the *olinabte'* [thin sword; *h, j, k* on loom illustration] on our own.

Magdalena López, Bayalemó

The *comén* [*u* on loom illustration] is the stick that measures the threads that are going to be used for each work. The fundamental parts of a loom are the *jit'ak'* [*a* on loom illustration], a thin rope used to suspend the weaving and the *ta'mpat* [*p* on loom illustration], a wide rope or belt that is tied around the waist. We use a bone or wooden needle to spread the weaving. In the past bones were used more often—chicken, turkey, or sheep bones. We also use a wooden comb to comb the thread. In the past the thread didn't break as easily as today.

All these tools are necessary to make blouses; if one of them is missing, we can't weave.

As I mentioned earlier, there are several sticks, and we place them in different parts of the loom according to their thickness. Sometimes we use reeds. If we need to combine several colors when weaving, we use different sticks for the same purpose. For some embroidery, we use the colors red and white. We need all the sticks so that we can weave.

OUR WEAVING DESIGNS

In each municipality the designs are different; they don't look alike. . . . Every community has its own weaving and embroidery designs. I believe that God put us in different groups.

Manuela Hernández, Tzutzbén

There are several ways to make textiles. If we don't make the woof [horizontal] threads tight enough, the cloth will not be good, nor will the embroidery, whether it is a blouse, a pillow, or a tapestry. We [make the woof] loose on purpose when we know we are not going to be paid properly. When we do it well, we weave it together strongly and we locate the design points correctly. If the weaving is going to be used in a ceremony, we make it with rows that will stay flat. There are different ways to do the work, and it looks different when it is finished.

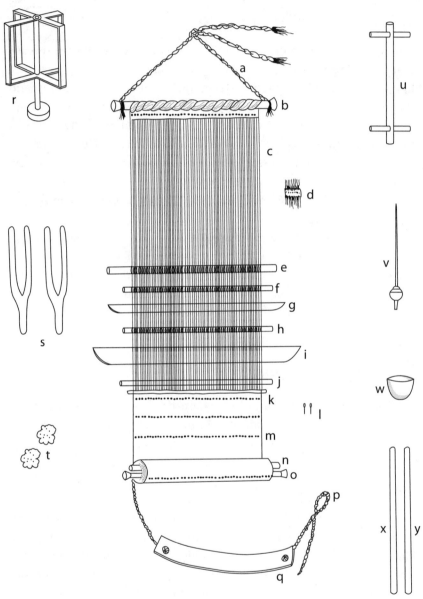

Parts of the backstrap loom. Illustration by Bill Nelson. Copyright © 2018, University of Oklahoma Press.
See next page for figure key.

Figure key: Part label followed by Tzotzil name in bold; Spanish name in italic; English in Roman

a: **ts'uy; jit'ak';** *lazo amarrado a un árbol o poste*; tie cord
b: **steel; jit'ak'ubte';** *palo superior de donde se amarra el lazo*; warp bar
c: **snaul;** *hilos de la urdimbre*; threads of the warp
d: **sjot'obil;** *peine*; comb
e: **yakan;** *vara de paso*; shed rod
f: **yolanabil;** *vara de lizo*; heddle rod
g: **bik'it jalamte';** *machete chico (en algunos tejidos de lana)*; small sword
i: **muk' jalamteil;** *machete grande*; big sword
h, j, k: **tstsubil; olinabte';** *machete delgado para levantar los hilos y tejer los diseños*; thin swords (used to raise the thread and weave the designs)
l: **chi'xte';** *espinas usadas para fijar el templero a la tela tejida*; finishing needles
m: **jalbil xluchol;** *tela tejida*; weft
n: **sbalobil pok';** *palo enrollador*; roll-up stick
o: **steel ta olon;** *palo inferior donde se amarra el cordel de la faja*; loom bar
p: **yak' il ta'mpat;** *cordel atado al telar de cintura*; cord to tie leather strap around waist
q: **ta'mpat;** *faja de cuero*; leather belt
r: **tuki'om no';** *devanador*; winder
s: **smajovil tuxnuk';** *abatanadores para el algodón*; cotton fullers
t: **tuxnuk';** *algodón crudo*; raw cotton
u: **sniobil; comén;** *Urdidor*; warper
v: **petet;** *huso o malacate*; spindle
w: **voch;** *jícara en la que gira el huso*; bowl in which the spindle spins
x: **sbuk' ul sakil no';** *bobina para hilo blanco*; bobbin of white thread
y: **sbuk' ul stajal no';** *bobina para hilo rojo*; bobbin of red thread

Magdalena López, Bayalemó

We don't usually combine cotton and wool in weaving; only a few women do so. Once, a woman brought a textile to the cooperative to sell. The warp consisted of cotton thread, and the weft was of thin red wool yarn. [The textile] was made of white cotton with red wool embroidery; it was considered very pretty, but it hasn't sold. When we use thick wool, the textiles don't turn out well. But every combination of materials is possible, if we are creative.

In each municipality the designs are different; they don't look alike. I would never wear the clothes of the Chamula women; I would never go out on the street in those clothes, because I am not from the community of Chamula. Every community has its own weaving and embroidery designs. I believe that God put us in different groups.

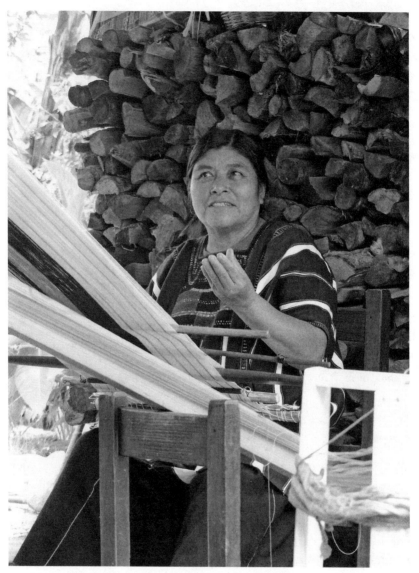

Maria with loom, 2015. Photo by Marla Gutiérrez.

THE BREEDING OF SHEEP

I once sheared one of my sheep and didn't bathe it with the chi-jilte' leaves, and it got sick with a fever and died. I was very sad because for me it was like the death of a person.

Pascuala Patishtán, Bautista Chico

For a very long time our ancestors kept sheep because they made their clothes of wool. In the past, clothing was made only of wool; they didn't use cotton cloth like we do today, so it was essential to keep many sheep.

My mother was an only child, and she grazed thirty sheep that belonged to her uncle. She lost her parents, and as her uncle had no children, he raised her. In the past, there was a lot of land for grazing. Now that is no longer the case, and the sheep are kept in corrals; they cannot be left [to roam] free.

We do everything possible to raise our sheep so that we can use wool, because the commercial woolen yarn is very expensive.

Sometimes, it's not easy to breed sheep because they don't reproduce very much. However, with just two or three sheep we can get enough wool that there are few colors of yarn we need to buy.

The skirts that we wear in my community are still made of wool; what has changed are the shawls.

Each sheep produces different amounts of wool. Some have long coats and some short. We use the long wool fibers for the weft of the loom, and the short wool fibers we use for the warp. That is what my mother taught me.

The long hair is easier to spin, although this also depends on the quality of the wool. The smooth hair is used for the warp. The strong and thick wool we use for the weft, where the length of the fibers doesn't matter as much as the quality. I shear my sheep every six or seven months.

Sheep have different coat lengths because they belong to different breeds. The big-bellied sheep have short coats. The thinner ones have long coats—even though they eat well, they don't get fat.

One sheep gives approximately one kilo of wool; if the sheep is small, [the yield] might be a little less. The sheep live for five or six years.

The males produce more wool than the females because they don't get pregnant. When females deliver they are weaker and produce less wool. However, young female sheep produce plenty of wool; male sheep produce less wool when they get older.

The colors of the sheep are black, white, gray, dappled, and *tsajal chak xik'* [reddish]. When we use this reddish color for the *chilil* (wool coat) we call it tsajal chilil, and this color doesn't need to be combined with other colors.

After shearing the sheep we put *pinole* [traditional drink made of roasted ground corn and spices] on their skin so that it doesn't get infected.

All the sheep have names. Even if we have thirty sheep, we call them by name and they understand. When they are newly born, we name them according to the day they were born. For example, if a sheep is born on a Monday or Tuesday, that is its Mayan name; or if it is born on the festival of the Candelaria, we call it Candelaria. If it is born on Wednesday, we call it *kulix*, or if it was born on Sunday we call it *romin*.

A woman can breed only about twenty sheep on her own. If there are more than twenty, women breed them together as a collective. People who have money have more sheep because they have more lands for grazing.

In our case, we only have ten or fifteen sheep, but for us it's a lot. It's women who have the responsibility of keeping the sheep, much more than men; in fact, it's very rare to see a man herding sheep.

When I was growing up, I used to graze sheep with my sister, and then we had to spin. Our mother told us we could play only when we finished our spinning. My sister wanted to play with me, and I asked her to help me spin so that we could play together. Together, we spun so we could play later.

Not all men help with the work of keeping sheep. One of my brothers helps care for the sheep and grazes them when his wife has other work to do, but this is not very common.

After the sheep are shorn, we talk to them and cover them with leaves of chijilte' so that they can resist the cold and rain.

On rainy days, we look for chijilte' leaves, and we boil them and use this water to bathe the sheep so that they are protected from the rain and they don't get sick.

I once sheared one of my sheep and didn't bathe it with the chijilte' leaves, and it got sick with a fever and died. I was very sad because for me it was like the death of a person, not like the death of a dog or a chicken.

Sometimes, sheep die because they eat a plant named *ch'ixte'* [wild chamomile]. They come down with a fever and die. We call this illness *k'ak'al ik'* [swelling of the stomach]. If we find out early that it's sick, we can cure the sheep; if we don't realize it's sick, the sheep dies very quickly. To cure this illness we give the sheep pinole or *matul* [a flower].

The sheep also fall ill with a cough and we cure them with *trago* [aguardiente, or *pox*].

Female sheep are similar to women when they are pregnant, because sometimes the lambs come in breech position; there are people who know to place them properly for the birth.

Some people kill their sheep to eat them, but others don't like the meat and call it food for the coyote. We don't agree because people eat pork, and pigs eat dirty things, while sheep eat only grass. It's not that we are poor and have to eat whatever we can; those with money and cars eat lamb and mutton as well.

My mother used to say of those people who are disgusted by mutton that it's because during the night their *nagual* [spirit] goes to the corral to eat the sheep. And when the [people] wake up, their mouth tastes like raw meat. And when the spirit can't find mutton during the night, the next day the person falls ill.

When we eat sheep, we boil it or roast the meat; we prepare it with vegetables, and we add thyme, oregano, mint, and garlic to it.

María Patishtán, Bautista Chico

I have six sheep, and from them I get enough wool for my clothes. I don't need to buy much yarn. I shear them every six months.

If the female sheep are healthy, they have a lamb every year; but if they are not, it may be two years between each delivery.

When the animals aren't accustomed to being herded by men, they sometimes get frightened and run, but when men help us in caring for them, the animals recognize them and remain calm. My mother's sheep aren't used to men, so when they see them the animals start running— even if it's a boy, they are frightened.

I, too, have observed that when the sheep are bathed with chijilte' water, they don't fall ill and the leaves protect them from the rain. The sheep also get sick with diarrhea and sometimes they die because of it.

My father-in-law knows how to shear sheep. He tells us that he practiced first with a dog and that's how he learned the technique.

My grandmother used to tell us that when there were only rams in the farmyard, it was necessary to kill one of them so that the next lambs to be born would be female.

Juana Jiménez, Bautista Chico

Sheep eat grass, but sometimes we also give them spoiled corn, cornstalks, salt, and stubble. It's important to give them salt, because otherwise they don't eat anything even if they are starving. During the dry season, we have to feed the animals, but in the rainy season lots of grass grows, and they can go out and graze.

When female sheep don't have milk to feed their lambs, we give them pozol to help them produce milk. A sheep's pregnancy lasts six months; it's only in the last month that the breasts appear.

When it's time to shear the sheep, we look for someone who knows how to do it. In my case, I don't know how to shear them because I'm afraid that I will hurt them. My grandmother knows how to shear sheep, and people look for her to do it. Not every month is good for shearing; it must be done in August.

My grandmother also used to castrate the rams, and people paid her with refrescos or alcohol; they gave her pork, chicken, and sometimes beans and corn. It's said in the community that after a ram has been castrated, the animal must not see a pregnant woman because it will die. To avoid this, the pregnant woman must be present during the castration process rather than after it.

In the past, after castrating the ram, people threw the animal's testicles in the fire and ate them. I was not allowed to eat the testicles because, according to my grandmother, they have a meaning. She said to me, "You can't eat the testicles because you are still a child and you would go mad as happens to the ram." Rams run away looking for female sheep, and my grandmother thought that would happen to me as well. And it's the same with the testicles of the rooster; we can't eat them.

Our grandparents ate sheep. My grandfather killed the sheep to eat them, but [my family] didn't eat sheep because my father didn't like its meat.

WORKING WITH WOOL

It takes me a lot of time to weave my nagua. I am weaving one now, and it's taking me almost a year to finish it.

Lucía López, Bautista Chico

When we want to work with wool, first we have to shear the sheep, then wash the wool, clean [it], and comb it. And then we spin it.

Once the yarn is prepared, we have to work out the exact measure needed to do a vest. Then we put the yarn on the comén for the warp, and when we complete the warp threads, we set up the loom to start weaving the weft yarn. When we finish the piece, we have to wash it and shape it by opening the neck of the vest. We show our work to Pascuala, the representative of our group, and if she says it's satisfactory, we begin the embroidery. This is what we do with every piece of clothing. No matter if it is a vest or a bag, first we have to wash it and then [do] all the rest.

Manuela Hernández, Tzutzbén

To make a wool nagua and a rebozo, first we have to shear our sheep. We have always had sheep, ever since we were small; we use their wool to make our clothes.

We use the wool to weave our naguas, and the yarn to weave and embroider the blouses, and that is how we work.

Pascuala Patishtán, Bautista Chico

First, it's necessary to shear the wool from our sheep. Then, we wash it and work out the measure for a blouse or a skirt, and then we spin the yarn. It takes time because sometimes the thread is very thin, and we have to take the time to spin it again. When we see there is enough yarn to weave one strip of a nagua, we make a second strip of the same length. That's how we do the nagua. I remember that my mother used to work out the measurements of the first strip of nagua, and based on that she made the second strip, and that's how one makes a skirt. [The traditional cylindrical skirt requires two panels of fabric, sewn together horizontally, to achieve the desired length.]

We have various ways of doing the work. Some of us measure the yarn and others just calculate the amount by eye. Most of us work out the quantity of yarn we are going to need, and this [effort] serves us later, when we have the exact measures we need to make each piece of clothing.

Once we have prepared the yarn for the warp, we begin to weave the weft. For a blouse, it needs to be light and smooth so that the blouse will proceed well. As my mother said, "If you prepare the wool yarn for the warp properly, the blouse will go well; but if not, when you put the blouse on it will be prickly." And so I have followed my mother's advice. I prepare the yarn for the warp and the weft carefully. It needs to be regular, because when it's too smooth, it doesn't weave well.

My late mother used to dye the yarn first before warping and weaving it. She worked out the measure of yarn she was going to use and made balls out of it—for example, a nagua takes two or three balls of yarn.

She dyed the yarn until it was a very dark black color, and then she wove it. Nowadays we are lazy and we weave the fabric without dying it first.

When the wool is ready to be woven, we boil pozol. It must be very thick. We put the wool into the pozol to make it easier to weave. Then we start warping the wool, and we place the sticks and loops to do the weft.

If we don't do this process correctly, the yarn may break easily or be too loose or even slip off the loom.

When we finish the weaving, we remove it from the loom. Afterwards, we brush the piece little by little, and we do this process with every type of textile.

In the past, my mother answered my questions and taught me. Now, I have learned new techniques, and they are what help me.

The preparation of the wool takes a lot of time; one makes little progress in a day. To make vests one needs a thicker wool, and for naguas, a thinner yarn, so [the latter] take more time and the fingers get tired. It's very difficult, our work! In the past it took me a whole year to weave a nagua. Today, thanks to commercial woolen yarn, it's faster to do a nagua because the yarn is ready to be woven. But this also implies that we've become lazy because we've become accustomed to buying our yarn.

Things have changed greatly, and now [women] wear sweaters and shawls, and have little time for [considering their] appearance. Before, we didn't use sweaters and shawls, we didn't have cotton clothing— everything was made of wool. My body was accustomed to wool; it didn't scratch me, it kept me warm.

My mother used only wool. The clothing we wore to go out was white, and we wove the belts of wool. The faja [sash] was a good length; the sashes weren't made of commercial wool.

The shawls were made of wool and we called them *mochibal.* They were of very good quality; they protected us from the rain and didn't get wet quickly. They are very warm and in winter are very good to use. Nowadays, we only use shawls; we also use them to carry our babies. Our mothers wove white and *chak xik'* [gray] woolen rebozos to carry their babies. They also wove blankets of wool. These were very wide; they wove them in two parts and then joined them [*cha'jis*]. Today we have lost all this skill; we just buy the products that the kaxlanas sell.

It was ten years ago that we began buying sweaters from the kaxlanas. Some men still use their *chilil* [wool coat] and traditional pants from time to time, but other men prefer to wear them only at fiestas.

We must admit that the manufactured clothes help us in our daily life, because we don't have to spend a lot of time weaving them—we just buy

them. Moreover, we can weave our textiles to sell, and with that income can buy new clothes or other things we want.

For myself, I would like to wear my traditional woolen clothes but I can't weave them because I don't have part of the loom anymore, the *sbuk'ul* [bobbin; *x* on loom illustration]; what I have is the *ste'omal* [winder; *r* on loom illustration]. I've been thinking I should make something.

My father didn't know how to make money, so mother had to buy me secondhand sweaters because she didn't know to weave a chilil.

Later on lengths of wool serge were for sale, and we bought them; and so were woven and embroidered clothing like we use. If we wanted these things, we went to San Cristóbal and bought the fabrics by length. Another man began to sell cotton cloth in the market and when I was a child, my mother bought this cloth, washed it well, and made blouses out of it.

A nagua of wool can last at least two or three years if we don't wear it a lot. I have a nagua that I've had some ten years, but I only use it occasionally; for instance, when I go to another town. When a nagua is well made it lasts a long time. But when it's made well on the edges but the middle is thin, it comes apart. This happened to a blouse I made, I didn't do it well. I know how to weave blouses but I'm not very good at it, so I have to pay someone to weave the part that I don't know how to do.

When I make a nagua, the edges are very strong, but in the middle it doesn't seem that there is any wool—it's very thin, and when it wears out it tears in the middle even though the edges are still strong. It's necessary to weave evenly so that all parts are strong.

Weaving a skirt takes a lot of time and effort, and it's expensive. If you buy a nagua it costs one thousand pesos [almost $100 in 2004], or if it's very cheap, four hundred pesos, but when a nagua is of very good quality, the price is higher, two thousand pesos.

Only women that have money can buy them. For example, the women who sell in the market don't have time to weave their skirts, so they buy them.

Juana Jiménez, Bautista Chico

To weave a faja you need very thin wool yarn; you make very slow progress in spinning it. It's very labor-intensive!

We weave a nagua in two parts, and then we sew the [parts] together. In the past we spun the wool; now we buy wool yarn. We had to spin the yarn because there was nowhere to buy it. We kept a lot of sheep for wool.

It takes me six months to finish a nagua because I have to prepare the wool and everything. I am not very fast; there are other women who do it in less time.

María Patishtán, Bautista Chico

When a wool skirt wears out, we patch it because a new one is very costly. We use the old skirt for work [everyday wear]. It takes me a lot of time to make my nagua. I am weaving one now, and it's taking me almost a year to finish it.

NATURAL DYES

Now we weave our fajas with commercial yarn; we don't need to spin anymore. It's less work, but the bad thing is that we've lost our culture of using natural dyes.

Pascuala Patishtán, Bautista Chico

My mother's aunt used to dye her fajas green, and she also dyed the thread to embroider her blouses. My mother never learned how to make the natural dyes.

The people who know how to make the dyes put water in a cooking pot, followed by the dye. The pots must be outside of the house, far away from people, because the smell of the process is very strong.

My mother used to tell me that if she had learned to dye, she would have taught me, but she never gave her attention to it. Therefore, I hardly knew anything about natural dyes until a woman from Spain called Gloria came to Jolom Mayaetik and taught us about the plants that can be used to make dyes. The only color I knew how to make was black.

My mother's aunt made a huipil, and she dyed the wool for the embroidery. She colored the yarn with *ch'uj* (a dye from a long time ago), and to get the color for the faja she used *tsajal ch'uj* [red dye].

Since we took the natural dyes course, we have tried different plants to make various colors. For instance, we get the yellow color from a plant called *Eugenia*.

To get a green color, the process is longer. First, we make the yellow color: we put alum in a pot along with two branches of the *Eugenia* plant. Then we add to the pot the fruit of the *on te'* [*coyo*, a big tree similar to the avocado tree] that makes a very intense green color. So every time we want to make the green color, first we have to make the yellow. Another way to get the green color is by using the *majt'as* [wild aster] and a fruit called *chail te'*, which has no translation in other languages. We get the purple color from cochineal, adding a little blue from indigo.

To make red dye, we boil together alum and *k'an ak'* [yellow reed]; after it boils we add a stick of brazilwood. The red color is a very good one because it doesn't fade even when exposed to the sun. We get the red and green colors from trees.

Before this class on natural dyes, we only knew how to make black dye, and just a few women knew how to make a red dye. In reality, almost no one makes natural dyes; the majority buy colored yarn. And we no longer weave our fajas, we buy them as well.

In the past there were no stores [where we could] buy clothes, so we had to make everything ourselves. We had to weave the chilil and the mochibal. Nowadays we buy blouses, skirts, and shawls.

The black color is very easy to make. It doesn't need alum; it's just the mixture of *ch'ate'* [a wild plant] and mud, that's all. Before, we didn't know how to use alum, but Gloria taught us. She also knew of the *chi'ilte* [sweetbush] and how to use it. If not for the class, I wouldn't be able to use it in the things I make.

It's not easy to get the chi'ilte, because sheep eat it. It's prepared differently than alum. It needs to be cooked first. Unlike the chi'ilte, the alum can be added together with the thread or clothing that is going to be dyed; it just needs to be covered very well if it's in a pot.

For the chi'ilte you put a large quantity of it in a pot, and it takes a lot of space. Before you put it in, you have to boil the water and, once it is boiling, you have to have the color ready to put in. Before you put it in, you have to put the chi'ilte into another pot. [Making] it was difficult.

Once the yarn is dyed, you take it out of the pot and cool it. When it's cool, you wash it and examine it to make sure it is evenly dyed; if some part is not dyed, you return it to boil a little more.

María Patishtán, Bautista Chico

Although we use commercial yarn today, our elders used wool to make their *fajas*. Now we weave our fajas with commercial yarn; we don't need to spin anymore. It's less work, but the bad thing is that we have lost our culture of using natural dyes.

My mother said that to get a good red color, it was necessary to check that the water in the pot was really red and that it was mixed evenly.

When you dye a skirt blue, you must put it on the fire three times; it takes all day to dye a blue skirt. It's not a short time, it takes a lot of water and firewood. We have to replace the water when it boils away, so we wait for it to boil again, and then we put the clothes in the pot. It's necessary to stir the water with the clothes all the time.

Juana Jiménez, Bautista Chico

From the fruit called on te' we get the green, blue, and purple colors.

To get the yellow color we use alum, if we have enough money. If not, we can use the chi'ilte'. Sometimes when I can't find the chi'ilte' I buy alum, but it's not very easy to find in the stores. Although they tell you they're going to sell it, they don't have it.

When you're going to dye, it's important to use a pot of good size. It's better to use a big pot for the dye process because if it's not big enough, the dye will be uneven, striped.

Weaver's hands, Pantelhó, 2010. Photo by Charlene M. Woodcock.

THE NEW DESIGNS

> The new designs are not like our clothing. This is work woven to
> sell, rather than for our own use.

Magdalena López, Bayalemó

With the new designs everything is different. We prepare the loom and
the thread in a different way. Sometimes it feels like hard work, above all
when we weave many pieces of the same type. The new designs are very
different; they represent a different taste, other color combinations, but
I believe they are good because they sell.

The new designs are not like our clothing. This is work woven to sell,
rather than for our own use. Weaving has become a way of making an
income; we no longer make clothes for our husbands, because they wear
common [commercially available] pants and shirts.

In Jolom Mayaetik we learn new designs for our textiles. Now we weave
in stripes and make tablecloths and pillowcases. The tablecloths we make

are wider than the pillowcases or the blouses; sometimes they are made up of three or four panels. We have to want to learn the new designs, we have to give [the learning] much attention.

For the new designs we use colors such as brown, black, gray, and light green. These are colors we have not used before. When we began weaving with them, we thought that the clients wouldn't like the results; but when the [textiles] were finished they looked very pretty.

I believe these colors are well received, but we would never use them in our clothing. We are never going to change the color of our clothing because the way it is, that is our tradition. Some clothing we embroider with flowers, and this clothing has changed a little. But to make our clothes in other colors, never!

The colors that we use in our clothing have varied a little over time. Our ancestors wove their clothing with the "real" red color, and made them of cotton. Today, no one uses that color; they use *guinda*, a cherry color, or some women use black. The colors have changed a little but the designs are still the same.

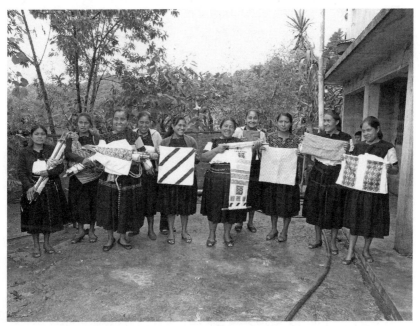

Bayalemó weavers, 2016. Photo by Marla Gutiérrez.

Afterword

Voices and Stories of the Women Weavers
of Los Altos de Chiapas, 1984–2006

> The women of the community went to the authorities of our
> municipality to ask for help, more exactly to the president of the
> municipality, Lorenzo González. He told us that he wouldn't help
> us or take us into consideration because we should only take care
> of the hens [and the] animals, and do the housework instead of
> meeting and organizing ourselves.
>
> Juana Sántiz Díaz, founder of J'Pas Joloviletik

At the beginning of the 1980s, indigenous women from different com-
munities of Los Altos de Chiapas began to meet and organize themselves
with the aim of selling their textiles. This decision changed their lives
and those of their families. This radical change in their lives can only
be understood in comparison to the previous decades, when they wove
primarily to make clothing for daily life and special festivities. They sold
very little, just a few textiles to the shops of San Cristóbal de las Casas.

By forming cooperatives and selling their handmade products, arti-
san women began contributing to the family income. Even though their
income was small, it was significant for their domestic living standards.
Apart from this economic change, there were other changes in family
life, including changes in the relationship between husband and wife.
And for the first time, women handled money. Some of them began to
travel to San Cristóbal, and others began to meet and decide to talk to
authorities of both the municipality and the National Indigenous Insti-
tute (INI), an unprecedented decision for indigenous women to make.

215

The hours-long trips to San Cristóbal enabled women to discuss their family problems together and also gave these Mayan speakers contact with the Spanish language. In the past, the men of the community had sold the women's textiles, asking a commission of between 10 and 15 percent of the total amount of the sales to compensate them for their time.

The step outward from private space to public space brought the women many advantages. For example, in addition to learning Spanish, they also began to understand how to manage their financial resources and to present their economic projects to state authorities. They began to interact with women of other Mayan language groups, especially Tzotzil and Tzeltal women, and they shared their problems as well as their joy when they made a good sale for the cooperative.

Entering into a more public life has been painful. Women participating in this process often felt alone and suffered from extreme insecurity and low self-worth, especially during the process of negotiating sales and when meeting with various authorities.

The J'Pas Joloviletik Cooperative was the antecedent of the Jolom Mayaetik weavers' cooperative, whose members' voices are recorded in this book. The internal structure of J'Pas Joloviletik was first proposed by the INI in 1984 and remained in place until 1991. During this period INI authorities controlled the administration of the cooperative and the commercialization of its products. There were also bilingual coaches, an accountant, and a bilingual promoter who later became the leader of the organization. This team also oversaw a project of encouraging the use of natural dyes among the weavers of wool. The main criterion of the INI team in choosing one representative over another was very simple: a minimal knowledge of Spanish. In other cases women chose their relatives, which later made it difficult to rotate leadership and introduce change. Yet family relationships also constituted an important source of power, supporting what UNAM Professor of Feminist Studies Marcela Lagarde said in 1991: "Power is not a natural quality but a historical construction. The first source of power creation is the expertise of the subjects in some activities and not in others. The power is not created from nothing, and the concrete powers come from specific situations and activities."

Illustrating the social and historical construction of leadership, several of the initial leaders of the cooperative stood out for their role as

intermediaries in community conflicts. They were good at listening to the problems of the different women in the community and were recognized as "keepers of knowledge." Some were known for their weaving skills and knowledge of textile patterns and symbols. Others were known for their knowledge of Spanish and their open spirit. As Juana Sántiz Díaz said, "Begin to open the eyes to walk with the heart." And thus, among coffee plantations and cornfields, in bare feet and wearing red huipiles, embroidered blouses, and indigo-dyed naguas, these women began the history of the two cooperatives. For more than two decades, their effort has enabled women to create a space for themselves and to debate complex issues of power among themselves and the importance of rotating leadership positions.

Between 1985 and 1991, the J'Pas Joloviletik Cooperative experienced its first internal crisis, due to a lack of new markets for their products and the continual deceptions of the *coyotes*, or middlemen. These indigenous or mestizo men went to the indigenous communities and persuaded the women to give up their textiles without signing any legal contract. They then sold the products in the shopping malls of Mexico City and in Cancún.

At this time the first secret textile sweatshops sprang up in San Cristóbal de las Casas as well as in Cancún. Women weavers and embroiderers worked there more than ten hours a day for miserable pay, creating textiles that would later be sold to collectors in Canada and the United States. In Cancún young women recruited with lies and threats worked on backstrap looms, in high temperatures, with little light, and without access to food or water. Their products were sold later by men in the malls of the city.

Meanwhile, most of those who controlled the cooperative were women leaders from the municipalities of Tenejapa and the municipal seat of Chenalhó, all coordinated by a bilingual promoter from the INI. This period, when indigenous women first took on leadership roles in Los Altos de Chiapas, deserves serious consideration. They were promoters of the cooperative's work and at the same time were transgressors of tradition in their communities. New power relationships were created among these women and with women leaders from other grassroots organizations.

Many of the conflicts during this time had to do with beliefs and tra-
ditions. For instance, interpretation of dreams and consultations with
the *iloles* (fortune-tellers) led to power plays among the curanderos
who supported one or another group of weavers. The power struggles
that peaked at this time manifested in dead black hens being left at the
cooperative store entrance, signs of evil that required exorcism through
cleansing rituals.

In 1991 the first division within the cooperative took place, as women
members and representatives of the cooperative raised several concerns
in their assemblies. Pascuala Gómez, representative of the community
of Chichelalhó, complained that they lacked financial information, that
they had been working for several years without a single profit report,
and that they did not have sufficient information about the management
of their store. Some women also claimed that the women who worked in
the store were mistreating them and taking pieces of clothing for them-
selves. Furthermore, weavers were never advised on how to improve the
quality of their work; some winners of textile contests never received
their prize money; other members who placed their work in the store
were never paid; and some women had been filmed and photographed
without their permission or being informed how the images would be
used. Some women also said they felt awkward when they were obliged
to pose in a particular way. In many cases, women were required to sign
documents but never received copies and did not even know what the
documents contained because many of them could not read or write.

As a result of these assemblies, the structure of the cooperative was
changed. A new board of directors was established, representing women
from all the municipalities. From then on, three representatives of each
artisan group (president, secretary, and treasurer) had to participate in
the general assemblies, and any member weaver could participate as well
if she wished.

At the end of 1991, during this divisive time I (coauthor Yolanda Cas-
tro Apreza) was invited by the INI director to advise the J'Pas Joloviletik
Cooperative. I accepted, with my only demand being that the assembly
of the cooperative had to approve my work plan. The director stressed
the need to share information with all members of the cooperative, as
well as to provide training in management and accounting. When my

proposal was accepted, I began to work with the artisan women together with a Tzeltal indigenous woman named Micaela Hernández Meza, and in mid-1992, another indigenous woman from the city of Los Angeles, California, joined us.

We then began teaching young indigenous women about financial management and accounting, from simple tasks to more complex ones. The women learned, for example, to visit the banks in the city of San Cristóbal de las Casas, where they learned about the responsibilities of the manager and cashier, and their work with clients. They also learned how to use credit cards and checkbooks, and how to open a bank account with the signature of the board of directors. And, finally, they learned to look for national and international markets for their products and to understand the currency exchanges for other countries. A special team of weavers was charged with quality control, advising cooperative members about the quality of their products and helping them with organizational problems.

THE RIGHTS OF THE WEAVERS AND EMBROIDERERS

This new period was closely tied to the political context of that time. On the one hand, amendments to Article 27 of the Mexican Constitution opened up the privatization of lands. And on the other hand, the signing of the Free Trade Agreement was approaching. These factors generated many debates and discussions within the peasant organizations whose members strongly opposed them. At the same time, the state coordinator of the INI received a serious political blow when the director and the staff under him were accused of diverting resources in the municipality of Ocosingo and were imprisoned by the governor of Chiapas, Patrocinio González Garrido.

These incidents marked an important change in federal government policies toward indigenous communities. Institutions were instructed to cease providing space to peasant and indigenous organizations, and people accused of being leftist were expelled. These developments reduced the support that the women's weaving cooperatives had previously received.

In 1992, the women of J'Pas Joloviletik took part in the Fifth National Feminist Conference, held in Acapulco, Guerrero, and they also celebrated five hundred years of indigenous resistance. Meanwhile a new generation of young indigenous women was elected by their communities or pressured by their mothers to take positions as representatives of the cooperative. It was also a troubled time for the cooperative's store and office due to confrontations between groups from the different municipalities of Los Altos de Chiapas. It was not unusual to have windows and doors broken and anonymous threatening messages sent to our adviser and representatives: "You'd better stop working or else we are going to screw you and accuse you all of stealing money from the artisan women."

This was a period for reflection and analysis about the rights of indigenous women. The new representatives began to open their own bank accounts and use checkbooks and make payments to the weavers for textile sales. They assumed the challenge of being part of the new board of directors gladly and with a sense of responsibility, and they visited the different municipalities represented in the cooperative. This was exciting for most of the women because they had not left their communities before and did not know the markets in the other municipalities. That is how, among coffee plantations and the aroma of coffee, beans, tostadas, and pozol, these young women experienced their first assemblies and regional meetings. Young women began to get to know each other and to share their dreams and fears.

In time these young representatives moved to the city of San Cristóbal and began paid employment with a dignified salary, better than the one they earned as domestics. They organized themselves and looked for a house to share, and after working the whole week they went for a walk together on Sundays. Thus, together and with the advice of their mothers and grandmothers, they confronted the problem of the threats to the store.

These women remember themselves as a new generation in resistance who refused to serve merely to ornament the regimes of the different governors of Chiapas. As I noted in my diary, the young women said, "They told us how we had to behave and gave us orders: do this, smile, get serious, take your loom with you, wear your traditional huipil, dress

nicely because the governor is coming and you are going to walk next to him, he is going to help you because the government is good. I didn't like how they treated us and what we represented because we were uninformed; we never knew what those meetings were for."

And so these women stopped appearing at the public events organized by the PRI. This second generation of indigenous leaders came from different spaces. Some of them had been peddlers since they were children, selling in several public markets in the north zone of Chiapas; others had accompanied their mothers and grandmothers during the activities of founding the cooperative, or they had assisted at the general assemblies; and others were part of the supporting base of the EZLN.

Eventually, some of them left the movement because they realized that there was more freedom for women to participate in other events in the civil space, and others sought to continue selling their products while studying. Other women who came from the most conservative Catholic families in the municipality of Chamula decided to leave their communities and confront the municipal authorities who wanted to force them to marry men who were their sisters' husbands. They were beaten and humiliated at every religious festival in San Juan Chamula as well as during its traditional Carnaval. Facing violence from drunken men, these women and other women from Chamula who had rejected local traditions and settled in Chenalhó decided to run away, and they sheltered with the board of directors of the cooperative. These women's decision to seek shelter in the cooperative brought disagreements and arguments. The disagreements affected the rotation of the representatives—choosing new officers—which has never been an easy thing, and it forced us to rethink everything.

Thus, the young weavers began to enter new public spaces, join different networks, and even participate in research projects, such as a study of indigenous sheep breeding by the Autonomous University of Chiapas (UNACH), coordinated by the Batsi Chij group. Formal contacts with other nongovernmental organizations were established in Chiapas, and at national and international levels. In 1993, the cooperative voted at its general assembly to take part in the Network against Extreme Poverty (Recepac, A.C.), operating in the states of Oaxaca, Hidalgo, Guerrero, Veracruz, and Chiapas. The adviser teams and representatives of each

grassroots group participated in several activities, leading to exchanges of productive experiences, reflections among the advisers of the different groups, and also creation of new production networks.

During that period, new working committees were created within the cooperative. As a result, some women traveled for the first time to look for manufactured cotton cloth for embroidery and yarn for their textiles. This experience made them aware of production costs, of the real costs and value of their craftwork, and also of the lack of recognition it received. During the general assemblies attendees came to the conclusion that it was essential for women to travel, so that they could visit new places, share their life experiences as women weavers from Chiapas with other people, and show them not only their products but also how they had organized. When Doña Juana and Dominga Gómez from Catixtic went to Sweden for the first time they were amazed. "It's another world completely different from ours," they said. Thanks to this decision of the cooperative, many women have traveled since then to Norway, Denmark, the Basque country, Germany, the United Kingdom, South Africa, Peru, and various places in the United States, Canada, and Mexico.

In 1994 the national and state response to the Zapatista uprising changed attitudes in the community. Women switched from their usual tasks of working on the backstrap loom, herding sheep, and creating naguas and huipiles to new political tasks, including occupying the streets of San Cristóbal de las Casas. They began to use new words and phrases in Spanish at the general assemblies. And they debated and discussed the new Zapatista Women's Revolutionary Law (see Appendix B), formulated that year.

The law was analyzed and debated in workshops organized by the feminist women of the group who formed the Encuentro de Mujeres (COLEM) collective. Out of these debates, different groups, such as J'Pas Joloviletik, the Independent Organization of Indigenous Women (OIMI), and the Organization of Women Potters proposed the creation of the State Forum of Indigenous Women to provide a space for discussion of the law itself. Over time this forum evolved to become the State Convention of Women from Chiapas.

At the end of 1995, the advisers and representatives of the cooperative suffered intense harassment (including anonymous threats left on

their answering machine), and the store and office were raided. We suspected the team tied to the state government, which now saw our presence as usurping an important political space for them. Many documents (including minutes of the assemblies), photographs, telephones, clothing, and money were stolen, and after other events, including visits by elements of the Mexican Judicial Army, the cooperative divided a second time. After profound analysis, the women decided to divide J'Pas Joloviletik into Jolom Mayaetik (Maya Women Weavers) Cooperative and the civil association K'inal Antsetik (Land of Women). It was necessary to create two separate groups so that each would have a distinct identity under the conditions of armed conflict in Chiapas.

In this time of pain and sadness, the elder women of the cooperative did not agree with the idea of using violence, even though they agreed with all the demands of the EZLN and considered them fair and necessary. The younger women of the cooperative had a different point of view; they saw the necessity of organizing themselves not only to sell their products but also to take part in politics, since the conditions of poverty, exploitation, and subordination were getting worse.

Other women in the cooperative believed that their experience of being women, indigenous, and poor was what united them, but they were frightened by the harassment they were suffering, fearing that the cooperative would not be left in peace. This being the case, these women decided to leave all the inventory to those who chose to remain members of J'Pas Joloviletik, along with the store and a parcel of land in the neighborhood of Tlaxcala. Those who decided to break away and form Jolom Mayaetik received payment for their textiles and began their future with new initiatives.

Independently, Jolom Mayaetik took part in Civil Observation Brigades to denounce the presence of the Mexican army in the indigenous communities. At the same time, they continued selling their products, joined the National Congress of Indigenous Women, and continued debating the Right to Land with the support of Carlota Botey (anthropologist and cofounder of the PRD), who came to Chiapas to participate in a forum on this topic. [See chapter 2 for numerous complaints that women were not allowed to inherit land.] With this historical analysis of landownership and the role of women in it, members of Jolom Mayaetik began to

communicate and share their experiences, feelings, and thoughts with members of several other indigenous women's organizations.

THE JOLOM MAYAETIK COOPERATIVE

Jolom Mayaetik was formally founded in January 1996 with a majority of members from San Andrés Larráinzar and the remainder from the communities of Huixtán, Chenalhó, and Chamula. Over the years, the women from López Mateos in Huixtán left the cooperative due to the disintegration of their group, and women's organizations from new municipalities have joined it: Oxchuc, Pantelhó, and in 2005, Zinacantán. Some of these organizations had been part of J'Pas Joloviletik but had decided not to continue working together when it disbanded. Eventually, however, they joined Jolom Mayaetik because they approved of its way of operating. Today Jolom Mayaetik is composed of women from thirteen community groups.

The number of members fluctuates as some leave the group when they get married and others join it when they are of an age to begin weaving. An evaluation done in 2005 showed that in the previous year (2004) more than 339 women had submitted textiles. There are women of all ages in Jolom Mayaetik; however, an interesting finding from an evaluation carried out by Merit Ichin and Imelda de la Cruz in 2002 was that the majority of women in the cooperative were single. Even though today some of those women have married, the data show that the majority of cooperative members are second-generation members; they were children when their mothers fought for the creation of an independent cooperative.

Each group of artisan women has three representatives who assemble their group, collect the textiles, deliver them to the cooperative office in San Cristóbal de las Casas, and distribute payments to the artisans. They are also the link between the members of their community and the board of directors who reside in San Cristóbal. They convey information on products and sales from the cooperative and also advise the board of directors if there is a conflict within their group that the women cannot solve on their own. The representatives take part in the general

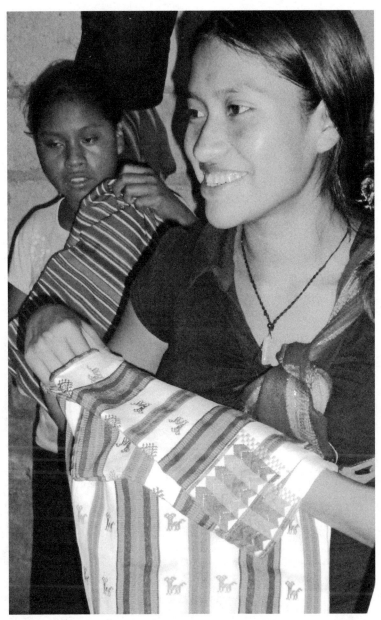

Young weaver, Pantelhó, 2010. Photo by Charlene M. Woodcock.

assemblies, where they are nominated and confirmed by the board of directors, and where they take part in decision-making about designs and pricing of products, among other things. They inform their group members about the activities in which the cooperative is participating. They also participate in various workshops and training courses.

The board of directors is composed of young women appointed by the general assembly. The three directors take care of all aspects of the administration, sales, and marketing of the cooperative. For the first time in 2001, the candidates for the board of directors came to San Cristóbal six months before taking office, in order to receive training, information, and experiences from the outgoing board of directors. The cooperative has grown economically and it is difficult for the new candidates to take on the complex work of the directors without such an orientation. Additionally, commercial relationships are increasingly affected by the changing of the board, and it can be difficult to find women who are willing to assume this work.

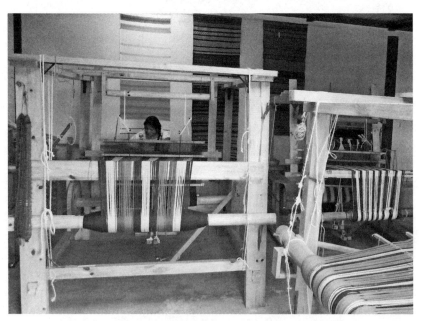

Jolom Mayaetik pedal looms, 2014. Photo by Charlene M. Woodcock.

In 1999 new forms of production, the pedal loom and the sewing machine, were introduced to the cooperative and instruction in their use required the presence of young women in the city of San Cristóbal de las Casas. The idea was to train women in San Cristóbal, so that they could later convey their knowledge to weavers in their communities and encourage the use of the pedal loom and sewing machine there, thereby expanding the economy in rural Maya communities.

In 2002 two new positions were created: two elders, women with moral authority who were founders of the cooperative, were appointed to be counselors. One of their main tasks was to supervise the work of the women in San Cristóbal de las Casas and help in the resolution of conflicts. In addition, they undertook an evaluation of the cooperative and have played an outstanding role in reflecting on the management and future direction of the cooperative.

The counselors emphasize that what characterizes Jolom Mayaetik in contrast to its predecessor is its independence, the social and political participation of its members, its administration by its own members, and the members' will to continue learning.

THE POLITICAL PARTICIPATION AND REPRESSION OF THE WEAVERS

The weavers of the cooperative continued engaging in social and political activities through their support for and participation in the Civil Observation Brigades in the Zapatista zones harassed by the Mexican army. They also joined the civil initiatives proposed by the EZLN in its four Declarations of the Lacandon Jungle. Without giving up the sale of their products, they also participated in the National Congress of Indigenous Women and the reflections about the Right to the Land.

The main topics of these meetings were the rights of indigenous women and denunciations of militarization and political repression. After the Acteal massacre—where uniformed men searched out and killed thirty members of Las Abejas ["The Bees," a Tzotzil Maya Christian pacifist civil society group formed in Chenalhó in 1992] and fifteen

children while the public security police turned a blind eye—women of K'inal Antsetik, Jolom Mayaetik, and Casa del Pueblo (a women artisans' cooperative) joined with the Emiliano Zapata Peasant Organization (OCEZ) to call for a public fast in front of the cathedral. The Acteal massacre was not an isolated incident. Subsequently a series of attacks against the Zapatista autonomous municipalities took place. This was a period of major militarization by the federal government and paramilitary groups.

Jolom Mayaetik and K'inal Antsetik took part in the brigades that crossed military lines to visit people who were under military siege in order to collect and report their testimonies. In 1999, the Fifth Declaration of the Lacandon Jungle called for a Zapatista referendum, and both Jolom Mayaetik and K'inal Antsetik participated in the logistical organization of the event and in receiving the delegates in San Cristóbal. Later, they also took part in the Coordination of Civil Society for the Zapatista Referendum, entrusted with new tasks by the EZLN.

In this period it was very important for the cooperative to define itself as part of civil society. Doing so meant, on the one hand, that they had no relation with the state and, on the other hand, that they differentiated themselves from the EZLN as a political-military organization. Nevertheless, in their public speeches they supported the demands of the EZLN and acknowledged that, as women within civil society, they were also impacted by this struggle. It was primarily the Zapatista Women's Revolutionary Law that strengthened them to claim their rights. During the marches and political rallies, it was typical to hear multiple slogans shouted equally: "Hurrah for Zapatista women," "Hurrah for women of the Civil Society," "Hurrah for Comandanta Ramona," and "Hurrah for Major Ana María." These slogans showed that Zapatista women were very influential and created a new model for themselves as political activists.

Tension and confusion characterized the years subsequent to the 1994 Zapatista uprising. Zapatista women were not allowed to travel to other countries to spread their political discourse. But members of Jolom Mayaetik were invited to participate in forums in other countries about the rights of indigenous women in Chiapas. In these meetings, they identified themselves as part of civil society not the EZLN. Nevertheless, some people chose to see anyone who came from Chiapas as

carrying the stamp of Zapatismo. This had direct consequences for the women of Jolom Mayaetik. Once, Rosalinda Sántiz and Cecilia López traveled to Barcelona. Afterwards, the woman responsible for the invitation to Barcelona came to Chiapas and interviewed the command of the EZLN in Aguascalientes de Oventik. She told the command that Rosalinda and Cecilia had been true ambassadors of the Zapatista movement to the Catalan people.

For the EZLN command that was a signal that the women from Jolom Mayaetik had spoken on behalf of the Zapatistas, and they were inclined to arrest them. Fortunately, this did not happen, but it has been necessary on more than one occasion to make clear that women of Jolom Mayaetik speak from a position outside the EZLN. Since then, in order to avoid problems, when women of the cooperative depart from Europe, they photocopy their speeches, their statements to the press, and the letter of invitation from the organizations abroad so that it is clear that they are not speaking as representatives of the EZLN.

Cooperative members were tired, confused, and saddened to be charged and reported. They could not understand why people from other countries assumed they were Zapatistas and why they were not allowed to express a citizen's point of view. They were harassed and pursued by indigenous leaders of several organizations in San Cristóbal because they participated in marches, demonstrations, and forums about indigenous women's rights. They were in effect the first generation of young indigenous women to decide to leave the private spaces of their communities and go to the public space of the city. They wanted to continue studying, traveling to other states of Mexico, and experiencing other countries where they showed their textiles in exhibitions. They were the protagonists of their organizing processes and the commercialization of their work. Their political participation helped them to better understand their economic activities, their role as women in family subsistence, and their own personal and collective development.

The creation of spaces for meeting other indigenous women and learning about the personal and collective experiences of women from other parts of the country revealed the difficulty women all over Mexico had working with indigenous male leaders. The process has generated personal, family, and organizational crises.

This new generation of women shared their personal stories even though their traditions differed depending on their communities. They learned to live together and share a room, they helped each other with looking for a house to rent, and they made the housework a group effort. They also discovered their sexuality. For the first time they felt free to build other kinds of love relationships—to kiss a partner in the street or walk hand in hand. Above all, they experienced the tension of being away from their community and adjusting to life in the city. Even as they were constructing new types of public and personal relationships, they also experienced conflicts, doubts, harassment, sexual assaults, and violence in the streets.

They analyzed the organizational processes of different indigenous and non-indigenous women's groups in San Cristóbal. They gave their opinions and perspectives in different meetings and offered to document violations of human rights in the indigenous communities.

These women were also the teachers of their non-indigenous colleagues, their mirrors; which brought both agreements and disagreements. As non-indigenous women we had to learn from them as they learned from us as well. It was not easy to walk between different cultures and worldviews. We had to understand the deep implications of the power construction among women and the inconsistencies we were facing. For instance, the "empowerment of women" was not merely words, but something much deeper. In order to decipher its meaning, we had first to examine our own personal and collective actions, our own ingrained attitudes and speech, to help us interpret, analyze, and transform the power.

In 2003, at the time of the settlement of the Zapatista caracoles, the cooperative broke with the Zapatista movement. The conflict began in the context of a production center that the women of the cooperative built in the community of Tzutzbén. They built the center after asking all the community authorities for approval of the exact place for the building and for their assistance, and with a commitment from the Autonomous Council of San Andrés Larráinzar to transport materials from San Cristóbal to Tzutzbén.

When the construction of the center was finished, it was inaugurated by all the groups of women in the community. Then, some weeks after the

opening of the center, a rumor spread in the municipality of San Andrés that the Zapatistas—specifically the Tzutzbén authorities who were militants of the EZLN—wanted to burn the center. This rumor worried the representatives and especially the family that lived next to the production center. This problem was turned over to the general assembly, and that was when the cooperative found out that the command of the EZLN and its Good Government Council were upset because their authorities in the community had not been asked to approve the project.

The weavers of Jolom Mayaetik acknowledged their error in not asking approval from the Zapatistas, and they tried to solve the problem through dialogue. For more than one year commissions of women of Jolom Mayaetik and their husbands tried to establish a dialogue through different means and different authorities, such as agents of the community, the Zapatista Municipal Autonomous Council, and the Good Government Council. But either there was no response or the respondent did not have the power to resolve the conflict.

The only authority that tried to help was the Autonomous Council, but they lacked the power to resolve the conflict. They were clear that there was a misunderstanding in the procedure of permitting the building but thought it could easily be solved through dialogue. It was not in their power to resolve the conflict, however, because the decision had been made by the Command. Throughout the entire year there was not only conflict about the building but also many rumors that the problem was being resolved.

When the women of the cooperative were allowed to meet with the Good Government Council in Oventik, which had recently begun its work, the council ordered them to destroy the building. They were outraged and saddened. They felt disrespected both as women and as indigenous people. Furthermore, they had formed a commission with approximately fifty weavers and embroiderers to establish a dialogue in the same language as the Good Government Council.

The council would not accept these women's proposal and asked them to leave the Caracol of Oventik, saying they would only accept a five-person commission: three women and two men. Zapatista authorities outside the commission were surprised to encounter former authorities of the Autonomous Council of San Andrés who wanted the problem

resolved. They had witnessed what happened during the construction of the training center because some of them were husbands of weavers in the cooperative. Yet the Good Government Council determined that the training center had to be demolished within just one week. From then on, the women would have to work separately, on their own; the council agreed not to obstruct the organization and commercial processes. Those were the conditions imposed by the council; the women had to comply because otherwise the council would publish a letter signed by Subcomandante Marcos denouncing these women as wives of the paramilitary.

These women did not want to lose their dignity as women, and they defended their cooperative as an autonomous and plural space. But in the end, they had to dismantle the center, before they even had a chance to work in it, because it had become a monument that represented the conflict. Ultimately, they did not want to deepen the problem, since some women or families could be hurt.

This year was one of the most difficult for the cooperative. The confrontation with their own people, whom these women still had in their hearts and hopes, produced an internal pain much stronger than did struggles with other opponents, such as the government. However, the cooperative continues united and the women work again in peace. Members continue their activities: they participate in state forums and regional meetings of the Civil Society in Resistance, known today as the Popular Resistance Movement of the Southeast (MRPS-FNLS). They also visit other communities within the state of Chiapas—the coast, the northern jungle zone, and the community of Marqués de Comillas—to share the story of their organization with other women. These discussions have changed: now they focus on women's rights and the principles of autonomy.

THE NEW LEADERS AND THE POWER CONFLICTS

Many young women have empowered themselves in Jolom Mayaetik. After their training some have decided to follow their own path, to join other organizations or to continue their training on their own. Rosa-

linda Sántiz Díaz and Micaela Hernández Meza, after concluding their terms as directors on the cooperative board, chose to join the nonprofit K'inal Antsetik. They share their knowledge with both organizations, with those women who followed them, and with other women from different regions and organizations. They agree that serving in the administration of Jolom Mayaetik is difficult, as it requires moving to the city, dealing with many administrative tasks, having to speak Spanish, and giving speeches before other women, sometimes even to elder women of the community.

Rosalinda explains, "For me, it's difficult to work with women in the communities because I feel tension toward myself, toward the work, or simply that women don't value my work. Often they think that just because you are in the city, your work is easy, that you aren't tired. That's not true. The work in the city is as stressful as the work in the community."

However, the training and knowledge that the women receive in the cooperative are a great step forward to a greater self-esteem, confidence, and a new sense of life. These women are role models for the younger women of the cooperative who follow them. Interestingly, the majority of women who have been in a director position within the cooperative remain in the city afterwards; they look for new ways to live as an indigenous woman and open new paths to a fuller role in society. Those who have been part of the production team tend to return to their communities, get married, and carry on their lives as indigenous women in a more traditional way.

There are two possible explanations for this pattern. On the one hand, the integration of women on the production team is limited because some do not speak Spanish very well, and their environment and relationships are limited to other indigenous women. On the other hand, those who choose to be self-sufficient, to work and study independently, pay a personal cost: they cannot count on being accepted as they are. It is not easy to have and share power, to recognize the power of others, or to leave power.

"Holding power is a challenge. We have learned these new things, but even though one may know things and know how one should behave, the will to hold power and dominate others is strong—'Who knows, indigenous people they make many things. I am the best and I can do it.'—Or

we presume we already know everything; it happens often that we don't realize that we're going astray. Or, we think that it's the others who know, that you are intelligent and I am stupid." (Rosalinda Sántiz Díaz, former president of Jolom Mayaetik, interview, November 2004)

The conflicts in the cooperative revolve around power. For instance, what happens to a strong woman when there are no spaces for her abilities to be acknowledged, when the dominant society continues to be racist? What happens when these women want to leave the cooperative but do not feel recognized by nongovernmental organizations that have other purposes? How can women handle the responsibility of a new position if they do not have the knowledge to assume it? How can a new president head a board of directors and convey that she will work to satisfy everyone? How can she gain the respect of the elder women? The strategies are diverse. The mere fact of not having enough authority in the group has led to some women being disqualified from office. To

Micaela Hernández Meza and Celerina Ruiz Núñez in Berkeley, 2004. Photo by Bill Woodcock III.

recognize themselves as indigenous women means growing together and not expecting the mestiza adviser to give them the knowledge.

Jolom Mayaetik today is a cooperative that manages itself. It is an organization with national and international contacts, with increasing orders, and with the ability to develop markets abroad, particularly in the United States and Europe, where it has strong support.

The women weavers of our cooperative have been accompanied on their journey by women of many faces, voices, and paths—feminists, anarchists, independents, Marxists, Leninists, mystics, lesbians—both as volunteers and as workers. Photos and videos capture the moments, the thoughts, and the hearts of the weavers who dream of a world without violence; who hope to find tolerance and respect. In order to listen to each other in spite of our ethnic and class differences, it is worth the challenges of being together. Every person who has crossed paths with the weavers of the cooperative has taken away something and left something.

The project of writing this book began in 2000, in the midst of political divisions and power struggles. The women recognized the necessity of reconstructing their history as indigenous women and recovering the transformations that unify them. It is a collective initiative of writing their story in their own words, to show the world their changes, wishes, and dreams.

Yolanda Castro Apreza and Barbara Schütz

Appendix A

The Life of Rosa López from Tzutzbén, San Andrés Larráinzar

GAMES

I didn't go to school because my father wouldn't permit it. When I was fourteen years old I realized that I wanted to study. But I couldn't go to school because the man that I was going to marry was waiting for me.

My mother didn't let me play, she just wanted to see me working. When she saw me playing she scolded me, so I always played in secret. I had girlfriends to play with. When my friends took the sheep to graze they did it quickly, and then they could be found playing with mud, making tortillas, and I went with them, but if my mother realized it, she scolded me and put me to work.

I sat down to work but when I got bored I went to play with my friends. Later, I gave up playing games. However, it wasn't so easy for the boys to stop playing. Once my mother scolded my friends; she told them to stop playing and start working, because they had invited me to play as well. The girls got angry and one of them said, "Don't scold me, my mother doesn't scold me!" My mother didn't let me play because she didn't want my clothes to get dirty. Those girls who were playing with the mud all the time had dirty clothes and cracked hands.

At the age of fourteen I already washed my own clothes. I stopped playing and worried more about work. It made me think that when I got married they couldn't stop me from playing.

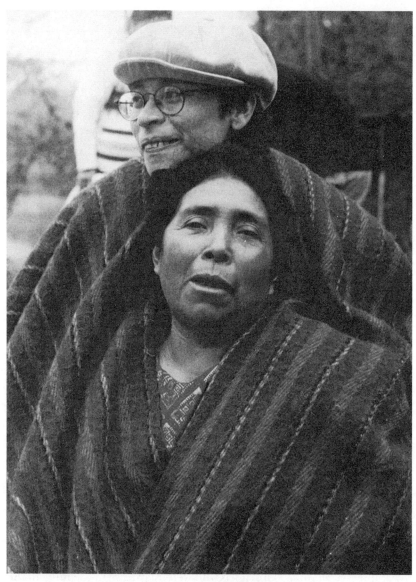

Rosa and Yolanda, 2003. Photo by Barbara Schütz.

LEARNING HOW TO WEAVE

I wasn't learning to weave, so my mother got angry and said, "Why is it so much work for you to learn how to weave? Do you think that I have so much time to help you weave?" Then she took my weaving stick and hit me with it three times. It hurt me a lot; I cried, then angrily threw down my weaving. I was upset for a while so I went out to play to distract myself. After that I took up my weaving again and continued working, and then my mother came close and told me not to get upset. I began to weave and proceeded a little, and she could see that my work was becoming even; she told me what to do. But I argued and she got angry again. She grabbed the stick and struck my hands twice. I got angry and cried until I succeeded in doing better. My mother continued teaching me; I also learned how to do other work.

My grandmother taught me how to embroider, and so I began to embroider my clothes. What was hard work to learn were the small designs, but my grandmother had no patience—she lost control and hit me. I remember that she hit me twice but not very hard. She thought that we learned best and most quickly by being struck. When we took the sheep to graze, we took our weaving to work on there, but when I got bored I started playing.

THAT'S HOW I GREW UP

I grew up without my mother; I was very young when she died. My family taught me how to count and I learned; they taught me how to write 4, 5, 6, 7, and 8 years. I remember that.

I didn't go to school because my father wouldn't permit it. When I was fourteen years old I realized that I wanted to study. But I couldn't go to school because the man that I was going to marry was waiting for me.

"You're not going to school because you are going to get married soon," my father told me. I didn't want to get married, I was trying to escape. There was a teacher named Alfonso who gave classes there. He taught me a little and I used to make tortillas for him. He and his wife came every Monday, and I had the tortillas ready for them. I cooked for them and cleaned their house every day. They told me that I could learn

to write and read. They taught me the alphabet and also how to cook. Then they told me, "Don't worry, we're going to Mexico City. If you want to study, you can go to school there and learn more, if you want to go." I accepted because I really wanted to go. A few days before they were leaving I told my parents that I wanted to go, but they didn't let me. "You are not going anywhere. If you're even going to think about it, if you die there, it won't matter to us!" they told me. But I insisted and they scolded me. I was afraid. I told the teachers that my parents wouldn't let me go. "If they don't let you go you should escape, we are leaving on this day," they told me. But I didn't go; my parents' reprimand frightened me. So I stayed and lost my teachers.

When I was eight or nine years old my father used to drink refrescos [accept drinks from a suitor's family] with some young boy. They were waiting for me to grow up and get married to him, that's why they offered my father refrescos.

Later I realized that we didn't have money because my dad drank alcohol a lot. He got married to another woman, my stepmother. She was a hardworking woman.

THE FIRST WORK

My stepmother sold tortillas, and I learned from her how to make them. She took me with her to sell them in town. I began to make small tortillas, small and round; they were lovely. I tried hard to make them the best possible, and sometimes I earned a tostón for them, but other times just one peso. The money that I earned was just for me, so I bought cookies, bread, or whatever I liked. When we went harvesting I collected the remnants of corn and beans and I made tortillas with them, sometimes I also made *dobladitas* [tortilla turnovers] We also went to herd the sheep together.

I knew that vegetables sold well to the mestizos in town so I woke up early in the morning to look for vegetables and then I sold them in town for five cents each bunch. If I my net bag was full, I earned a tostón or maybe one or two pesos, and with that I bought my blouse, yarn, things to eat, cookies, or bread.

That's the way I lived and how I learned to work and to buy my clothes. By the time I was eleven or twelve years old, I already knew how to work well.

When I was a little girl I took care of hens; my grandmother taught me to work. Taking care of hens was my first work. I gave them food, I gave them masa. But I didn't have a mother. I remember very little about when she died. I didn't know how to do anything else, only to take care of hens.

I used to grind the hens' food in the metate. That's how I learned to grind corn. My grandma asked me to grind corn while they were making tortillas.

They didn't scold me because I was obedient. They asked me to bathe myself and brush my hair, to grind corn, and to make tortillas. During my childhood I started working because my grandma had many sheep. When we finished making tortillas, we ate, fed the chicks, and then we took care of the sheep.

When I was older, at the age of six or seven years old, my grandmother gave me little time to play; she scolded me and made me work. She had to spin cotton and wool, so she asked me to prepare the cotton. We even worked while we were grazing [the sheep], removing the seeds from the cotton, and after we did that, I was allowed a little time to play with the other children.

As I grew older I wasn't allowed to play anymore. My grandmother thought that if I didn't play, I would learn how to work better and faster. She wanted me to work all the time. My father used to tell my grandma, "Teach my daughter how to work, she will have to marry soon; I am already drinking refrescos," so my grandma taught me how to work.

We also tilled the land to sow potatoes in the middle of the milpa. They were very tasty and they sold well. I sold the potatoes I grew, and with that money I bought my clothes on my own; I didn't depend on my father. I have bought my own clothes since I started to weave. Clothes used to be very cheap; they only cost one tostón or one peso, so I had enough to buy clothes.

THE COOPERATIVE

We were asked if we could gather a group of women in Tzutzbén to begin to work on arts and crafts. Women said they would do the work, but they only wanted to deliver the textiles, they didn't want to go to group meetings. They didn't go to the meetings. They said they would deliver their work, but they hardly even did that. They delivered the products once a year. There were few women who understood that it was important to work together and that it would be good to sell their textiles. The group disbanded for a time because women weren't interested in meeting.

Later we tried to get the group together again. We asked them if they wanted to work or not; some of them didn't, so they began to leave. About twelve women remained, very few. As we began to meet more often, other women asked to join and told us they would like to work as well.

Now there are thirteen women in the group, and I am the representative. Women in the group are very happy because they are selling more textiles, and they get paid every month or two months. If they don't want to work that's their problem, but those who have changed their minds are working well.

I feel good about our cooperative. When we sell our work, it's a great help to us, but if we don't sell or don't have invitations to show our work, then we don't progress.

What a good thing that the cooperative helps us to sell our textiles! It's difficult to look for people who are interested in our work and want to buy it. I can't do it because I haven't mastered Spanish and I'm afraid of traveling, but what a good thing that we have the cooperative to help us. I would like to travel, but I have no experience and I don't speak good Spanish. I hope the cooperative continues to support us and bring us money for our textiles.

MARRIAGE

I wasn't forced to get married, but my father had already taken refrescos and trago from the young man for a long time. He was satisfied when he saw that I had learned how to work properly. He drank with the boy without asking me if I wanted to marry him or not. I got married to that

boy. My father made the agreement for my marriage a long time before I got married. I believe he was taking refrescos and trago for eight years. That's why my father didn't let me play; he only wanted to see me work. My grandmother had to teach me how to work; for that reason she didn't let me play. At the age of eight or nine years old, I already worked on the backstrap loom, I wove little napkins. My grandma taught me how to warp the loom and the whole process of weaving, and so I learned. They didn't let me play, it was pure work.

When I got married I knew how to make tortillas, I was already working well; no one could scold me for my work, because I knew how to do it all.

WOMEN WHO KNEW ROSA

Manuela Hernández, Tzutzbén

Rosa worked for the INI; she delivered her arts and crafts there to sell. We worked together in the INI, and that's how we knew each other. She wasn't my sister, I only knew her from work.

We connected more when Yolanda Castro left the INI. We worked with her, she was our adviser, and [when she left] Rosa and I decided to separate from the group as well. Later, Rosa talked with Lucas from the community of Chichelalhó and joined the new cooperative Jolom Mayaetik. After some time, Rosa invited me to join the new group.

Rosa used to deliver the textiles we created with a woman named Juana. They went together with our products, and little by little the group grew. Over time, Rosa had some conflicts with Juana. They used to go to San Cristóbal to deliver the arts and crafts, but Juana started to speak negatively about Rosa, saying that she had stolen money.

Finally, they quit working together, and Rosa asked me to go with her to San Cristóbal to deliver the textiles, and I accepted.

The first time that I went with Rosa to San Cristóbal I attended a meeting of the cooperative with her, and since that time, here I am.

It was Rosa who helped me join the cooperative and sell my arts and crafts. She taught me to sell. She separated from her husband and made her living from her weaving.

As I think about Rosa since her death, I just remember that she used to sell my arts and crafts because she was a good woman, and she never got angry. I also remember the trips that we made together for the cooperative and that we never argued.

I don't know what she died from. I only know that she was sick after a man came into her house and beat her.

Rosa lived with only her youngest son because her daughter went to Mexico City. One night while her son was sleeping, a man came into her house and beat her.

The next day we had a meeting with various members of the cooperative, but Rosa didn't tell us that someone had beaten her. I found out about it long after it happened.

Rosa went to the dentist because her teeth were broken due to the blows that she received. The man also tried to abuse [sexually assault] her.

The mother of the attacker said, "Yes, this time she didn't let this man in, because she has already had enough men in her life."

When Rosa died, I knew that the mother of the aggressor had burned many candles in the church of Guadalupe, praying to shorten Rosa's life.

Rosa defended herself from the blows but she was badly injured. I think that the attack was the reason why she died, although they said it was diabetes. She didn't know that she was ill, she seemed to be well; we grew vegetables together.

Nobody told me when Rosa died. One day, I passed by her house and her daughter told me that [her mother] was feeling ill. Two days passed and I heard that she had died. Rosa had a good heart; she always offered us food. We're very sorry that she has died.

Magdalena López, Bayalemó

Rosa worked in the INI, and we worked together with her in the same group. She was a member, and Petrona was the representative. When Petrona invited me to the meetings, there was Rosa, she always took part and wasn't lazy. She was smart and wasn't afraid to express what she wanted to say. She lived in the municipal seat and I lived in a community, so we were far from each other.

When the Jolom Mayaetik cooperative was formed, I knew that she was the representative and knew her; she always greeted me whenever we met.

She spoke very well. When I had an errand in town she invited me to her house to collect vegetables and chayotes. Rosa was our representative because she was a responsible woman. She always went to the meetings; she never missed one. She was a brave woman and I mourned her death.

Rosa was an important woman in the cooperative. She always participated; she never gave anyone grief, she did all she was asked to do. Unlike many of the representatives who never participated in anything, if they asked something of her she always responded.

The last I remember of Rosa was when we visited the Monte Bello Lakes and the Maya archaeological site of Chincultik. That day I had a lot of pain in my mouth, and I could barely speak so we didn't talk much.

Rosa died January 31, 1998. I remember that in the last meeting we had, she spoke about the abuse she suffered and said, "That man tried to rape me and I had to defend myself. We fought and fell to the floor. He beat me and broke my teeth. I defended myself and so he couldn't rape me, though he tried." Who knows why no one arrested that man. What they say is that the man's mother is an evil person and people were afraid of reporting him.

I found out that she was dead after she was buried. I only took part in her *novenario* [funeral rite nine days after a death]. We can't believe that she is dead. We feel that she is still alive when we remember her. Every time she came to the office, she sat down in the place where I am sitting right now. She always greeted me. She was a tranquil woman.

Rosalinda Sántiz, Bayalemó

I came to know Rosa in 1996 when I began to come to San Cristóbal. I remember when we were visiting the groups of artisans in the different communities. There were groups that didn't make their products very well; they had to improve the quality of their work in order to increase the selling price. At that time Anita, Lorenza, and I worked together. When we found out that she had died, we couldn't believe it. It didn't

seem possible, it was very ugly. The worst was that we didn't find out until it was her novenario.

Rosa was a very important person for me; she always thought about the other women. I remember that once we organized a demonstration and no one but Rosa came, she was the only one.

I also remember when we visited Chincultik; that was a time that I greatly enjoyed. Rosa and I went to collect flowers; there were many, they were the purple ones. I think we learned a lot from her, she taught us the importance of talking about everything. We never heard a bad word about her, she was a very good person.

Rosa is very important because she was with us from the beginning when Jolom Mayaetik was formed, and before that she worked in J'Pas Joloviletik. Rosa always encouraged other women to participate. She was an optimistic and cheerful woman.

There are not many women like her. Rosa used to come to San Cristóbal by herself to deliver textiles to Yolanda. She was always very purposeful. When Rosa died, I felt as if someone in my family had died. I learned much from her; I believe that older women have much to teach the very young women.

Pascuala Patishtán, Bautista Chico

Rosa was a good person. When she saw people arrive with a musical instrument, she always asked them to play. She didn't let anything bother her. She was tranquil and kind.

I came to know her after my friends did, although I also knew her in J'Pas Joloviletik; but she was a member of the group and I was just a worker.

Juana Jiménez, Bautista Chico

I don't remember very much about her. I know that somebody tried to rape her and that her teeth were broken due to the blows that she received. In the meetings she gave all her goodwill to the women of her group; but that's the way life is, nobody knows who is going to die first.

Appendix B

Zapatista Women's Revolutionary Law

As published by the EZLN in the newspaper *El Despertador Mexicano* (Mexican Awakener), issued on January 1, 1994, in conjunction with the uprising.

In their just fight for the liberation of our people, the EZLN incorporates women in the revolutionary struggle regardless of their race, creed, color, or political affiliation, requiring only that they meet the demands of the exploited people and that they commit to the laws and regulations of the revolution. As well as taking note of the situation of the woman worker in Mexico, the revolution incorporates their just demands for equality and justice in the following Women's Revolutionary Law.

First—Women, regardless of their race, creed, color, or political affiliation, have the right to participate in the revolutionary struggle in any way that their desire and capacity determine.

Second—Women have the right to work and receive a just salary.

Third—Women have the right to decide on the number of children they will have and care for.

Fourth—Women have the right to participate in the matters of the community and have authority if they are freely and democratically elected.

Fifth—Women and their children have the right to primary [medical] attention for their health and nutrition.

Sixth—Women have the right to education.

Seventh—Women have the right to choose their partner and are not obliged to enter into marriage.

Eighth—Women have the right to be free of violence from both relatives and strangers. Rape and attempted rape will be severely punished.

Ninth—Women will be able to occupy positions of leadership in the organization and hold military ranks in the revolutionary armed forces.

Tenth—Women will have all the rights and obligations which the revolutionary laws and regulations give.

Appendix C
Weavers with Their Communities and Municipalities

Pascuala Díaz, Bayalemó, San Andrés Larráinzar

María García, López Mateos, Huixtán

Juana Gómez, Jolxic, Chenalhó

Juana Gómez, Yochib, Oxchuc

María Gómez, Yochib, Oxchuc

Martha Gómez, Yochib, Oxchuc

Rosa Gómez, Yochib, Oxchuc

Verónica Gómez, Jolxic, Chenalhó

Rosa González, Jolxic, Chenalhó

Antonia Hernández, Bayalemó, San Andrés Larráinzar

Manuela Hernández, Tzutzbén, San Andrés Larráinzar

Martina Hernández, Tzutzbén, San Andrés Larráinzar

Micaela Hernández, Shishintonel, Tenejapa

Juana Jiménez, Bautista Chico, Chamula

Adela López, Bayalemó, San Andrés Larráinzar

Cecilia López, Bayalemó, San Andrés Larráinzar

Ernestina López, Bayalemó, San Andrés Larráinzar

Lucía López, Bautista Chico, Chamula

Magdalena López, Bayalemó, San Andrés Larráinzar

Marcela López, Bayalemó, San Andrés Larráinzar

María López, Bayalemó, San Andrés Larráinzar

María López, Cabecera, San Andrés Larráinzar

María López, Oventik Grande, San Andrés Larráinzar

Petrona López, Bayalemó, San Andrés Larráinzar

Rosa López, Tzutzbén, San Andrés Larráinzar

Rosa López, Yochib, Oxchuc

Juana Méndez, Yochib, Oxchuc

Petrona Méndez, Yochib, Oxchuc

María Patishtán, Bautista Chico, Chamula

Pascuala Patishtán, Bautista Chico, Chamula

Francisca Pérez, Chichelalhó, San Andrés Larráinzar

Micaela Pérez, Bayalemó, San Andrés Larráinzar

Pascuala Pérez, Yochib, Oxchuc

Carmela Ruiz, Oventik Chico, San Andrés Larráinzar

Celerina Ruiz, Oventik Chico, San Andrés Larráinzar

María Luisa Ruiz, Oventik Chico, San Andrés Larráinzar

Celia Sántiz, Bayalemó, San Andrés Larráinzar

Guadalupe Sántiz, Yochib, Oxchuc

Petrona Sántiz, Yochib, Oxchuc

Rosalinda Sántiz, Bayalemó, San Andrés Larráinzar

Zoila Sántiz, Yochib, Oxchuc

Related Reading

Eber, Christine, and "Antonia." *The Journey of a Tzotzil-Maya Woman of Chiapas, Mexico.* Austin: University of Texas Press, 2011.

Eber, Christine, and Christine Kovic, eds. *Women of Chiapas: Making History in Times of Struggle and Hope.* New York: Routledge, 2003.

Healey, Kevin. *Llamas, Weavings, and Organic Chocolate: Multicultural Grassroots Development in the Andes and Amazon of Bolivia.* Notre Dame, Ind.: University of Notre Dame Press, 2001.

Menchú, Rigoberta. *I, Rigoberta Menchú: An Indian Woman in Guatemala.* London: Verso, 1984.

Moksnes, Heidi. *Maya Exodus: Indigenous Struggle for Citizenship in Chiapas.* Norman: University of Oklahoma Press, 2012.

O'Donnell, Katherine. *Weaving Transnational Solidarity: From the Catskills to Chiapas and Beyond.* Boston: Brill, 2010.

Ortiz, Teresa. *Never Again a World Without Us: Voices of Mayan Women in Chiapas.* Washington, D.C.: Epica Task Force, 2001.

Pozas, Ricardo. *Juan the Chamula: An Ethnological Re-creation of the Life of a Mexican Indian.* Berkeley: University of California Press, 1962.

Rosenbaum, Brenda. *With Our Heads Bowed: The Dynamics of Gender in a Maya Community.* Boulder: University of Colorado Press, 1993.

Rus, Jan, Rosalva Aída Hernández Castillo, and Shannan L. Mattiace, eds. *Mayan Lives, Mayan Utopias: The Indigenous Peoples of Chiapas and the Zapatista Rebellion.* Lanham, Md.: Rowman & Littlefield, 2003.

Sell, Sean S., and Nicolás Huet Bautista, eds. *Chiapas Maya Awakening: Contemporary Poems and Short Stories.* Norman: University of Oklahoma Press, 2017.

Traven, B. The Jungle Novels series.
The Carreta. New York: Hill and Wang, 1970.
The General from the Jungle. New York: Hill and Wang, 1972.
Government: A Novel. New York: Hill and Wang, 1971.

March to the Montería. New York: Hill and Wang, 1971.

Rebellion of the Hanged. New York: Hill and Wang, 1974.

Trozas. Chicago: Ivan R. Dee, 1994.

Walker, Gayle, and Kiki Suárez. *Every Woman Is a World: Interviews with Women of Chiapas.* Austin: University of Texas Press, 2008.

Index

Page numbers in italic *type denote images or photographs.*